HOW TO SLEEP

ALSO AVAILABLE FROM BLOOMSBURY

The Three Ecologies, Félix Guattari
Schizoanalytic Cartographies, Félix Guattari
Lines of Flight, Félix Guattari
The Poetics of Sleep, Simon Morgan Wortham

HOW TO SLEEP

The art, biology and culture of unconsciousness

MATTHEW FULLER

Bloomsbury Academic
An imprint of Bloomsbury Publishing Plc

BLOOMSBURY
LONDON • OXFORD • NEW YORK • NEW DELHI • SYDNEY

Bloomsbury Academic
An imprint of Bloomsbury Publishing Plc

50 Bedford Square	1385 Broadway
London	New York
WC1B 3DP	NY 10018
UK	USA

www.bloomsbury.com

BLOOMSBURY and the Diana logo are trademarks of Bloomsbury Publishing Plc

First published 2018

© Matthew Fuller, 2018

Matthew Fuller has asserted his right under the Copyright, Designs and Patents Act, 1988, to be identified as Author of this work.

All rights reserved. No part of this publication may be reproduced or transmitted in any form or by any means, electronic or mechanical, including photocopying, recording, or any information storage or retrieval system, without prior permission in writing from the publishers.

No responsibility for loss caused to any individual or organization acting on or refraining from action as a result of the material in this publication can be accepted by Bloomsbury or the author.

British Library Cataloguing-in-Publication Data
A catalogue record for this book is available from the British Library.

ISBN: HB: 978-1-4742-8871-2
PB: 978-1-4742-8870-5
ePDF: 978-1-4742-8872-9
ePub: 978-1-4742-8873-6

Library of Congress Cataloging-in-Publication Data
A catalog record for this book is available from the Library of Congress.

Series: Lines

Typeset by Newgen KnowledgeWorks Pvt. Ltd., Chennai, India
Printed and bound in Great Britain

CONTENTS

Acknowledgements viii

How to sleep 1
 1 Without thinking 1
 2 Dormant 6
 3 Alarm 14
 4 I don't want to be awake 17
 5 The domestic architecture of the skull 20
 6 Heroes of sleep 24
 7 Too much dream 31
 8 Imperatives on the importance of diet 32
 9 Mediating 32
 10 Sleep acts 33
 11 Repulsive sleep 36
 12 Supination or pronation? 37
 13 Ingredients of sleep 38
 14 Sleep glitches 45
 15 Body parts 46
 16 Chemistry sex 58

17 Be unconscious 61

18 The luxuriance of dissolving 69

19 Free-running 70

20 Sleep in love 71

21 Vulnerable 72

22 Hyperpassivity 77

23 The eye busy unseeing 79

24 How to thrive biologically 82

25 Repetition 85

26 Architecture 87

27 Laws governing sleep 88

28 Film sleep 97

29 The man controls the day. But we will control the night 104

30 Headless brim 112

31 At the edge of sex 115

32 No tools left in this vehicle overnight 121

33 Unswept benches 124

34 Trains and buses 126

35 The smell of sleep 128

36 The child's bed 129

37 Brain as labourer 130

38 Melnikov's Promethean sleepers 132

39 Sleep debt 135

40 Sleep on the road 137

41 Terraforming 139

42 Nocturne 140

43 Dozy-looking 144

44 Licked surface 150

45 Waking up 151

46 Equipment 152

47 Sleep upright in order to avoid death 156

48 Go to Guildhall Museum and look at the clocks 158

49 Animal sleep 159

50 Wrap up warm 160

Notes 163

Index 179

ACKNOWLEDGEMENTS

Many thanks for their assistance, ideas and support in the development of this book to Sonia Ali, Constant Dullaart, Arcadia Missa; Christian Andersen, Geoff Cox, Lone Koefod, Soeren Pold and everyone else at the Centre for Participatory Interaction Design at Aarhus; Bassam el Baroni and the Lofoten International Art Festival, Josie Berry-Slater, Ina Blom and Rosi Braidotti; Annet Dekker and Annette Weinberger at aaaan.net; Mijke van der Drift, Yingmei Duan, Andrew Goffey and Graham Harwood; Patrick Hanafin and the Department for Psycho-Social Studies and the Centre for Law and the Humanities at Birkbeck; Yuk Hui, Ai Kano, Scott Lash, Mujie Li and Li Li; Warren Neidich and the much missed Mark Fisher, organizers of the third Psychopathologies of Cognitive Capitalism conference; Simon O'Sullivan and the Visual Cultures seminar series at Goldsmiths; Luciana Parisi, Alexei Penzin, Lynne Pettinger, Tiziana Terranova and Ines and Eyal Weizman. Thanks to Liza Thompson and Frankie Mace at Bloomsbury and to Kalyani at Newgen. Thank you to Olga Goriunova for reading and improving the manuscript.

How to sleep

Having made the mistake of waking up, and having compounded the error by going in to work, my thoughts such as they are at this state of the day, turn to sleep. What might sleep be? An unfinished set of reveries, patches of movement that are rapid or quiescent, some kind of energy conservation strategy left as an evolutionarily acquired physiological fossil from the days before the omnipresent possibility of light? Gnawing on this question, this book tosses and turns quite a lot. It may seem to go on for a long time, and then abruptly end in a dazed kind of way, a state that is not quite distinguishable from the need for more sleep, but that surely cannot be due to the inordinate time spent under.

1. Without thinking

Sleep cannot be directly known in its native state. In order to think about it we must be awake or to know something use devices for recording and analysis. Even then we must wonder what we know. Sleep, unlike any other part of culture, has no capacity for reflexivity within its own conditions. In sleeping one simply sleeps; one does not know anything.

Sleep is ungraspable, unwritable, only perceivable at its edges or its outside. There is no immanent critique of sleep, only embedded reporters who, necessarily, have no capacity of seeing. Sleep operates in oblique ways, arriving at cultural reflexivity only by a detour.

There is a long and consistent thread in philosophy that thought and being are one and the same. To be is to think and to experience, to be aware to varying degrees of oneself and the world. The various fissiparations that this figuration of thought underwent through time, a process entailing a relation between a subject and an object, tend to neglect the relation of thought to sleep. Sleep muddles the superposition or identity of being and thought. A sleeper seemingly just exists, gaining respite from thought, and sleep is spoken of largely by those outside of its native state. There is little of a theory of sleep sui generis and even less of a philosophy of sleep produced by those asleep. The present volume regrettably presents no obvious breakthrough in this regard, but perhaps it is possible to make some preliminary notes towards a genuine thinking of sleep. As such it would have to tend towards being of a kind that is asleep.

René Descartes suggestively leads us in such a direction, even if he only adopts this position rhetorically when in the *Meditations on First Philosophy* he remarks, 'I am now seeing light, hearing a noise, feeling heat. But I am asleep, so all this is false. Yet I certainly seem to see, to hear and be warmed.'[1] Sleep introduces instability because it is the domain of sense perception but the properly perceiving subject is absent in relation to the veridiction of sensation. Although the sensation may be considered false, as in the case of a dream, the act of sensing it is not. This implies a thinker. Hence, it is the capacity of judgement that must be exercised, as distinct from what is perceived,

or is working on it but is uncontaminated by it. To occupy the chair of judgement – that piece of furniture that Lars Iyer most explicitly identifies among the household inventory of organized thought – you may, on no account, be asleep.[2]

But there is a bifurcation. The thought of sleep presents a form of logical uncertainty in that it presents the impossibility of producing a verification of a statement of its condition from within the system producing it. One sleeps, but given the possibility of a sleeping thought with the capacity for reflection, what might arise?

Logical certainty produces logical overspill, the slops of thought. Good thinkers do not repeat themselves. They may amaze, inspire, frighten, allude, provide occasion to imagine intimacy of minds or to stretch the capacities of perception. In dreams, we are shocked, mystified, stuck, vigorously sexual. Life is arranged otherwise than the shams and balances we may fall into, or mocks them by exemplification. Dream is the place where thought sabotages itself, begins to dance, drunkenly potted in its own fermented juices; is maybe subtle and intriguing, a refraction of the day or a return of prior life; is full of a rage more lucid and impossible than in the day; where the dog hunts down all the rabbits as it twitches in its dream, or so observes the owner performing an imagination of the subjectivity of the hound, in something other than an anthropomorphism.[3]

Thought's own chartered organs congeal something other than reason, the sense of a subject, something that can be remembered and held onto, turned into a proper sentence. To describe dreams is to convert them.

Working such a line, and feeding centrally into Descartes's argument, Augustine suggests that sleep accidentally produces a

self-knowledge of existence.[4] Rational thought is proven, the subject is established, because of the existence of dreams, in that they give not only something to differentiate from but also because in dreaming and the differentiation from waking cognitive life there is evidence that a subject is there even if in an only incipient form. Just as the Turing Machine was established via the proof of the incomputable, the waking working human arises due not to a categorical, but experimental, version of what it is not.

It is often metaphorically asked, what kind of unconsciousness is to be found in thinking. This is a basic operating logic of critical theory. But the reverse, what kind of thinking, as differentiated from bare cognitive processes, may be manifest in sleepy states of unconsciousness is also necessary to explore. In relation to the proper thought of the wakeful one, sleep is oblivion. Asleep, even the thought-virtuoso is released from the position of incumbent in the seat of decision. No thought, no refined judgement, is necessary or possible. There is something close to bliss in this oblivion, and beatitude is one of the states in wakening that is closest to sleep. It can be ventured that sleep is the subject of non-knowing which, more than even the lucidity of the idiot, produces thought.

The forgetful theorist is a familiar trope, one who is obsessed with an idea to the point that they become remiss in attending to the ostensibly proper matters of the world. To be absent-minded is taken as a sign of higher calling: it is a symptom of a mind focused on other things or of the inadequacy of the world in providing anything more interesting, leaving one to desire to be a 'brain without a body'[5] released also from the hassles that a body incites others to provide.

Perhaps we can see that this absent-mindedness, in a radical form, void of thought, is also a mode of thought in itself rather than a side effect of a higher mind.

One angle into such an understanding would be to recognize sleep's quality of obliquity. Sleep is at an angle to thought, but is not directly opposed to it. One might want to examine or to imagine how much covalence any particular waking notion has with sleep, how it contains sleep, or induces it, but it is also the specific kind of tangent to thought that sleep draws that makes it oblique. Sleep is not parallel to or contradictory to wakefulness in relation to thought; rather, it intersects with it at an unidentifiable point. Sleep and wakefulness introduce shifting perspectives on and into each other, but at the same time, sleep is an oblivion. The obliquity of sleep slices into thought, inversely traces its contours, but then suddenly finds itself in the middle of it. Sleep's oblivion is folded in and out of the rational subject. How many times does Ludwig Wittgenstein take his repose in between the struggle of writing down the well-ordered and sequentially stacked arguments of the *Tractatus*? How many cycles of sleep do readers engage in between phrases and pages?

Sleep persists. The repetitive inevitability of sleep is perhaps only tolerable due to our inability to assimilate, except in the most banal or arithmetic terms – sleep transposed by recording devices – what occurs within it. To fall asleep is to cope in some way, by evasion, with the likely boredom of the simplicity of being asleep. A direct encounter with our sleeping selves would be a profound one.

A problem with the above formulations is that the qualities of oblivion, obliquity and persistence may be taken to imply a self-sameness, a monolithic sleep that is marked by grey slabs of undifferentiated tissues

of time. Sleep would be the same across history and the life of an individual and the cycles and patternings within them. and there are a certain number of technical terms for different aspects of sleep that stand in for some of these qualities. The superficial identicalness of sleep is perplexing, but its actual variation is recognized implicitly in the question 'Did you sleep *well*?' There is evidently something of an art to this.

2. Dormant

Sleep in the back of the car, on the floor of a van or pickup while someone else drives, last of the amber sun sliding photons through bodies, cheeks bundled with shoulders, backs propped against bags, articulated limbs riding the bumps in the road and sending the movement across the boundaries and capacities of movement of one body into another. Lying together we absorb the jolt of potholes and the sway of cornering or breaking into the movement of bodies where a shoulder is jointed to a chin, a belly to a hand, the top of a head onto an ear. This the tangled bank of sleep of children returning from a holiday, hungover youth from a festival, labourers from long work, toddlers in the heat of the summer at sticky repose in the buggy section of the bus.

Peter Pan describes the hidden republic of unruly children as accessible via the few minutes before you fall asleep.[6] This is the hypnagogic state, a moment of free association and cavorting of brain, mind, memory, fantasy and happy ease. It is very easy to love this moment, the tingles of dozy recognition that one transits through in going into it, but it is not yet what this book is after. Here, I want to affirm sleep, full sleep, something that does not really work to think

about since it does not crop up exactly as a discourse, a text, an image, but as a force, a complex that may in turn manifest as these, make alliances with them, but always somehow lie beyond them.

It is said that the human being spends around a third of their life asleep, yet little is written about it. Most philosophy, film, cultural theory, computer games, novels are about people who are awake. There are few enough of these things with the people absent, but there are even fewer of sleep.[7] The theoretical or philosophical discussion of sleep tends towards assuming that it is simply a reduced or lesser set of the state of awakeness that is the assumed normative mode for sentient entities. Sleep becomes a largely unspoken category in which the same ontologies obtain, but simply in a curtailed set. However, we can also say that sleep is a state of things in which different relations between processes of individuation come into play. Sleep is a biopolitical state that is physiological and social; that has a profound possibility for aesthetics and that is also a place for the unthought and in turn is profoundly unthought itself.

Here in these pages, body parts, ecologies, anatomies that are both intensive and extensive, forms of political, sensual and biological relation conjugate with imaginaries, psychic entities and representations. The mundane and imaginal are mutually inherent, tangling with various kinds of scientifically arranged modes of enquiry and the exploratory capacities of physiological forms as they probe and inhabit and make the world.

This book undergoes multiple episodes of sleep. In 1972 Laurie Anderson produced a series of photo-texts called *Institutional Dream Series*, in which she slept in various institutional settings: night court, a library, a park bench, had herself photographed doing so and made

a written transcription of her dreams.[8] The work is a series; it comes to no necessitated climax and provides a platform for rumination on the nature of the conjunctions it brings together – power, institutions, bodily necessity, biological force, social convention, the spatial tropes of architecture and the difficulty of the technologies of image and text. What would it imply if there were a palpable connection between these things? Does dream have sufficient autonomy to operate entirely independently of the exigencies and heaviness of such locations? Inevitably a connection is made in the juxtaposition of sleeper, place, photograph and text, the run of events that they conjure. Although it absents itself from the extended discussion of dreams, which is done better elsewhere, this book takes a related approach in terms of its procedure. Sleep is had in several more or less secluded places, sampling some of the multiple scales at which it consists, and takes a form of argument that, it is hoped, is suggestive and enactive rather than imagining the possibility of being synoptic and deductive. The result may at times take on the model of a lacunary, or an incomplete non-set of non-conjunct parts, while at other times, it is hoped, these parts may join together and put on something of a somnambulant jig.

Sleep is often seen as a state of inertia, dormancy, turned, in highly capitalized forms such as sleep during air travel, into what Michel Serres calls a quasi death.[9] Although one imagines that he might have had to turn left on entering the plane to imagine it being even this wholesome, the argument here is that sleep, rather than being a form of utter passivity, has its own qualities of being that involve numerous kinds of action, of kinds that we might attend to. There is indeed a common emphasis on becoming, on restless and inventive activity, on

production, on the ability to live beyond boundaries within the most interesting and demanding of much recent theory. At times, one wonders if there is anything in the world that is not in a state of becoming or overturning: what happened to passivity, failure, stasis, except as mild warnings of what might happen were one not to attend to all this strenuous vitality? Sleep complicates such a dichotomy since it implies forms of passivity but also ranges through a number of different kinds of activity at multiple scales. Within sleep the hierarchy of the organs shifts, within the brain, different processes come to the fore. There is an interplay of actions and ebbings of action, cycles of the flow and build and wane of tens of different chemicals that act on and in the body in different ways throughout the cycle of the day and in sleep that produces sleep as a kind of metastability with its own characteristics. They may be read as kinds of passivity relative to other states, or by those inhabiting other states, but this passivity yields other kinds of liveliness. Indeed, humans tend to have to endure around sixteen hours of wakefulness in order to gain what historically accrues as a precious statistically normed eight hours of sleep.

Biopolitical theory has tended to be cautious in encountering the activity of biological matter, preferring instead to trace it beyond the point at which it exceeds such an innocent state through a sifting, reckoning and tracing of the means by which life becomes the incorporated subject of forms of governance in medicine, politics, morality, jurisprudence, sexual life, when humanity is taken as an explicit object of improvement and development at the level of population and at the level of the individual. Such a condition does not imply a deletion of the biological as a scale but a certain holding of it within

parenthetical tweezers due to the need to challenge the presuppositions of the autonomy of the biological in forms it may take, such as the idea of 'human nature' when the life of the species becomes material for, rather than necessarily material to, political or moral strategies.

Sleep provides a difficult object here in that, if they are to be worked with or at least recognized in the way that they construct scales of operation with different kinds of traction, the categorically distinct biological, cultural and biopolitical scales of sleep come more than immensely close, overlapping with each other, jumping categories in ways that they may not do quite so readily in other forms of life. The unit of conceptual differentiation of a sleeping entity as compared to a non-sleeping one, described in biological terms, may not be so different to that manifest in culture, through a custom of sleeping, or in its manifestation as a performance where an artist, for instance, sleeps. The distinctly biological and distinctly cultural converge in the same act. This consonance is perhaps what has allowed sleep to elide much critical attention; there is after all, an utter blank obviousness to it. It is something different to, say, sexuality, as a point, if not of agreement, of non-equivocation, something to be looked over rather than watched. As a human, you have to sleep; it is part of the category, something that has always been the case. There is no sophisticated learning involved, the development of good habits, perhaps extending to the notion of 'sleep hygiene' in various cases. There may be a little dabbling with the equipment perhaps, but essentially you lie down, you sleep and by the end of it, that is a third of your life over with. There is not much to think about there. In a sense, that is what makes it attractive as something forceful in itself.

An examination of sleep, however, especially one conducted through the developing scientific literature, also shows that we are dealing with something that is tendentially non-homogeneous, which may exhibit high degrees of internal differentiation and idiosyncrasy at different scales. These different layerings, that of the biopolitical recognition of the investment and amplification of certain aspects of sleep along with the diminution and training of others but also of the physiological creativity of the assemblages making up sleep, deserve, among other factors, to find a means to be more adequately registered.

Equally, such variation is intensified by the way in which sleep mutates across time and between and within cultural formations. What constitutes sleep in and across different registers of habit, economy, juridical allocation of agency and dispersal and congealment of norms can be widely variable.[10] Where biopolitical theory has tended to emphasize the political half of its conjoint name and the particular scales of knowledge and practices associated with it, it may also be possible to see this word as marking a passage between scales, marking also a transition from biology to politics.

There are a multitude of complex and mechanistic reasons and mechanisms for a rather more emphatic bracketing out of the biological or physiological from the cultural and political at times, a great number of which, with all their attendant mechanisms and techniques, are due to the nature of the subject construed in many formulations of culture and politics. One thing that sleep seems to lack is a subject. The sleeper becomes a null field, a placeholder for a thinking being, something that will come back to its senses in due course.

Equally, cultural forms extrude and ramify certain aspects of sleep, coupling it with expectations, norms, habits, which may in turn be conjugated with the capacities of certain bodily capacities, tendencies and entrainments emerging at particular conjunctions of time and space that Mikhail Bakhtin called chronotopes. These, however, may range down to the molecular and organismic through to the more individual, linguistic, historical or cosmogonic scales that he imagined, running, too, through cycles at all scales and all degrees of periodicity, overlapping, interweaving, entrenching and engendering amazing novelty by their generation of moire patterns between their regularities.

'Time, as it were, thickens, takes on flesh, becomes artistically visible; likewise, space becomes charged and responsive to the movements of time, plot and history.'[11] Bakhtin intended the chronotope to function as a device for literary analysis. It is one that also suggests the interweaving, conflict and mutuality of different forms of timing in numerous cultural genera but additionally in the numerously scalar spaces of flesh as it takes on, undergoes and produces time. Bodies and ecologies are chronotopic entities, and sleep is a densely interesting aspect of their existence.

Another drive for the categorical differentiation of the cultural and physical has been to emphasize the capacity for experiment, the openness and unfinishedness of the state of bodies, habits, becomings, even at the scale of the most mundane or necessary of things. Preserving a thick margin of experiment against the imperatives of what is assumed to be, is enforced or experienced as biology must be insisted upon as an ethical imperative but also as a condition of the aesthetic creativity of the force of life. Here, attention is paid particularly to the ways

in which the chronotopic force of sleep becomes artistically visible, sensible, palpable and in certain conditions unavoidable. Time dilates and engorges; plots are made, as is history, in conditions of sleep.

Can one ever truthfully say, 'I am asleep'? This is the somnolent version of the Cretan Paradox,[12] with thought and being overlapped, and it also provides the grounds for the distinction between being awake, and thoughtful, hence conscious and knowing, and what is sundered from that state.

As Édouard Glissant says in his argument for the quality of opacity in relation to the forced transparency of global domination that he also argues operates at the scale of the infrapersonal, 'It does not disturb me to accept that there are places where my identity is obscure to me, and the fact that it amazes me does not mean I relinquish it.'[13] Sleep is the regular occurrence of our own opacity to ourselves, a kernel of the post-human inside the most apparently predictable of habituations and needs. Whether it is cosy, or a physiological burden that exposes one to danger, sleep is the third third of human experience: an unknown. Arguments for the post-human have tended to find their evidence in the most exciting science or the most highly technical, adventurous activity. Sleep, by contrast, is beneath mundane. In its opacity, it is always both beyond the human and at its core. In this it finds commonality with Rosi Braidotti's reformulation of the notion of the human and the humanities in the post-human via changes in medicine, ecology, selfhood.[14] As a kernel of the human, sleep is hardly represented in culture, and those places where it does leak out it is exceedingly telling, sumptuary, overpowering, animal, incomprehensible, both escape and idyll and yet the subject of intense

politicking and enculturation. In all of these it is also ambivalently cathected to the post-human, where it also forms another potentially potent kernel, an abandonment of thought, of self, a relinquishment to the status of complexly active matter.

3. Alarm

Among the debris of sleep are some patternings that are disturbing. Why is it that one sets the alarm clock to rise, work, attend to children, dither about in a haze. Even on those days the alarm does not ring, why does one awake at the same time? Solely to witness the failure to sleep long enough to recover from what preceded it? One stares at a magical line of salt written in habit, neurons and entrapment within a system: why can I not eat up my day beyond this boundary? There is a violence of training by the clock that underlies many of the popular reactions to its introduction – involving destructions and sabotage.[15] The clock is the enemy of sleep, but it is also that which commands the watchful citizen to their bed.

Sleep is a means by which people turn themselves into objects, or by means of which they becomes most object-like, but it also figures in contemporary and modern literature as a means of reproduction for work and as a form of escape or a means of accessing the marvellous. More recently, sleep has become a means of mobilizing the brain or of putting it to work for the purpose of problem-solving as synapses are rinsed and discretely confer together or rejig themselves overnight. But in relation to work and the state of everyday life, it is also often

a means of escape, some kind of refuge from the incoming signals of the nervous system. Psychology, medicine and neuroscience as disciplines 'own' sleep, and indeed this is where the bulk of the sleep literature is produced, but sleep should also be examined and experimented with as a cultural and social phenomenon, one that is somewhat infrequently theorized and indeed as one that produces its own kind of conceptuality.

Sleep as a state is something that immediately ironizes the alert, productive, learned body. It is profoundly democratic, of course, to recognize the sleep of one snoring, farting philosopher; factory worker; princess (equipped with a pea or otherwise); or administrator as the same as any other, but perhaps there are modes of distinction that can ruin this generic figure for us. Sleep as a form of protest, as the straightforward display of bodies in refusal became a symbol of the Occupy movement, and a point of contention, as hoax heat-detection images of apparently empty tents gathered outside St. Paul's Cathedral in London in 2011 were made.[16] The machine did not pick up traces of body heat (being incapable of doing so) and was touted, by the right-wing newspaper that led the story, as evidence that the tents were empty overnight, rendering the protest null and void. As a form of veracity, sleep is about the aggregation of bodies willing to undergo discomfort in order to make an argument. But as a form of protest it also asserts the rhetoric of primality, putting the human body in a vulnerable everyday state at the core of political action. A genealogy of such a state ranges from the every day sleeping on the streets by those who must, to the activity of peace camps and squatters.

As such, sleep also doubles as an imprimatur of enthusiasm. People scoff at those camping outside shops for the latest console or the first

opening crack of the doors in the post-Christmas sales, cameras squeezing their image into the footage of a slow news day and the event queues of social media. People scoff, but at least these punters have some drive, if only to be romantically and definitively crushed to death in the rampage for designer handbags: in their shopping for Thanatos.

During the General Strike of May 1926, workers formed blockades to stop the flow of traffic into London. In Camberwell, in a tactic seemingly copied from French syndicalists, mothers placed sleeping babies in the road to cause lorry drivers to halt.[17] At this point the drivers could be removed from their vehicles, which in turn could be rendered immobile. Immobility, correctly placed, concatenates outwards and expands.

At this point it is worth setting down what are at a certain scale of resolution some of the key themes of this book. There's a sense in which it has hopefully been written with sufficient concision to act as an introduction rather than to need one. Firstly, that sleep has the possibility for an aesthetics and politics of its own that if attended to in a speculative and experiential way yields a sense that, secondly, sleep is not something solely acted *on*, but that is, as a combination of things, a force and multiplex of forces and matters whose particular set of natures provokes particularly interesting and intensive encounters. Thirdly, that in this combination of forces and the manner of their coincidence and mutual amplification and disruption sleep exemplifies many ways in which bodies are not homogeneous. Fourthly, and perhaps most dubiously, that there is the capacity for a reflexive theory of non-thought not as simply the absence of a capacity for

the thought operations characteristic of philosophy, but that there is something interesting to be found in the thinking of sleep.

To place such a row of babies down at the entrance to a book implies perhaps an over-eager trust in the efficacy of readerly brakes or in the kindness of those who encounter them. It may also be a means of removing oneself from the obligations of spawning or as an advisory notice to take a few swerves at key moments. You are welcome to speculate on the accuracy of such diagnoses in the consistency of what follows.

4. I don't want to be awake

Poets turn the wreckage of love into verse; insomniacs turn the ruin of sleep into emails, lists, late-night radio, carpal tunnel syndrome, the circularity of nervous arguments, stupid intransigent loops of lost thinking. Alongside defecation, insomnia is one of the primary aspects of human culture that is universally enacted despite oneself. Disregarding those customs that should only be imagined on the basis of such a condition, insomnia is the culmination of our failures and convolutions in love, reproduction, work and money, that is to say that it is their inverse achievement, a photogram.

Insomnia is often characterized as resulting from circular thoughts; solipsisms become circuits. Thoughts shuttle back and forth in overwound snagging weaves: anachronistic memos of preemptive administration, things permanently undone and to be done. Thoughts that make their own claustrophobic maze: betrayals of love; the humiliation of being left for another; the annoyance of not being

able to think about anything else with any persistence or resolution in such a situation; inadequacy to the actions that are obvious if one takes cultural norms as a guide by which to act but which one cannot trust in any case and for wont of which one anticipates failing in the hopes of others and thus then has to offer some explanandum which must correlate in some way with one's own sense, which is not itself worth the candle in any case, being so obviously flawed given the present predicament. Strings of words that loose their object; the cretinizing remembering of things that need to be done if the work is to succeed, the others are not to be let down, the children are to grow up well; disgust at oneself for becoming subject to such grinding notions as what is *well* but too lagged in fatigue to other than surrender to the circulation through such obscurities to engage in precise enough self-delusions to escape. These are delirium tremors of thought, but too bland for that, the twitching, the ticcing, of daily stupidities, that when but written out seem simply like items on a list but in themselves are labyrinths with no feasible point of navigation but simply the exhausting compulsion to endure them. The soul tetchily emails itself with missing attachments and recalls of non-documents. It is so boring being so irritable, so productive of desperation – one that it seems might be resolved were one to fully wake up. But insomnia, with its insurmountable repetitions and knots, its circuitousness, its seeming endlessness is not absolutely distinct from normal waking states that simply colonize more areas of the sensorium with their repetitions, differing from them in part in that the chains of association and complication are, not less simply seen, but simply longer and more ramified in the quandaries they imply about why one is actually constituted by all this tedious quasi-individual thought stuff

hanging together by a skein of normalities, customs, urges, hungers, habits, obligations, contracts, debts, mechanisms, prices and things. One feels as if it is one's own mind doing all this moronic braining, but surely they are there as a by-product of nerve tissues with only the inside of eyelids to gawp at and admire, conjuring up something to torture themselves on? It is an important ruse to be able to blame it on the nervous substrate and not what emerges out of it, nor that which it connects to and joins in the ensemble of its composition.

Insomnia provides all these things with their infinite branching, the splitting of possibilities, but also their haunting worried doublings, how they are seen and interpreted, by oneself, who may be wrong, who is so inevitably, and by the other who examines what passes for one's ideas or actions, the extent of whose maliciousness is unknown and who may be a boss, child, lover, committee, data trail. Sleep is a merciful chance to escape the treadmill of your own subjectivity.

But then you are awake again. One of the procedures adopted by Franz Kafka in writing *The Castle* is an insomniac method.[18] Joseph K lies in bed often. It is the second place he is sent to after arriving in the village. The bed is not a refuge but a place to be beset by problems in a different mode. The method goes like this: if there is a problem that grinds on your nerves, a caviling uncertainty, or better a doubt, or perhaps an attack disguised as a procedure, a suggestion that something might be the better choice due perhaps to the way it recedes from possibility, make sure that it is split into two, not to surmount it by the method of divide and conquer but to multiply it, as in cell division. Make sure that there is a reflection of a problem, that the traits of one niggle migrate into the inner architecture of another. This is

what is meant by the dual meaning of the word 'apprehension' – one worries about being captured, but it is impossible to understand the situation. Take care to look behind every question or resolution to a still further doubt that can then in turn proliferate. Subject everything to drowsy galling worry, which is only after all a matter of reflecting fully on the true state of affairs. The niggling, the panic, the determining indetermination it yields, will gratify you with in its endlessness.

5. The domestic architecture of the skull

One is scripted to make a house, ensconce oneself within a flat, set out a home in order that there can be some calm space outside of the turmoil of the world against which a membrane has been erected, a place of allocated peacefulness where things such as children and some idea of oneself can be nurtured, and what is nurtured is the downfall of that house since once the peace is stabilized all the forces that went unnoticed are able to hatch themselves in comfort after devouring that nutritious yolk of the domestic egg. Things are stabilized, facts among their instruments and witnesses; households among their debts and the collections of organs, of flesh, and media, the domestication equipment that gather around them.

Just as this happens, after the walls have gone up, the internal space is made warm, the processes of sorting, elimination, chastity, the gatherings of larders, processes of cooking, the interior cycles of washing, which in turn involve some movement in and out, to the outside, in an atmosphere saturated with spores, a little speck of something enucleates and invokes the forces of ruination. Devastation has its own

modes of becoming. Among these, in recent years, the sinkhole has become an object of extreme fascination and exultation: a phenomenon where earth is washed away by hidden underground currents of water corroding a limestone layer, until what is there at the surface, a house, road, school, bedroom, can no longer be supported. The enclosed space plunges into it, and crowds gather round and images are taken and posted online. Tumults of horror result, and an unabashed enthusiasm for this orifice of the earth, which is in truth an ulcer, is expressed, along with a little envy for the persons whose problems have been immediately and finally resolved. There is a comedy of geology at work here.

Sleep, in its relative or variable state of quiescence, carries out such a stabilization for the brain under the childhood imperative to 'settle down'. The dream is part of what provides a modicum of unruliness. One can be cautious, take some engineering measures, inspect the ground before assembling the bed.

Sleep is presumed to lack culture in part because it usually lacks intensity of feeling, but this is in turn due to the things that stand in for such feeling. Every simple film has someone say to another that they love them or has a man squeezing his trigger, has a face offering some kind of grimace or at least the evidence of endurance by a kind of uncannily admirable stillness. Each of these offers a kind of intensity. Regret, joy, anguish, hate, intelligence can be attached to them all. When a person on film says such a thing or does it, there is a kind of discursive proprioception in operation. We can inhabit the phrase, the act or its reception, even at arm's length, because of this capacity of intension they bring. For sleep, the capacity to be affected

is flatlined. Nothing appears on the monitors. While it is possible to attach emotions to the viewing of a sleeping figure – unease at vulnerability, erotic attraction, a recognition of a certain peacefulness and so on – we are not affected *as* asleep.

As mentioned, psychology, psychiatry, neuroscience and medicine as disciplines own sleep, not solely because no one else is interested but because it is taken for granted that here the brain and the body are in a particularly unvarnished state. If as Aristotle suggests, 'waking consists of nothing else than the exercise of consciousness',[19] then nothing distinguishes waking except that exercise. Sleep is a condition under which things may be especially answerable to certain kinds of probing. Electrodes, observant eyes, sensors pry under the surface of personality and presentation and epitomize the body in a state of objecthood, one guaranteed because it is logged, rendered tractable as an electro-numerical double. Medicine likewise is trained to focus largely on the good functioning of the components and what stands in for them in terms of the panoply of symptomata. The interpretative apparatus produces a powerful knowledge of sleep that is rarely brought into active conjunction with the cultural or aesthetic dimensions of sleep. How is it possible to recognize the ways in which the nominally, if not entirely actually, different modes of science and culture place their electrodes on each other with the specificities of different kinds of scientific knowledge being neither effaced nor unduly ramified?

The historical work of Roger Ekirch, and his proposal, through attentive and sustained archival sifting, of the existence of a common habit of sleeping for two separate periods in a night, reminds us

that technocultural forms and systems of mediation, lights and now glowing screens, enter into even this most intensely physiological of processes.[20] Ekirch's finding was that there is sufficient documentation to suggest that when nights are long, with only weak sources of illumination from candles, lamps, fires and other such means available, people tend to fall into a pattern of sleep distinctly different from that of the overdeveloped world characterized by an assumed norm of a monolithic block of around eight hours for adults. In this genealogy sleep in early modern Europe was characterized by two distinct phases: the first between nightfall and around midnight; the second following until dawn after an hour or two of wakefulness.[21]

Illumination, that of the increasingly generalized gas and then electric light, as its moves across the world and through classes and cultures, disrupts the circadian predilections of the body changing sleep into a process that takes the whole night and is achieved in one go.[22] Part of the way that this is said to occur is in the way that the pineal gland's secretion of the sleep-encouraging hormone melatonin is repressed by its registration of blue light arriving at the retina. Hormones interface humans to circuits, and the interweaving of bodily capacities, social patterns and technological development becomes key to understanding the complex aesthetic generating sleep.

The attended overnight polysomnogram in a sleep research centre, where one is watched by a camera eye hooked up to a computer analysing movement, wired to monitors for the brain's electrical activity, and recorded in terms of respiration, eye movement, the tonus or tension of muscles, limb movement, snore volume, blood-oxygen levels and heartbeat, is the apex of sleep psychology in terms of the fullness

of specialist attention devoted to a specific body as it is scored according to standard protocols.[23] This is a space in which disturbances and debilitating woes are instantiated in darkened comfort for the instruments and those that observe them. But sleep also finds itself the subject of survey questionnaires, as something logged and analysed by apps run on mobile phones in both ambulatory research and in the self-monitoring activities of the quantified self. Schedule when your heart attack is ready, fit it in amidst the meetings and the gym. See if, by sustained aerobic work, you can arbitrage it from a cardiac arrest to a more beneficial stroke. You may even recover the ability to speak a forgotten language. Somnological equipment is one of the means by which the object of the sleeping body makes itself manifest, but is also a site of invention of new medial organs that trail across the pulses that a beating heart makes on a sweating surface of skin, into sensors, into processors, interfaces, databases, analytical routines across to servers and the harvesting of populations.

6. Heroes of sleep

Sleep research has among its greats a tribe of adventurers, heroes of self-experimentation. These were scientists who would walk into caves to withdraw from sunlight and clocks or other timing systems equipped with logs and recording mechanisms. In doing so they revealed the particular nature of what would become known as the circadian system – a literal translation of which is 'around a day'. Nathaniel Kleitman, a founder of sleep laboratories as an institutional form, and Bruce Richardson, a younger researcher, spent 4 June to

6 July 1938 in Mammoth Cave, Kentucky, in order to remove themselves from the influence of the sun and to see if it were possible to operate via cycles of waking and sleeping other than those of twenty-four hours. Their beds were fitted with 'motility sensors' of Kleitman's own design devised to register sleep by its capture of the relative absence of movement in the subject, in turn yielding a chart directly onto a roll of graph paper.[24] Detailed logs were kept of temperature, and meals were regulated in time, with warm clothes worn due to the chilly, water vapour–saturated air. Media contact, via daily delivery of newspapers and post, was maintained.[25]

Part of what had stabilized as questions in Kleitman's work was the ambition to test the putative activity of cortical and subcortical 'sleep centres' representing a tension between conditioned patterns of sleep and wakefulness developed at an early stage in evolution to maintain organismic function and evolved patterns of sleep due to evolutionarily later higher cognitive and social imbrications of sleeping behaviour. Richardson was, in this experiment, able to push his own cycle to twenty-eight hours, while Kleitman's stayed roughly as at the surface.[26]

Self-experiment in science has a varied history, but in that context was a way of moving towards forms of holistic, or what would now be called 'multifactorial', research, involving experience, quantification, the discovery of unknown patterns through monitoring. Holism was one of the responses to behaviourism, whose then-dominant discourse aimed at reducing processes to hierarchies of stimulus and response. But this holism also expanded out to the wider sense of experience, and experiment as stunt. Held in a sectioned off gallery of a popular tourist site and well covered by the media, the stay in

Mammoth Cave was also a partial means of turning sleep science into something of a laboratory reality by feeding it through newspapers, newsreels and radio at a time when dance marathons and other spectacular stunts of endurance were popular and historical circumstances made the characteristics of endurance itself something of wide interest.[27] The combination of science, the undertaking of an amazing feat through the extrapolation of mundane activity, and the media event of the mass audience flagging the achievements of determined individuals brought sleep a new level of reality as an object.

The experiments at Mammoth Cave were a follow-up to prior experiments in which a team tried to sleep at either twelve-hour or forty-eight-hour intervals along with changes in activity and timing of food intake. A key datum for record here was the body temperature of the subject. Temperature, with body temperature characteristically highest in the evening and lowest early in the morning, had been linked to sleep since the end of the nineteenth century.[28] The difficulty in physically breaking out of the circadian rhythm, before this mechanism and its interaction with the homeostat, had been fully conceptualized, is manifest in both cases. Kleitman referred instead to the 'diurnal' or twenty-four-hour cycle, linked most strongly to hormonally regulated body temperature and the 'most easily measured' of the diurnal cycles.[29] The ability to self-regulate temperature was, to Kleitman, characteristic of the development both of a species in evolutionary terms and of the individual as an index of development. In Mammoth Cave the cycle worked to involve time, with nineteen hours spent awake with nine subsequent hours allotted to staying in bed, whether asleep or not. Richardson was able to come into phase with this cycle, but Kleitman was not.

The probing and stretching of the capacities of the body as an action of the body make the 'disinterested' quality of science into an existential act. Kleitman notes that 'the important conclusion to be drawn from our experiments on the artificial cycle is that the cause and mechanism of the cycle are to be looked for in the physiological processes of the organism rather than in some compelling external force.'[30] Sleep was understood not as being solely driven by cosmic forces such as the position of the earth in relation to the sun or the passage of the moon. The relative autonomy of the individual body in establishing sleep patterns is emphasized again when Kleitman returns to the account of this experiment in 1963. What can also be suggested is that such an undergoing indicates that the experimental act is not simply existential in the sense of a consciousness and of a set of acts determined by such a thing, but that it is also biological. Yet it is a biology that is not simply subject to 'mere' biology. Such experiential science probes the capacities of the body through means of a body, what has assembled as such. Diminishing the impact of certain possible variables, or isolating oneself from them completely, allows other factors to become manifest.

Rather later, in a key expedition in 1962, the cave explorer Michel Siffre endured and supervised a two-month bout of cave dwelling in order to gain a grip on the knots of biological timing systems.[31] Starting in an icy wet cave in Alps Maritime, he pitched a tent on a glacier for three months and stayed there. The mode of the experiment was rather open ended. Both Siffre and Kleitman detached sleep from light, enabling the recognition of the circadian system running within the body at a roughly twenty-four-hour pacing.[32] Here, their

work contributes to chronobiology and the complex relations to time and timing within and among organisms.

But Siffre also underwent sustained hypothermia. The equipment was too cheaply bought from meagre funds and absorbed water constantly. Carried into the cave with him were notebooks, a record player, books, a cooker, a mound of food supplies, a weak electric light, a tape recorder to take dictation among the panoply of equipment that accompanied him through life in the insistent cold and damp. Certainly of its time, his narrative is driven by curiosity, a modern enthusiasm to face challenges and openness to experience. The down jacket he wore has a chalked notice of allegiance to the self-founded Institute Français de Spéléologie on the chest rather than today's inevitable throttling by brand sponsorship or logo placement reassuring us that anything slightly odd is done for the benefit of charity.

Confusion between the state of waking and dreaming, the blurring of familiar chronotopes fed into a loss of memory. A moment's nap could seem like it had lasted a day; a day staring into darkness could seem, in its undergoing of pure duration, to have passed in a brief moment. Disorientation against external time was measured by a telephone call to the surface at every point when Siffre awoke, ate or planned to sleep, and via keeping a diary or log of activities. The cold meant the tape recorder came in useful, as it could be addressed from the relative warmth of the sleeping bag.[33] Exploratory tasks in the cave, taking and examining samples of ice, keeping a log, the activity of scientific busywork, are all means of taking and biding time.

There is an intriguing quality to being an experimental subject that directs its own rigours, is the centre of attention, is the disavowed but

over-attended-to child who is also the parent of its own assemblage of expression – where the sensors are placed, what is logged, what is or is not sneaked in or excluded. Over the two months, Siffre became physically weak from the pressures of this difficult mode of survival, his wet equipment and food packaging refuse became a scene of 'indescribable disorder' and the microworld of the cavern was encountered by him in a state of fear from the many falling rocks.[34]

The 1960s provided, in the throes of the Cold War, the space race and the ergonomic pressures that they entailed, the need to discover the psychological and physical parameters for submariners, space travellers and the dwellers of fallout shelters, total institutions with greater intensity of proximity of person to person than even the Benedictine monks who, in the West, first regulated sleep for the purposes of religion. Funders of such research imagined the ability to defeat sleep, or to reorder it into manageable batches, an approach at odds with the more open-ended drives of the self-experimenters for whom amazing feats of consciousness, endurance and being in the beyond had more importance. They were driven by enthusiasms for caving, for research, being slightly buccaneering and, like explorers of distant regions, not being overly disquieted by withdrawal from the sediments of social norms involved in everyday life. Sleep self-experimenters walked into the depths to endure and indulge in what Soviet dissidents called inner emigration and to yield up the capacities of the body when withdrawn from one variable, the cycle of sunlight.

Such self-experimentation involves the design of protocols to be followed by those in the depths, and those on the outside, at the end of a fixed telephone line, guides as to what is to be recorded, when, by whom and how. Part of the function of the protocol is to provide

a scaffold for attention to keep the subject focused, but there may also be electrodes to take readings of brain activity; thermometers to take a dose of core, rather than epidermal, body temperature; a tail of cables linking a rectal thermometer to recording devices. Experiment burrows into its common etymological root with experience. Sleep in these cases provides a refuge within the chamber but also a thick marker of cycles within the seams of time composing a life.

Alongside the record-breakers and endurance artists, bleary-eyed conjurers of inner stamina, there is a house I go past on many evenings where a variation on a theme is played out, a lace-fringed diorama of a comfortable room. A sofa and an armchair of oxblood leatherette form the centrepiece. A couple sleep or eat or watch a programme. He is large, wedged into the chair, its evident master. She perches on the nearest side of the sofa, all boniness. When they are both asleep his pink flesh and white vest are basted in the flickering light of the telly; her face is yellow, the white powder reflecting light from the walls, a black disc open mouth foreshortened and raised by the tilted head up to the ceiling to only appear as a circle by an implied anamorphosis, the required position for which can never be established. A grey cardigan appears on one, a blue one on another; a tray of food is taken in or out, sits on a lap. The sleep of old age seems so merged into the flow of the day, one moves in and out of it imperceptibly, its colours flowing rheumatically between snatches of video.

Sleep can be a necessary means of withdrawal from the world, William Wordsworth's 'Blessed barrier between day and day',[35] or an evolved means of conserving energy, avoiding the dangers of night and assembling the cognitive churn of the day into something

sublimatable by the aggregate organ resident in the bucolic cottage of the head. But it can also be a means of blurring withdrawal and moving into the world as a process of drowsily smeared wakefulness and slumbering attention.

7. Too much dream

The dream often presides over sleep to assign it meaning, to plug it into the proper spaces of culture with all its images and allusions. It is, after all, quite exciting at times. But, as Samuel Beckett notes in the voice of a story told by something other than a living body, a being that may be a wandering ghost of some kind, 'For dream is nothing, a joke, and significant what is worse.'[36] Such significance has been fought over and finessed by any cultural movement worth its teething powders, the Surrealists and Sigmund Freud – who reported himself to be 'an excellent sleeper'[37] – starting the twentieth century's iteration of the formalities, although disagreeing on their terms.[38]

It is fantastic that dreams are so routine and everyday in their crystallization of the fantastic. In some ways dreams are indeed overrated, but at other times, they are what drives us into our beds, a chance for a glimpsing divagation into something interesting. It is tempting to say that it is better perhaps that they remain misunderstood, not worthy of too much, let alone of analysis. This would be too trivial. Beckett's roaming spirit is correct. Dreams are both trivial and too much, too thick with implications and significance. As such, they block our attention to sleep. In this book, then, dreams may be spoken of, but as incidentals, externalities, a part of the effluvia of sleep, not its underlying

force or locus of cultural meaning. This approach is taken not due to the lessening of the status of psychoanalysis in sleep science given its recently more mechanical emphasis, but more due to the question of how to address sleep outside of the usual way it is set up in cultural terms. The attention to the skull as infinite nocturnal *Wunderkammer* has also often been a means of missing out on the other part of the action, its precondition: sleep is the unconscious of the unconscious.

8. Imperatives on the importance of diet

Eat less, fall asleep more easily from lack of energy.
Eat more, fall asleep more easily from the ardours of digestion.
It is better to eat whilst you. sleep in order to save time for more sleeping.

9. Mediating

Sleep is a moment when one is absent from traditional media as a recipient, the user, audience, viewer, gamer. The media pertaining to sleep are medical, performative or quasi-surveillant. Instead of being in front of you, aimed at the eyes or ears, media clusters around the person listening, recording, logging. A pattern of nine electrodes attached to the scalp, a breathing monitor, a device clasping the wrist or the tip of a finger taking data on the circulation of blood.[39] The baby wireless monitor/camera used in the overdeveloped world as the intercom by which entities in a household can transmit the audio

registers of stirrings, up the hierarchy of age and down the hierarchy of labour, acts as an archetype for the mediation of sleep. In sleep medicine, the focus is on bodies and their behaviours arising as an ensemble of interacting processes, cycles and organs. Media assemble around the organism, attending to it as a bearer of qualities and states registerable as numbers mapped over time, in turn transmogrifying into data sets, graphs, articles, rankings, treatments, equipment, research proposals, the establishment of labs and the care and scheming of the wakeful.[40] This is a form of medicine that is rarely 'invasive', going into the assembled body or drawing things out of it via a needle or forceps, but rather, one that is additive, supplementing skin with electrodes, topping up levels of hormones, adding clocks to body clocks, tracking, balancing, looking for patterns or things that agglomerate as known patterns and become syndromes, conditions, diagnostic tropes accreted in manuals, training, instruments, bodies of knowledge, which append themselves to and weave their way into the layerings of sleepers. Sleep is auratic in this sense. It creates an entourage of 'reliable witnesses'[41] able to stand in for the sleeping subject, to let them know what realistically happened while they were gone by virtue of their indefatigable attention to a certain set of stimuli.

10. Sleep acts

In contemporary social thought sleep is shown to be inextricably influenced by society, but in its most common form the traffic only goes one way: from social norms, configurations and problems on to sleep. While earlier critical thought had congealed the figure of

the sleepwalker as that most adequate to describing the members of modern societies with all their stereotypic behaviour, contemporary capitalism is accounted for as having lost its sense of any dignity. It will thrust its shovel into any untouched place in order to prepare the fracking out of value. Emails and information are squirted in under high pressure in order to flush out any pockets of trapped consciousness that can be turned into fuel. Sleep is a new continent to colonize and establish intensive means of capture or to degrade as a superfluous and primitive wilderness.[42]

We may say that sleep, as a sociological category, is something that is mainly acted on, rearranged and demarcated, gnawed at or ablated by social requirements, turned into another category of need and anxiety for which consumer items, services and treatments (including academic expertise) can be flogged.[43] These are operative as factors. However, as factors, they modify something that is itself also active, a coefficient that is itself internally differentiated as much as it is acted *on*. The argument against the model of hylomorphism is familiar enough by now.[44] Matter, stuff, practices, physiologies are not simply and identically moulded by ideal forms even in their compromised form as social forces. Rather they exist in complex ranges of dialogic interaction and co-emergence with patternings, ideals, categories, formalisms and so on that in turn have their own particular and specific qualities and propensities and that in turn are shaped, fatigued, propitiated and enhanced by their interactions with other kinds of entity and relation at multiple scales.

Sleep however is often figured as form of dormancy, as a state of passivity whose plasticity can only be mobilized by constructions from outwith. Yet an argument of this book is that sleep is a capacity, a power,

that as it comes into combination with other objects, kinds of relations and capacities, becomes productive. This proposition is made as an extension of arguments around biological power, the will to power of Friedrich Nietzsche where he addresses the capacities of complexly or simply arranged matter, and other accounts that acknowledge and work with the active capacities of matter in its various states.

Heraclitus remarks in a well-known fragment that 'even sleepers are workers and collaborators on what goes on in the universe.'[45] And this sense of sleep as something more profound than a state of dormancy is respected here. Indeed, to trace this movement, this book follows certain research in sleep science that elaborates an understanding of it as arising out of the interaction of two relatively discrete processes and systems, the circadian system and the homeostatic system.[46] This understanding of sleep as dynamic, slightly out of kilter and possessed of pulsions and forces that have their own degrees and kinds of expressivity in such interaction is key here.

In a survey of the changes to the spatialization of sleep in the Victorian era, Tom Crook notes that in combination with beds, bugs, sexual desire, poverty and other factors, sleep was thought capable of producing moral contagion and pestilential atmospheres, and thus had to be contained, demarcated and then spaced out through the disciplinary techniques of dormitories, barracks, hospital wards, improved dosshouses, hygienic bedding, model dwellings and the separate bedrooms of middle-class housing.[47] Sleep changes, but sleep as a force also makes itself active in these places, and as such there is a process of becoming between kinds of sleep and the artefacts, norms, experiences, organizations and understandings of sleep and what is attendant to it.

It can be patiently noted that sleep indeed *produces* problems, or what might be termed expressions of its power – such as snoring and apnoea, key symptoms of concern, in sleep's medicalization, and that it does so in combination with the tissues of the throat, as they may become slack when one lies horizontally. Sleep also produces the conditions for dreams, nightmares, night terrors and the various active or passive means for demands and obligations to be placed upon people by others. (*You* feed or change the baby, this sleep is fast upon me and I am unable to wake as you can see by my immobility, which is not after all stubborn but simply a necessity that you, by virtue of being awake, already can see, and, were you a sane person not given to the cruelty of waking another, would acknowledge). Here, there is a rhetoric of sleep that operates at multiple scales, in the shifting of labour from one person to another, the refusal to partake in it, but also sleep as disinterest, the folding of the body to take up the smallest space possible or a voluptuous abandonment to the carousing of the organs, glands, processes, cycles that cohere as sleep.

11. Repulsive sleep

The sleep of the conformist is seen as a key to their soul. The policeman who sleeps curled over with his hands placed between his thighs in a forlorn embrace of his former foetal self; the citizen whose bed is tightly made with the turned-over sheet entering the armpit to force the arms to rest at their side above the blanket; the figure of the conformist, in their pyjamas, is somehow more loathsome in their intimacy than in their daytime regalia since it invites pathos, and worse,

not consciously but without thought. But such sleep may also be a sign of eagerness, of childish earnestness in the embrace of the world, like waiting for the future as it comes in the guise of Father Christmas, or lying spreadeagled and awaiting the godhead in a state of unconscious hope. Such interpretations are however simply a cipher.

Accordingly, there are sets of diagrams available that map the ideograms of couples' sleep identifying the nature of the relationship on the basis of their postures. They are useless as the keys to sleep, but are spelled out in some bodily argot that assumes a direct line between posture and intent, or worse, to truth. To fear finding oneself conforming to such positions, and, more basely, that they might tell you something, is childish, but as J. M Barrie puts the world of such fantasy, 'in the two minutes before you go to sleep it becomes very nearly real'.[48]

12. Supination or pronation?

In a joyful domestic situation one may sleep in such a doxalogical position in order to show the other, 'Look, this is what I am reduced to – clinging on to the edge of the mattress with my buttocks and teeth, and in my sleep even – a position so evidently encoding something manifest in my unconscious, telling us directly about who precisely I am condemned to share this bed with!' Newspapers may pad pages with guides to reading the ideograms made by the bodies of sleepers in shared beds, but they rarely mention the repulsion that cannot even be countermanded by a sagging mattress and collapsing bedframe. The ragingly ablated fury that appends each end of such sleep may last a life or may be over in a moment.

An account of the murder of a repulsive sleeper, a corpulent man on a train whose belly revolves like a disgusting blob of gelatine provides the prelude to Octave Mirbeau's *Torture Garden*.[49] In this anecdote told to strangers, in a book made of sewn-together parts, the febrile hands of the murderer act on their own. There are deeper and unnameable drives at work beneath this trigger of physical disgust, a collection of impetuses convulsing over and over again, in endless and aimless pulsation, while looking like the most gorgeous of abstractions. The repulsiveness of this sleeping human cyst merely acts as a trigger to the dark realization of the dreams of the awake. It is the bareness and ignorance of sleep, the brute fact of a body asleep in all its fleshiness and with its own mode of the violation of decorum, that may indeed cause it to inspire hatred. When the passenger awakes as the strangulation attempt commences, the killer, with a certain amount of dash, sits down to gaze at a newspaper as if nothing had happened. The shock of waking to the recognition of the attempt is, instead of a throttling, what kills the sleeper.

13. Ingredients of sleep

As well as proliferating outside of the body, sleep in humans is composed by the range and complexity of several kinds of activity within and between different parts of the brain and the rest of the body it entails. Equally complex are the ways in which the phases of sleep involve various kinds and rates of synchronization between these elements at different times. These can be described at a number of scales of generality, one of which is in terms of systems that produce two key means of producing sleep. First, there is a sensitivity to circadian rhythm, an internal

body clock that entrains sleep to light via the eyes and a consequent chain of other nervous and glandular systems. Secondly, a biological clock or homeostat itself runs slightly beyond twenty-four hours. The simple interplay between these two predilections sets up moire patterns of timing within and among bodies and what composes them.

The mammalian body is an assemblage of intense variation and peculiar intimacy, and that of the set of humans within them is a reasonable context within which to explore the meta-animality that is implied by the freaks of luck that constitute their shared and variable characteristics. Nevertheless, to map the ingredients of sleep is to figure it within myriad systems of interpretation and scales of existence, each with its own attendant modes of enquiry and hierarchy within scientific history and imaginary of order of causality and precedence, such as the cosmogonic stack of scales interpreted by the fields of physics, chemistry, biology, psychology, sociology and culture. Each of these can become an entry point and exploratory base for any of the others while retaining the distinct characteristics and relative degree of autonomy of each scale, each of which is also potentially momentary, multiple and fissiparous as it is interrogated and constituted by others. Any description of sleep must fall short of an impossible fullness, may lack, for instance, sufficient relation to its operation within the terms of a certain scale at the same time as the watchword of any synthetic account of the inventiveness and conditions of sleep must be to *proliferate*. Such a motto in turn implies numerous problems of achieving the requisite conceptual or empirical state of repletion.

Within sleep as described in physiological terms, then, at the scales of molecules and its interaction with that of organs, the state of sleep

produces chemical changes and cycles in the body as well as being produced and involved in them. Sleep has also become interpretable if not entirely legible in certain impressive ways to researchers through its manifestation in neuroelectrical terms with techniques, equipment, manuals, methods and protocols proliferating from the point of Hans Berger's 1929 exposition of the electroencephalogram (EEG) and with more recent work addressing the brain via spectral analysis among other techniques.[50] Aside from the clock, thermometer and plethysmograph, the equipment that allowed sleep to become detached into further parts, and to come into combination with systems of recording, abstraction and evaluation, is the EEG. The EEG measures the different rate of interactions between nerve synapses, that compose waves (alpha, beta and so on) that become predominant or recessive, without disappearing, at different times during the sleep period. Each electrode is attached to or finely slid into the scalp reading en bloc the activity of thousands of cortical neurons, eliciting the alpha and beta waves of activity that are then charted and analysed.

The brain thus speaks electricity, the correct vocabulary of the twentieth century. In these terms, activity lessens during sleep and increases during wakefulness. Whether, in turn, the readings of this signaletic organ are seen as corresponding to an operant chamber, a measure of the psychic energy consumed by thought or a method for attuning researchers to the localization of function in the brain depends on the analytic and diagnostic, rather than instrumental, methods applied to the star witness. Here, the instrument as media creates not a determinate set of readings, impelling a certain correspondence to a directly extrapolatable real, but feeds into a milieu. In turn, it also seeks out its own alliances with certain conditions,

symptoms, institutions, research agendas and individuals. Kenton Kroker's fine extended history of sleep medicine is the place to look for a detailed account of the kinds of enthusiasm and capacity that brought such alliances together.[51] Crucially, however, along with researchers' interest in the EEG as a means of investigating the then-burning topic of localizations of brain function, and of providing the ability to distinguish epileptics by the pattern of their brain waves, the EEG was a key mechanism for the framing of sleep as an object of scientific study.

Berger 'leapfrogged' existing research on brain function by ignoring morphology, localization of function and the mechanism of electrophysiological function, but instead working to elicit a tracing of the activity of the brain through one factor.[52] A strong interest in telepathy, the subject of a 'wrong' science, is what initially occasioned this leap yet it was one that remained unexplored in his scientific works, which initially operated via the then more conventional temperature studies.[53] An abundance of skull defects and wounds after the First World War brought a sufficient quantity of brains close enough to the surface of the organism for their delicate electrical activity to be sensed and monitored.

Reading Berger's papers on the development of this approach one is reminded again and again of the way in which scientific experimental work often consists of arranging a set of instruments and specimens, often in this case human patients, in a way that allows or elicits a passage of affect through an ecology of media, theoretical resources and enquiry: each scale of the assemblage articulating, offering intransigence, eliciting interpretation, amplifying and transcoding the potential and resonance of what is translated.[54] Working

with machines and instruments at the edge of their competence, after the normal hours of the clinic, in a state of electrical isolation with an intellectual isolation to match, Berger's research was highly marginal until it was recognized by the physiologist Edgar Adrian, at which point it became conventionally accepted and began to flow into the academic literature, complementing, concentrating and disrupting existing techniques.[55]

Running alongside and through the kinds of patterns identified by Berger, a crucial aspect of sleep that fuses the conceptual with the physical is that of oscillation. In 1982 Alexander Borbély proposed the model of the two oscillators,[56] the homeostatic and the circadian systems. These interact as two uneven waves, modulating each other's thresholds. They are instrumentally identified in turn by waves of electrical activity in the brain. Each oscillator has a different characteristic cycle of change over the course of a roughly daily cycle. The homeostatic process is governed[57] by the hours of wakefulness, during which it increases, in terms discussed more fully below, and by sleep, during which the pressure to sleep decreases. The homeostatic system thus functions rather like an hourglass. The circadian rhythm has a different degree of periodicity and, rather than being set by the pressure to sleep, it modulates when the sleeper will awake in interaction with the homeostatic process.

One aspect of the interaction of the two oscillators described by Borbély therefore is their non-linear character. Accordingly, if the time of sleep's onset is delayed from the habitual time by a shorter amount of time (four to twelve hours), the total length of time asleep shortens. If it is delayed by sixteen to twenty-four hours, the total

time asleep is extended.[58] Simply by the interaction of two slightly out-of-sync characteristics some of the complex qualities of sleep are arranged.[59]

Here, too, in describing sleep in such terms we are also recognizing its variable, contested and difficult interweaving with systems of measure, instrumentation, counting and recording. We may make recourse to charts, graphs and groups of equipment that make such traces and that call upon the reliability of certain entities within bodies in order to posit, witness and to map such patterns. There is a ripple of standing in for, or of transduction:[60] electrical activity for sleep; the sensitivity of electroencephalographic equipment to such activity; the skill and work of experimental subjects and operators in placing and working the equipmental apparatus; the acuity of numbers and models to articulate and array the quanta as organized data (for instance, in charts directly drawn onto or by numerical recording on a computer); and the capacities of interpretation, dissemination and evaluation of wider networks of knowledge systems with, in turn, their attendant systems of machining by evaluative metrics, funding, the direct or indirect investment into certain problems rather than others, and the variable kinds of noise, politicking and interpretation that feed out in turn from such brain waves and their wider interpellation within related systems and the activities of thought and understanding that they in turn stand in for. Finding means to articulate the interaction of such parts and processes becomes key to understanding the wider ecology of sleep.

Chronobiology is one of the interdisciplinary scientific fields that feed into the wider unevenly composed context of sleep research.

Concerned with the nature, effects and gestation of time and timings in organisms and ecologies it moves across the scales of matter, species and habitats to develop a richly composed aspect of what might be thought to be a 'metabiology'. Time and cycles of time allow for a means of cutting across different biological and social operations through this scale of interpretation. Thus an issue of the *Journal of Biological Rhythms*, which is core to the field, might include a discussion of the effects of light on certain proteins, the role of the hormone adenosine in circannual hibernation cycles in ground squirrels and the effects of shift work on the cardiac-nervous system in humans.[61]

In another issue of the journal, Derk-Jan Dijk and Malcolm von Schantz describe how sleep is produced by a 'symphony of oscillators'.[62] Within chronobiology, this sense of multitudes of interactors inhabiting, producing and modulating multiple scales and thicknesses of time makes a fascinating complement to the rhythmanalysis proposed by Henri Lefebvre and others who attend to such characteristics at scales such as that of cities.[63] Chronobiology posits time and timings as a significant factor in evolution and, in turn, the development of such time as being that of a process of evolutionary *kairos*, the choice of an opportune moment. How do bodies align with and make timings?

Timings hinge on, are blocked by, geared, modulated and subject to various forms of structuring relation or are amplified by their location within organisms, within and among a species or a kind or organization of organic matter, and within ecologies and across a planet, itself cycling among other entities. The speed at which a muscle may respond to a nerve impulse; the rate at which an eye can sample movement or at which a plant can bend towards a source of light; the

mode of inhabitation, asleep or awake, of a particular evolutionary niche; the rate of undulation of a cilia or the capacity for reproduction within a species or individual, all have both evolutionary bearing and the capacity to be analysed as chronotopic factors.

The condition of sleep needs to be understood as part of, but not reducible to, this manifold and dynamic range of factors. Dijk and von Schantz's figure of the symphony of oscillators, then, certainly spreads out beyond sleep, but it also vividly sets out the complexity of interactions making up such a symphony. It implies an organology, one of music but also of organs.

14. Sleep glitches

Falling asleep, as Jean-Luc Nancy notes in a phenomenology of this singular moment, has its repertoire of kinds of dropping off.[64] Most particular of these are the hypnic jerk, or hypnagogic myoclonus, those little sensations one has when drifting into sleep of falling: falling from a pavement, a cliff, a bicycle. They are not full dreams, but neither are they fully understood. Myoclonus, muscle arousal or twitching, of which this is a kind, can also be found in hiccups and more serious forms of illness.[65] They form a cut into sleep, a little break-in by the muscles. One hypothesis is that hypnic jerks are a residue of the evolutionary development of nest-dwelling prehumans where muscle relaxation might signal that the primate is falling out of a tree and has to take rather swift action.[66] A related explanation is that while the brain may be moving towards sleep, the muscles of the body have relaxed to a more advanced state.[67] In such a condition the

limpness of the muscles surprises the brain, which assumes it is falling and reacts by tensing the muscles. The effect is most common in babies of between two and four who can repeat it over and over again in a celebration of the free-falling joy of being newborn.[68] In either case, different layers of the body perform a kind of hardware handshake on each other, working out the protocol between them. These twitches or jerks are in effect glitches, with one system of the body sensing and anticipating the world in one way, leading to an overreaction in another – the parts don't quite fit.

15. Body parts

The writings of the early Greek philosopher Empedocles come to us in a mess of parts, fragments of manuscripts and reports on his philosophy from others, the proper combination of which provides the cause for much labour and the exercise of learning. In his writings on nature, from what can be worked through, Empedocles theorized that the parts and organs of the body were once independent free-roaming entities: 'Here many heads sprang up without necks, bare arms were wandering about without shoulders, and eyes needing foreheads strayed singly.'[69] Plunging towards each other out of hungry attraction to make up a composite being in all its majesty and succulence or shrivelling away from others into the wilderness or other hiding places, these parts in turn were transient alliances of matter since the cosmos was a turmoil of the four elements or eternal roots: fire, air, water and earth. In their familiar forms such as sun, rain, mud and breath, such matter is easily discernable, but their complex interplay

generates all that is as shaped and given liveliness by two principles. As with all of the cosmos, such parts were gradually brought together by Love, or affinity, and their integration was tugged at and maybe ruined by Strife. Perhaps Empedocles thinks of these principles as something akin to the build-up of pressure in a woman who is in the last stages of pregnancy, in which the fullness and weight is so overburdening that the momentous violence of birth is to be wished for as a relief, not to mention the interplay of waves of desire, love and hunger that may motivate and give rise to such a situation with its crushing implosive dynamic. These principles and material forces were operative in the development of the current form of the human body over time, but in a previous era had also manifested in beasts with a 'face and breasts on both sides', 'bull-headed men' and 'man-faced bulls' and others 'with male and female nature combined'.[70] The admixture of stray limbs made up these composites, and the humans of the present day brought up the shoots of men and women.[71]

What manifests as an individual, the physiologically discreet organism, by this measure becomes an alliance of other entities, an ensemble of transient or greater duration. Such a thing could be configured as a world of components, a very modern cosmology of plug-in architectures, modularized and delimited, replicable components assembling a self out of more or less well-crafted parts, but Empedocles's schema of the interaction of forces and matter is a formulation of the world that is at once both more cosmic, that is to say, abstract, and more visceral.

In her story *Life, End Of*, a lively, wistful, grumpy and catalytic reflection of a late old age, Christine Brooke-Rose restages something of

this moment, as a troika of illnesses compete, via different parts or systems of the body, to lay siege to the life of the character she writes through.[72] Polyneuritis become the variously named Polly, withering the nerve fibres and turning the legs into pillars of fire. Vascular and cardiac problems appear as Vasco de Gama among various other alliterative monikers, as well as the seemingly independent contents of the cranium such as the thalamus and hypothalamus, completed in turn by the appearance of glaucoma, dousing the eyes. The body's systems churn up a civil war fought out on its own terrain, along with medicines prescribed at odds with each other by doctors with different expertise who take the side of one or the other of such systems.[73] Sleep too becomes part of, is precluded by and found in between such a cacophony of interacting, surging and failing systems among trays, trolleys, beds, wheelchairs, books, pens, tables and other stubborn objects.

Developing Lefebvre's proposal for a Rhythmanalysis[74] that would attune critical thought to the cycles of process and behaviour at multiple scales, Charlotte Bates remarks how 'each organ, function, or segment of the body has its own rhythm. Some, like the beating heart, remain mostly hidden, while others like respiration, are heard.'[75] Among such rhythms everyday activities such as eating, exercise and sleeping are affected in different kinds of illness. Sleep is stirred into illnesses in uneven ways. One may be unable to sleep due to discomfort or pain, or as an unruly diabetic wake at night feeling a hypoglycemic fit coming on and reaching for a nearby bottle of sports energy drink to calm its demands. Sleep is a moment, in the admixture of love and strife, when the influence of fire becomes less manifest in the

blood, in which we can sense something akin to such a process still operative and find ourselves composed in it.[76]

Among this panoply of parts, the circadian rhythm is challenged not only by the exposure of an organism to light but also by societal structures, technologies and individual behaviour. These may entrain, loosen, disrupt and drain sleep in minutely detailed ways, the specificity of which is the focus of much individual and population-based sleep research. Geography too becomes interwoven with sleep, since exposure to sunlight marks territories in their relation to soporific life. There is an interesting recursion and leakage between the stack of scales since culture is directly woven into the activity of the sleeping organism here, but there is also intense material resilience within the different sleep systems.

While different scales and parts of the body may be more or less autonomous in relation to other scales and forms of relation, the circadian system interfaces flesh to psychic, social, ecological and other forces. External *Zeitgeber*s (time givers) such as light can be disruptive, edited to extend along the timeline of the day by many means such as jet lag, shift work, purposive exercise flooding the body with momentary wakefulness, and the abundance of light. Shift work, unless properly handled, can inflict grievous duress on the process of a life and the ability of a body to recuperate.[77] Here, cycles and forms of governance such as scheduling, management, rates of profit, annual reports, projections and plans tangle with the multiple urgencies and imperatives that intrude into drowsy, uneasy being. Amidst this, the suprachiasmatic nucleus, a region of around twenty

thousand neurons within the hypothalamus, structures the circadian rhythm as its 'master clock', something that continues to grind on through time, relatively independent of sleep–wake behaviour feeding into organs and other bodily systems while itself in liaison with light.

While we can describe the sleep cycle of human as being generated out of the interplay of the circadian and homeostatic systems, it would also be possible to arrange a description of such timings as arising from the more than twenty genes involved in generating the body clock of humans and other species. In turn, cells contain systems described as clocks, each with their own periodicity and life cycle. Sleep also arises from the interplay, determinations and bracketing of these entities and the systems that produce them. With genetically traceable predispositions for certain orientations to sleep, or for conditions expressed as sleep, such as narcolepsy and cataplexy, sleep is a process that is differentially expressed as cellular as much as at the level of individuated organism or person.

Amidst this cascade of multiple rivulets of the expressivity of matter and the organs and systems that are expressed by it and which they in turn express is the homeostatic system. As Jean-Luc Nancy notes, sleep is by and large inaccessible to phenomenology.[78] To talk of sleep at the level of the systems that comprise it implies a relation between capacities for and propensities of abstraction, and of experience. To come into a composition of understanding with sleep implies a relation of the non-self with what accretes as a self. This is one of the methods of science. It is a point where the posthumanities, in their

emphasis on fusing the humanist working of subjectivity as a hot crucible of knowledge, meet with the experience, thought, historical action of those agents and movements not imbued with, or immune from, the accretion of a self. Such a state is one that has a cyclical dimension.

The pineal gland is an organ which famously contains photosensitive tissue while, in the human, being nested in the epithalamus at the centre of the brain, thus inside the brain but outside of the blood–brain barrier. In other species, such as the hagfish – writhing schools of which feast long in the corpses of cetaceans in the pits of the oceans and produce a fantastic welling of throat-clogging mucus from their skin when attacked – the pineal gland is lodged in pairs at the surface of the head, where its photosensitivity allows it to pass for an eye. In the human, the gland is folded inwards and arrayed in a different network of entities, secreting melatonin, a hormone it releases at night.[79]

Georges Bataille has this unseeing eye at the core of the orientation of the human from the animal horizontal to the sapient vertical plane, a movement that entails the hiding of the vile hypnotizing and seductive anus between the fold of the buttocks, the attempted entraining of the explosive powers of waste, and the caesura of science from myth, a movement that Bataille attempts to make convulse in on itself. To achieve such a violent shudder, the power of myth, as good and nourishing as a bucket of vodka, is to writhe through the entire body as a morphogenetic force in itself. The sun's gales of electromagnetic force and the spinning earth's belches of black night make the physiological unconscious speak in their fields of energetic lightness and succouring darkness.[80]

Travelling through time in bodies of thought, Descartes suggests in his anatomization of the cogito, that the pineal gland is the intersection between the crucial soul and the body, seat of memory and generator of movements, a colander and switching system for animal spirits and ideas. The pineal gland is the coordinator of the stimulus-response system, which Descartes is first to name, although he describes the wrong mechanism – the nerves as a system of tubes. This in fact is key to his distinction between the soul and the body. The anatomical rationale for this proposition is that the pineal gland is an entity contradicting the generally dichotomous nature of the body, a sole gland nested inside the brain in which everything else seems to be doubled or split further. Seldom can a mere gland have been freighted with such an ontological load!

By various sips and leaks of fluids the pineal gland feeds the body its dose of melatonin at around one or two hours before normal sleep onset. As sleep continues, the need for sleep declines, generating shorter cycles of slow-wave sleep and longer periods of rapid eye movement. On awakening, the homeostatic system begins again, with sleep deprivation gradually building up to coincide with the circadian rhythm of sleep propensity or to continue into a period of the lag of sleep.

The circadian and homeostatic systems are in turn involved with the interaction of several different brain regions, each variably active within different kinds of sleep and organs such as the thalamus, hypothalamus and amygdala, which can be further differentiated into specialist cell groups such as the hypocretin/orexinergic neurons of the hypothalamus. Neuronal loops reciprocate in linking regions of the brain together in ways measurable by the different kinds of slower or

faster oscillations recognizable from the various forms of sleep. Such changes involve the waxing and waning of blood flow, with blood itself carrying hormones such as prolactin, melatonin, serotonin and other biochemicals of various kinds released and inhibited at different rates during the day as they are taken up absorbed and used as prompts and sources of change in the multiple systems of the body that these chemicals interrelate with. Such change however is always in relation to other singularizations of the moment as receptors in cells have to be ready and available to receive the molecule, as must sufficient binding sites in the nucleus. Cofactors may need to be present as may enzymes that aid in metabolization. The specific qualities of particular endocrine substances measured in avidity, sensitivity, specificity and the question of the volume of such molecules and the rate of other reactions also underway change the fullness and effect of the process.

In the *Monadology*, Gottfried Wilhelm Leibniz suggests that in order to understand the inner workings of the body, we can enlarge its scale to that of a mill, enter it and examine the parts, each a monad, working upon each other. Such an examination would show that each element of the mill can be understood both when reduced to its simple parts and in composite, in the machine. There is a flickering of scales and of their adequate descriptions, between object and relations, system and entity. Caught in this flickering is the moment of emergence of the soul, a problem that will be later taken up in accounts of individuation or *subjectivation*.

For Leibniz, the simple monad has perceptions and appetites but of a particularly limited scope or kind. How do aggregations of such

monads jump scale to engender a soul, something that has distinct perceptions, feelings – complex ensembles of perceptions, memory? Partially it is because each monad implies an 'incorporeal automata', an abstract machine by which it implicates and makes enquiries of the rest of the world.[81] There is a kind of brokering and fixing, loving and hating and alliance making that goes on between monads that produces complexes of kinds.

For Leibniz, one of the cases in which this movement from one state into another, from simple monad to ensouled being, is to be found is in sleep. In sleep – as Leibniz specifies, deep sleep without dreams – we become like a simple monad, an object with its own tendencies and qualities but without distinct perception. The soul is what exceeds this state of simplicity, making the body hang together in a way that induces memory and distinct perceptions coming together as an ensemble rendered as feelings. But this transition also proceeds in the other direction. Certain stimuli are so fine and so rapidly proceeding one after another that they blur the capacity of perception. Taking on the role of body experimentation, Leibniz proposes that spinning round very fast does this to the eyes, but it may also cause you to faint. Dizziness makes the ensouled human proximate to an object as each moment blurs into another. Only strong and distinct perceptions are able to make the soul 'snap out of it' and properly emerge. Permanent stupor, by contrast, is the condition of the completely naked monad unperturbed by contact with others.[82] Such stupor can be obtained by repetition, by the sequencing of events so alike that they appear entirely continuous, evoking apparent continuity in those who undergo them. Reason, in turn forks this condition, arising out of recorded attention

to the cycles of repetition that can be afforded by the entrained use of memory.

Following Leibniz, sleep is not strictly reducible to its physiological aspects, the secrets of which lie dormant like a maggot cosily ensconced in the apple waiting to be revealed. If sleep is a symphony of oscillators, perhaps there are other musical and sonorous modes that it can also segue or break into, networks of organs and systems that do not quite cohere into a symphony, or for whom the symphonic texture is rather too reminiscent of the alluring body of the smoothly surfaced and superb conformist in harmonious relation with a whole world that it, in a reflection of its virtue, also attempts to assimilate to itself. It is too easy to simply set the sleep of perfect skin, well-spaced teeth and notable, well-cited and defined muscle groups against that of the more obviously crippled, bent, fatty, neurotic or ill disaggregating body whose composite organs, parts and systems hang together in a less orderly, discombobulated fashion, as the one inversely includes the other in an implied pyramid of rejects and misfits. But perhaps there is an adventurousness of musicality that can find something to dance to, not in all bodies but in each body. Those alert to different timings, that of the factory, the racetrack or the dance floor, the Skinner Box, download or livestream, how does their symphony manifest? We are not simply talking about the mechanism of the orchestra with its immensity, fine variation and massed ranks of players, not to mention its divisions of labour of clustered or antiphonic parts arrayed in the numerous ways it has accreted over the history of its genesis. Let us also relish the sleep of bodies assembled as quartets, bands, duets, one-man bands, choirs,

machines, sleepers that are played out through the musicological body and the wider ecology of chambers, halls, streets, earphones and files that they might vibrate into, the yodellers' throats reciprocated by the steep valleys and extended into the sonorousness of the drowsy air – traditional choirs of highly adept snorers growing over time in villages dotted across the vastness of the well-littered steppe.

The symphony of oscillators as a figure however is also a moment when a form of science recognizes its musicality, developing the means of scoring and patterning. It is sometimes frightening, obviously, when scientists begin to dance, but they look so cute when they are asleep all curled up together in order of eminence. Figuring sleep as a symphony is something akin to declaring it an ecology, an assemblage, an ensemble, something arising out of many that form, in turn, a body. One composed of all sleeps? Sleep is a city peopled with susurrations and hums, growls and ground teeth.

Such musicalities also imply the possibility of a panoply of kinds going into the ensemble, and the histories of their invention. In a related register, Preciado reminds us that all humans contain sufficient tissue to create a reservoir of potential phalloplasties, incipient organs drawn from the arms and legs that can be imaginally and surgically reinvested as a penis, that complexes of vaginal folds, chambers and labia may be introduced at many parts of the body, and that the pluripotent cell provides the orthodoxy of flexibility and plasticity required of all components of the larger organismic arrangement.[83] Given the prolixity of flesh, an Empedoclean organology of alliances and temporary ensembles suggests that we might also think of the implicit capacities of flesh played out at the gross level of members and cavities but also at the

subcellular level of populations of capacities and propensities, manifest in the numerous modes of delicate form such as nerves, hormones and ideas, with their attendant modes of expression and the wider compositional forms in which they are arrayed and gain liveliness.

Such alliances are gathered or found, and named bodies, and are arranged in mirrors, significatory systems, workplaces, reproductive orders, hospitals, universities, streets, cars, clubs, clothes, sports grounds, media systems, beds, books and embraces. Whether we are to maintain their relation to love and strife, or to the compositional force of the four elements is moot, according to their diagnostic, expressive and critical potential. Each of these arrangements has its own capacity for delirium; each is a madness and a tune of a kind transcribed and echoed further into the modalities and others. Each meshes with myriad other factors, such as ageing, physical capacity, custom, training. These in turn are riven with the melodies made by organs and parts and their relations with systems of nutrition, breath, repetition and heat. The chemical and geological scales of elements accrete into tissues, organs and arrangements, capacities and movements, and each of these beckons, maintains, induces and disgorges such relations, nurturing, thickening and depleting through different movements over time. And each is more or less adequately addressed, described, attended to and put into place by instruments, modes of knowledge and handling and the modes of ignorance that they in turn imply. These in turn may accrete and establish as institutions, specialisms and disciplines among others, each with its own patterns of growth, disruption and cosmic musicality.

In his anatomy of a heroin fix Alexander Trocchi describes how, following a concatenation of operations introducing the drug, he reaches

a state where 'the blood is aware of itself'.[84] Different drugs, as well as ideas, choreographies and situations, have the capacity to momentarily draw out the entelechy of different organs and bodily systems. Heroin renders a user capable of staring at a wall endlessly, without even the need of interest, until the next few grams are found wanting. For Leibniz, permanent stupor is akin to sleep but is without its own cycles of need and satiation, any symphony replaced by the sonority of interweaving drones and jarring cessation characteristic of heroin use. Beneath stupor is not more stupor but the naked monad, an entity that is either entirely fulfilled in its incorporeal automata or, to put it otherwise, in a state of complete immanence.

16. Chemistry sex

When we walk into the clattering, grinding, straining mills in which humanity produces itself to the measure of its own incorporeal automata, we encounter at one end of a chain of causation, the figure of the hormone.[85] Hormones are endogenously produced chemicals that, in the informational image of bodies, function as messengers between cells. They are a means by which clusters or kinds of cells coordinate among themselves or are released by glands. In animals, hormones circulate in the blood and tissue cells pick them up if they contain the right chemical receptors for that hormone. Once part of the cell they express long-term or temporary changes to it, perhaps to the way it reproduces or interacts with other cells.

Hormones are also monads articulated and set up by biochemistry; by laboratories; by marketing agents; by the receptive, stabilizing and

osmotic capacities of gels; by the predictability of tablets; by the different kind of predictability of intravenous injection; and by sachets, ampoules, sets of instructions, contraindications. The human body, as an entity that reads off the activity of chemicals within a bipolar system of genders, can often seem reduced to the activity of hormones, a gonadology.

Entering into play with such a system, Preciado yields a related effect to that of Trocchi: certain systems of the body become more alert to themselves when you rub a daily dose of testosterone-suffused gel into the skin.[86] Monadically speaking, along with Empedocles, everything depends on what it comes into composition with. Physiological events coded as belonging to the regime of masculinity may be one set of results,[87] sports-related 'doping' another, and an open-eyed free-form experimental migration into the circuits of bodies, chemicals, rushes, bleeds, commodities, slaughterhouses from which testes can be especially rendered (echoing the stables from which urine is gathered for the extraction of oestrogen – making the economies of meat and milk go that little bit further), medicalization, muscularity, sensation and self-intoxication, which constitute just part of the assemblage of hormonal humanity, may be one more. Here even straightness, being gendered, as rather incidental characteristics, might be potentiated as another mode of queerness, albeit one that comes, along with the excuses, domination and cowardice, with a rather large amount of, perhaps perversely appealing, clunky equipment. What Preciado insists upon is the coupling of experiment and experience in the formulation of a self as constituent form of ideas, what he calls the 'principle of the auto-guinea pig'.[88] Here this takes the form of a reassembling of the mill of humanity starting from the scale of the molecule around which it ostensibly

so fundamentally turns: 'Hormones are bio-artifacts made of carbon chains, language, images, capital and collective desires.'[89] What is also telling in this cluster of kinds is that hormones, by various means, not only move both into and out of bodies as well as being made in and secreted by them, but also show their nature as distributed across scales of kind, intensities, and greater or lesser openness to imagination.

As entities that are also exogenously produced within laboratories, hormones are preceded by raw materials and research programmes, processes of identification and accreditation; set aside as specific chemical formulae with attendant processes and equipment; and stabilized as compounds that may be recombined into pharmaceutically tradable entities framed as stock-market vehicles that in turn rely for the predictability of their investments on the longevity of the physiological conditions and the cultural formations their molecules and delivery media are addressed to. As such, the Empedoclean body is one that is always in the process of falling apart, spreading, dilating in range of process, kind and scale as much as it seems to congeal or be killed. Bodily parts in this figuration may be radically extracorporeal at the same time as they are plugged directly into the flesh, working their way through labs, social and chemical imaginaries, procedures and accidents, and the sorting systems of economies and media.

Molecules are not the only scale at which such an operation may occur. Temporal processes are marked out and metered and fed back into the world. Computers from Apple have for a long time had a standby mode called 'sleep', in which the power supplied to the different parts of the machine is sufficient to keep basic functions running and to enable a swift restart. In recent models this state is represented by the pulsed glowing of a light-emitting diode, behind the power button, or

in a thin slit in the metal casing of a laptop. The diode lights up slowly, around twelve times a minute, moving from darkness to full brightness according to a sinusoidally arranged flow of power, establishing the approximate breathing pace of a sleeping person. Indicating the sleep mode by the pulsing of a light with subtly varied modulation of periodicity to enhance the sense of liveness is patented in the name of a team of engineers from Apple dating from late 2003.[90] The timing of sleep as something that is abstracted and reimplemented in another medial form is something reworked in turn by Constant Dullaart, whose sculpture *Brian Q. Huppi* (2014) presents a sintered nylon bust of the engineer who led the team in developing the patent. This work is usually displayed surrounded by a set of images, printed screens entitled *Shenzen Skies* (2014), showing the smoggy sunsets around the Foxconn factory where the laptops are made. The bust and screens luminesce to the same rhythm. This timing in turn governs the artwork's offer of wireless access to the Internet which phases in and out in the space.

17. Be unconscious

As distinct entities of scientific knowledge, as the fruits of differentially fluctuating patterns of memory and attention, of intervention and investment, hormones are delicately interlaced with the manifestations of sleep. Those associated with gender are only part of the broth seeping between cells and circulating in sleep. While testosterone is usually at its peak in the morning, thickening up the uncannily autonomous erections of some sleeping persons, one other hormone is, in certain parts of the world, also in variously regulatory frames

available in commodity form as tablets to dissolve in the mouth. Endogenously produced, melatonin rises one to two hours before the habitual time of sleep and remains high during sleep, dropping off during wakefulness. It is one of the key chemical factors in sleep, but is also active in numerous other bodily processes. Here we can say that its expressiveness depends upon conjunction.

How do you address a molecule in relation to sleep? What kinds of aesthetics can it said to operate by? What are the politics of its modes of conjunction, assimilation, exhaustion? In the mode of information, the hormonal molecule makes a proposition to a cell in relation to flows of time, energy and saturation, but it also is such a flow in itself. A molecule is a potency of matter that makes demands, exercises powers and is transient. It exists in a state of alliance between other scales, scales constituted by relative immutability or stability and by modes of interpretation and use. Félix Guattari saw language as a chemistry set, of interlocking formations describable at the scale of letters, words, syntactical formations and entities at larger scale such as conversations, books and bank statements.[91] Entities interlock in ways whose paths are indeterminate but patterned in their opening to contingency. Letters are monads, while words are molecular. Although scripts inhabit it, the world is not a text.

A molecule of melatonin, though, may be diagrammed by a simple graph, something that traces it without touching, but by means of which it forms a chain of things that are handleable and interoperable: not any such molecule, of course, but rather those that enter the lab or those that come out of the lab, into the factory, the bottle, the mouth and the bloodstream, by which point the diagram will be need to be renegotiated, will have become a little mixed. This diagram is

also intercepted by others: melatonin is available in the United States from the pharmacy shelf or via a doctor; to obtain it in the United Kingdom requires a prescription.[92] Alternately, in either place, it can be purchased straight from sites on the Internet. The aesthetics of a molecule as a commodity arise also at the point of governance. Within what schema of regulation is it co-constituted? In which grammar of economy is it to be conjugated? Such a molecule is less fixed in relation to massive molar formations such as gender. There are fuzzy aggregates of affinity and definition around which our species may like to experiment with as being less grossly manifest. Sleep science often proposes the figures of larks and owls, for instance (those who rise early or late and begin to sleep at time of equal variance.) In such a figuration one might pass through a constitution of many unknown kinds in a day. Doziness, vagueness, absent-mindedness; harassed feelings of duress, confusion and overload; and moments of daydreaming may even be interrupted or overlapped by spikes of lucidity or arousal.

The aesthetics of a molecule become partially apparent once it has become dislodged from the place of endogenous generation, is diagrammed and reproduced, turns into something that one takes or administers. The position is telling, with some degree of knowingness akin to Leibniz's 'acts of reflection'[93] and the abstractions they necessitate as truths. As distinct entities of scientific knowledge, hormones appear variably to the sleeper, the biochemist, the sleep scientist or the pharmacologist, and they are still being discovered in the unfolding of their interaction with body systems, in manifestation across species and as treatment or supplement (the category is variable in legal terms) for different conditions. In this, there is something uncanny

about these shifters of shape as they force and imply transversal relations across such boundaries of knowledge and of being.

Cholinergic, serotonergic, noradrenergic and histaminergic systems modulate what sleep scientists equipped with EEGs read off as electrical activity. Cortisol increases during sleep, secreted by the adrenal cortex. Growth hormone is entirely dependent upon sleep. The appetite-regulating hormones ghrelin and leptin are also linked to sleep, requiring that we eat more immediately satiating foods if we are tired. There is subtlety and art as well as repetition in devising and implementing and refining means to identify the presence of these hormones. Instruments, methods and tests engage in a mutual interplay of expressivity with the scales of bodies, leading in turn to their identification as healthy, troubled or troubling.

Melatonin is not quite yet capable of presaging the transvaluation of values in the manner presented by the diffusion of estrogen through the water system via the contraceptive pill as the story about it strains and swirls through various media platforms, and into the swollen glands of unloved mutant fish. It lacks both a chemical composition capable of sustaining and enduring such a transition, and the ability to latch onto the social and cultural formations expressed as so biologically disruptive. What it and other sleep treatments do come into composition with, though, are notions of normality, healthiness and expectation in sleep.

These combinations of forces, and of sleep with an illness, its interpretation and its treatment, can be found as the compositional forces that are further articulated or ablated by specific architectural designs. It is not likely that specific bodily chemical formulae are taken into

account of course in the design of the programme of a building, but notions of cleanliness, hygiene and the migration of materials between bodies and among bodies and the conjunction of forces and processes with bodies may certainly do so.

Alvar Aalto's noted Paimio Sanatorium, a building constructed for the treatment of tuberculosis, involving long, often terminal, residency, is a functionalist equation of such. Expressed in concrete, glass, fittings and furniture, and constructed between 1928 and 1933, the building arranges the labour of the hospital around recumbent bodies where sleep, the needed exposure to sunlight, and the exigencies of tuberculosis meet with hygienic cleaning, efficient plumbing and the imaginary of programmatic modernism.[94] The patient's time consists of rest – by night in a two-person ward, by day on the generous sun decks (with a sheepskin sleeping bag in winter) – and light walks in the surrounding woods, and the perpetual effort to feed the body and expel phlegm into a spittoon. This entity then becomes the focus of progress and, built into the wall just above the finely proportioned and noiseless basin, of progress too in architectural design. The portable stainless steel spittoon, somewhere between a small vase and a whisky flask, and the shared spittoon, a clear funnel between the splash-free waterbasins that is easy to clean and down which the mucus glides easily into pipes, form the receptacles for the results of the labour of sleep.[95] One's task as a patient then is to move between repose and the agitations of expulsion with the maximum of efficiency.

Sleep within functionalism was not simply about a state defined by its negative relation to wakefulness but rather as something with its own ergonomic and hygienic requirements that could be expressed in the quality and arrangement of materials and things. These could in turn be

factored into multifunctional designs, for furniture, for rooms, that allay the clutter of a specific function tied to a particular object but enhance the ease of moving from one activity to another by the degree of generality and fit to purpose of each object. The bed, for instance, did not attempt to engage with an ontology of sleep so much as it read a statistically likely sleeping body as a bearer of a set of requirements specifications that were to be decoded and most adequately met. If these needs could be met by a design that also enabled, by a swift and efficient transformation of the bed or lounger, the satisfaction of the need to sit upright, to be examined easily by medical staff, so much the better. Sleep therefore contributes to a generality of requirements, to which it contributes a set of needs, from which can be abstracted the criteria for design.[96]

The relation of time and motion studies to functionalism in design is well known, and it is in the expansion and refinement of what constitutes good function that Aalto's building is remarkable, with arrangement of surfaces, windows, lighting and heating to maintain a maximum of ease and equilibrium, without glaring light or annoying drafts, free of noise from the clatter of objects or the running of water or the mouths or movements of other patients.

The problem with functionalism, as a subset of all programmatic relations, is encountered when it is asked whether it is the case that each need, each productive capacity, finds itself harmoniously met or expressed in the design of our surroundings. Each of the warring, collaborating or glitching sets of organs and systems, along with the multifarious stylings of life, modes of savoir vivre and self-fashioning that are devised to cope with, compensate for and accentuate them, are entangled with, conformed to, challenged and recomposed.

Designers make alliances with certain tendencies. Furniture seduces new beings into existence through compositions with limbs, postures, ideas of life. But these are apparently rendered less tractable, less subject to propositions or nicely phrased invitations in sleep.

Time and motion are not only a reified disciplinary force but also something that is worked in and with as a means of form-finding, one that crosses various modalities and kinds of encoding, entraining and capacitating life in ways that are magnificent in their inventiveness but daunting in the way they make evident the qualities of the multiple kinds of coupling between organism and ecology. The carnal expressivity of the many kinds of what have momentarily settled out as bodies and the entities that gather together in them bear this out in their relations to time.

Some species living in the intertidal zone, that between high and low tides of the sea, do not have a circadian system of around twenty-four hours but rather one of 12.4 hours, matching the phasing of tides.[97] There is an expressivity of life that lies in the minutiae of interacting elements. The phasing of rhythms is simply one among many of what Stephen Jay Gould, speaking of evolution, calls 'a staggeringly improbable series of events, sensible enough in retrospect and subject to rigorous explanation, but utterly unpredictable and quite unrepeatable.'[98] The question of rhythmicity and phasing, then, should be seen also within a wider sense of genesis.

Contemporary biology complexifies the idea of the individual organism as an alliance, tracking the tendencies towards irreversibility as dependencies are fallen into or established over the course

of evolution.⁹⁹ The movement from self-replicating molecules to self-replicating complexes of molecules, in processes that are still underway, also provided the means for the generation of discrete cells, in turn developing organelles containing gene sequences. Over time some cells coalesced in multicellular organisms, changing form as they did so. Each of these shifts created new forms of material consistency and composition that implied new modes of response to and affordance for evolutionary pressures as they are articulated through them.¹⁰⁰ As such changes are accreted, they imply too changes in composition in relation to time as a field of polyphased becoming. Evolution's operations on and manifestation through organisms is itself compelled to occur through the cyclical aspect of life.

Many cells come with their own circadian rhythm, a relation to time manifest through light and the rotation of the earth around the sun. Even single-celled organisms may display relatively rich behaviours in relation to the passage of light on the surface of the earth, for instance, rising or drifting downwards in bodies of water.¹⁰¹ How these propensities are intensified, abnegated, blocked and rendered collectively symphonic remains in most cases an open question. The organism, however, is composed of multiple concatenations of such entities, variations of them, each in a process of prehensively figuring out, of stabilization or disruption or entrainment of others. One may be nested in or adapted to the conditions of another. Others may hang together thanks to the beneficence of the immune system, grown so that the elements of bodies are generally precluded from attacking each other, with the self 'a

metaphor for a figure'[102] outlined by a particular immune system's indifference, its non-reactivity.

The annoyances or difficulties of sharing a bed and some of the happiness and conviviality of sharing a bed are in part due to the other kinds of alliances between organs across bodies, the full abundance of imaginary, incipient and actual sexual organs most evidently, but there are also alliances of annoyance between mouths and ears, structural couplings of thrashing or roving limbs, the hocketing of a movement as a shuffle or a turn from one side to another reciprocated and passed back in a modified form, one body alternating with the other in ramifying or dampening a shift. Body parts and systems make their own alliances across bodies, in their physicality, but also in their capacities of prehension and awareness. These operate at different scales of singularization, but here we can feel the Empedoclean forces of love and strife recomposing existing bodies into new compositions. There is a somnolent versioning of conatus in alliances between bodies of sleepers, breaths, movements, limbs, the coming into and out of cycles. Humans cluster into cities for the processes of collective differentiation. They may also cast themselves into beds for such adventure.

18. The luxuriance of dissolving

It is pleasant to momentarily wake at that point that sleep evaporates a sense of self. If you happen to notice yourself falling asleep, there is an overcoming of disappearance by the recognition, for a moment,

of everything from the organs that bring the world inwards. All that comes in diffuses into a sumptuous attenuation of capability and of function as the outside arrives as the sensation of a faint rain on a hot day, a shimmer of recognition before a more substantial wave of sleep. Such a moment may be textured by whether it arises from an internal shifting of relations within the body, as one force affects another, or from something changing on its outside. I do not want to wake up, but in the faintness that arises at such a moment as the world clumsily collects itself through my sensorium before melting again is sometimes a pleasure that can never be arranged or scheduled.

19. Free-running

The composition of bodies as assemblages of parts achieved in sleep achieves different modes of expression if certain particular elements are withdrawn, held in suspension or encouraged to articulate themselves in a state that is more free of interrelation to the rest of the assemblage. Diminishing the impact of certain possible variables, or isolating oneself from them completely, allows other factors to manifest.

We can say that there is a certain capacity for the deterritorialization of homeostasis from interrelationship with the circadian system. The free-running of the body once 'internal desynchronization' is reached, allows for extraordinary modes of inhabiting time. Typically this is something attained in experiments where subjects have no access to information about the time of day, for instance, sunlight, clocks or media. Lighting conditions and sleep–wake time are selected by the subjects. For the first period, the twenty-four-hour cycle is maintained

with a usual ratio of time spent asleep to time spent awake. A few weeks in, however, people predominantly shift out of the twenty-four-hour cycle into a sleep–wake cycle of up to forty to fifty hours in length but maintain the same ratio of sleep to wakefulness. The roots and potentials of this internal desynchrony are unknown as yet.

20. Sleep in love

Sleep in a state of love is often impossible, a point of the concatenation of the ridiculous exhilaration it brings. For the Arcadian youngsters Daphnis and Chloe, sprung where life is forged in the potency of a rural idyll, sleep is so much at one with the all that it is barely mentioned, except when disturbed by the wing of a swallow chasing after a cricket resting on the sleeper's bosom.[103] At that moment there is a cascade of consequences, all of them of no import but of great moment.

Sleep plus the stupor of love is also a formula for comedy, as in the episode where Daphnis comes courting in the middle of winter after a long period apart. After celebrating with a feast of roast birds and honey cakes, the time comes to sleep. Abed, but separated by propriety, Daphnis embraces Chloe's father, whose bed he must share, imagining it is she.[104] The latter does not seem to mind. Imagination couples with anticipation in the painting of Daphnis and Chloe by Giovanni Battista Bertucci that is presently transfixed in the ostensive pomp of the Wallace Collection in its crowd-scuffed state between Selfridges and the gloomy plastic surgeries of Harley Street. In the painting, one lies asleep, the other awaits, gazing, arm raised slightly towards the viewer, warning them to silence with the tilt of a finger,

extending the line of her leg through his body. In sleep, the stroke of one slides into the other as the composition echoes the sympathy between them.

An expert in the state of recumbency, who knows well the unfortunately minor place of her expertise in this world, has been known to sleep with a smile. This smile is ramified across her face, until in the dark light of the bed it is composed of them, with the curve of mouth echoed in the sweep of eyelashes, arch of cheeks, eyebrows and on into the curls of hair. To witness such a face is so enthralling that it is impossible to fall back to sleep, but to dream alert in full gaze, until the sleeper awakes and is then, over the course of the day, driven mad by the red-eyed maniac who is turn demented by his failure to keep alert and coordinate.

21. Vulnerable

Samson, as pictured by Peter Paul Rubens and Antoon van Dyck – the latter who oversaw the painting of two canvases on this theme – sleeps besotted. At that moment he is fatally betrayed by his lover Delilah. Samson's enormous bulk lies slumped on the crossed leg of Delilah. Love makes the form of the lover the sweetest place to crash out, overcome by slurping on her perfidious tits. Compromised and paid off, she allows the Philistines to shear the hair that magically retains his enormous strength. In turn her fate is echoed in the sagged and wretched faces of the crone who, in each painting, stands watch behind her. Vulnerability to time and ageing, love and the sleep trapped with an unworthy trust are here conjoined. After a period

sufficient for his hair to regrow, Samson will die in a last surge of strength among the ruins of the temple of the fish god. Delilah will simply wither.

There is a contrasting affinity perhaps to Sandro Botticelli's *Venus and Mars*, where, in this panel of elongated width, the god of war lies slumped away from Venus, crashed out and pestered by toddler satyrs while Venus looks on, coolly arranged, perhaps a little peeved since Strife evidently has not the energy to exhaust Love.

Sleep, as with love, makes one vulnerable. This is one of its pleasures. But it is also one of the reasons that social forms arrange themselves around sleep, with those who are willing to share their somnolence, and sleep together having at least a certain trust in the cohort of others around them. Families, communes, tribes, clans, couples and other transient or coalesced groupings arrange themselves at least in part around their sleep. Thus when, in an early memoir, André Breton says, 'every night I would leave the door to my hotel room wide open in hopes of finally waking beside a companion I hadn't chosen',[105] and on the same page, rages against the 'somniferous bedboards', the boring necessity of sleep, he both tries to break this most unspoken of the social contracts and yearns to escape from the compulsion to lie down. But who can serendipity find to come and lie with an anonymous figure behind an open door? Drunks, the less fastidious poets, sleepwalkers, accidental persons, gods and the incurably optimistic should establish a trade union lest they get turned into angels incarnate by those who receive them between the sheets.

Guarding too much against the possibility of an unarranged partner can be a convenient means of gaining such. Adolph Loos's

arrangement of a bedroom for his wife, Lina, was an ensemble of white angora carpets on floor and walls that produced a stilled, almost shadowless space of ease in which to park her. Designed as the stage for Adolph's adoration, the bedroom became one in which she rarely slept alone and far more rarely with him.[106]

A kinetically opposite approach is taken by Július Koller, in Prague in April 1975, in an action descriptively entitled 'After three days and nights without sleep I spent the fourth night in a tree.' Instead of sleeping in conditions in which novel objects and companions are drawn towards you, try to find rest in a place in which you may unexpectedly gravitate elsewhere. Koller's actions were a means of inhabiting the stuff of the everyday askew to its normal insufferable knitting together of things, and often involved the redirection of basic bodily arrangements, as for instance in a project, from February 1976, entitled, 'After three days which we had both spent without any liquid intake, I offered myself and a hamster wine to drink, every morning and evening over the next few days. The action was to end when one of us (in this case, the hamster) took a drink.' Sleep deprivation, or that of thirst, is a means of allowing latent forces within the body, including stupidity, to come out of hiding and to take precedence over the manhandling of its fate by the executive role allotted to the possessive individual. There is a laxity here, a delegation of results not to something as grand as fate but to other agencies, clumsiness, a sudden thirst, the vagueness of sensorimotor coordination under conditions of great tiredness, a rush of building boredom against the constraints of one's own rules. Try playing Russian roulette with a gun loaded with a tranquillizer dart instead of a bullet, but then, let a tree or a hamster, or some other collaborator, less itchily replete with self, handle the trigger.

The accident is at the core of such work, but not the catastrophe, a slightly awry arrangement of things that suggests the composition of all kinds of balancing acts, that we can be aware of, or not, and whose fine attention to the displacement of attention and intention can be exemplified in lying down to doze. Sleep, and its relation to chance, then is not filtered through by the attenuated aspect of dream in its entertaining disgorgings of patches of synapses one into the other but by its involvement in life.

When it occurs as art, sleep in the gallery may be arranged to emphasize both the sleeper's vulnerability and also their indifference to the context, establishing an autarchy of time in which the clock is set by the sleeper's own requirements and the capacity of sleep that they embody as a power of polyrhythmic oblivion rather than that of the surrounding panoply of viewers, invigilators, works of art and the schedule of the gallery. Indeed, sleep as the producer of forms arranges the bodies of sleepers as a compositional force in itself, but one that is submerged, like a fantastic leviathan lurking imperceptibly underneath the glittering smooth surface of a rock pool.

For a performance named *Sleeping*, Yingmei Duan arranges sleep in a gallery.[107] Cloaked in a blue quilt on a white shelf at face height, the shelf on one wall among two others (one a body-length shelf with a circular hole to allow for a person to stand upright and to be transected by the shelf, the other a carcass too thin to lie in, also long enough to lie on), the force of sleep, the ability of the performer to lie down and be voided of the performance of self by the enactment of sleep, creates the atmosphere of the space. This is not so much that

one must tiptoe to avoid being impolite, more that there is a conditioning of the space of the gallery, relatively small, rather intimate, by the proximity and evident sleep of the body. When a certain time comes in the daily schedule, an electric alarm sounds and the sleeper gets up, collects the quilt and walks out in her pyjamas.

This conditioning of an atmosphere by a certain mode of presence that is irreducible: a living through time, conjoint with but largely disjoint from the space that sustains it; a sleeping among others, even if no one is there, but, if they are present, are implied as inevitably awake, being customers of an institution predicated on sensory alertness and the anticipation of the possibility of interpretation; a being covered in and exuding warmth, in a gallery space in which thermal comfort is a matter of moderate indifference; a claim, via the proxy of press release, that the mind, in such a state, is able to float free of the encumbered, positioned and postured body.

One would perhaps like to climb into bed alongside the sleeper and take a nap, but there is insufficient space on the shelf. The tender force of the work shows that sleep is not limited to the mere mind but is thick with soft breathing, and in that shared air one does not judge it nor assign it a meaning, not even perhaps recognize it, in the engrossed mass of its simple presence.

Vulnerable sleep is a crucial figure in horror films, or the cinema of suspense. The sleeper is unaware of the knife raised over them, of the immanence of the malevolent and shadowy threat. This form of vulnerability, unconscious passivity in the face of threat, predicated on waking to horror, the drama of expectation hingeing on the ratio between the time to wake up to the depth of incipient horror.[108]

Rather than the body or the self as the black box that perpetually expiates and expounds upon its innards, sleep in such moments when the body can be taken most fully as an object. The relation of horror to the sleeping body is that the innards come out without the mediating interference of the consciousness.

Vulnerability here, in sleep, is not simply that proximity to mortality that is supposed to make all of life swell in attentiveness and self-knowledge, heightening sensuousness and ethical integrity in experience, simply because the vulnerability of sleep is not that of the properly conscious subject. If finitude, in forms such as mortality, perspectivalism, history, can make us attend to the world in a rich way once it is recognized, during the flux of consciousness into unconsciousness, once asleep, one is finished. One is not simply not of one's own making, coming into composition with the world, but one's self makes something other of itself. This is something of a relief, but it has many aspects, including some that dislocate.

22. Hyperpassivity

Samson's sleep in love-intoxicated trust in what turns out to be, or that might have been read as, an enemy, indicates what may be one predominant view of sleep, that it is a state of real weakness. Max Weber's scrutiny of sleep in Protestantism is that it renders it commensurate with idleness and the temptations of the flesh.[109] Sleep is here simply a functional requirement, but one that had better be done with, like other forms of ablution, before the alert work of the day is to be done.

Just as there are quasi-conditions ascribed to contemporary forms of alertness, in which the ability to be attentive is disrupted by a twitchy, roving, irritable mode of overactivity that can only be dampened by the darling amphetamines of childhood, we can also say that there is, in present times, a pathologizing of sleep in relation to the equally twitchy functionality of irritation-based communication. Hyperactivity is thus complemented by a mirror condition that must be named as hyperpassivity.

Sleep as a form of unfortunate bodily necessity has other genealogies too. Seeking to realize the stoic imperative to know his nature and to command it, Seneca notes, 'I have no time for sleep: I just succumb to it, keeping my eyes at their work when they are heavy-lidded and exhausted from lack of rest.'[110] Seneca was a fortunate man. To fall asleep is a surprise for some, the very shock of it incipient enough to keep them awake and alert for the next shock.

To wake up tired is a mystery, a foreboding. To return to bed in the day, a sign of impending or actual illness. Fail in the appropriate dosage of alertness, and you become a loser – in the cosmology of northern Europe, where sleep is only a command given to a computer, somniferance is for those who have given up and become slugabeds and wastemen. Those who espouse sleep must learn to embrace them.

The grand list of vile indolents gathers aristocrats, prostitutes, students, husbands, artists, welfare claimants, bookworms, loonies, adolescents, junkies, cripples, children of millionaires, masturbators, dissipates, depressives, mathematicians, boozers, wearers of onesies, resting actors, devourers of happy meals, all of that laxly limping cavalcade who spend altogether too long in bed for social acceptance. All the freaks who can taste a passage to indolence with their whiskers, all

who nurture an inkling about the recondite passages through to the great continent of sleep. They flaunt their opacity or have no sense of an outside to it. Weaklings, burning with pale fire, gorged on pointlessness, heads swollen, blotchy and too dreamy from the embrace of the pillow. Each of those makes up and is inhabited by their own little assemblage out of the compositional forces of sleep, in, with and against the wider patternings and configurations of daily and nightly routines. In each such figure over time the question of which bodily systems combine to make sleep or determine it has its own history. The centuries have analysed and imagined sleep according to digestion and the balance of humours, the lack of blood to the brain or cerebral anaemia, the interrelation of different systems of reflexes, each linked to different patterns of life and their attendant conditionings of the body, such as gluttony, vice or virtuous physical labour. There is a phantasmagoria of sleep in the configurations. What would it take for them to multiply?

23. The eye busy unseeing

Sleep as process, as an undergoing of physiological events composed as art, emphasizes the activity of the eye as something more than solely the organ of sight, that is, of light resolved as signals composing an image to be read off from the retina. In the transduction of light from the eye to the pineal gland via the suprachiasmatic nucleus, the photosensitive ganglion cells, making up around two per cent of the light-receptive cells in the retina (alongside the more familiar rods and cones) are crucial in transmitting blue-frequency light to the

nervous system.[111] Light in this case does not resolve as an image, but, tied into the circadian system, acts as an energetic force around which the body organizes.

The complexity and polyformal nature of rhythms in sleep places the eye within a subtly shifting body. This body is articulated in a language developed by scientists in order to be able to speak of it and with which they pass tokens for the elements of sleep among themselves. Within sleep, rhythmic processes continue through the ultradian cycle of rapid eye movement (REM) and non-REM (NREM) sleep. Sleeper's eyes make slow rolling movements; muscle tone slackens; brain waves, as taken by EEG, move from beta waves (20–40 hertz) characteristic of wakefulness to a shifting pattern of alpha waves (registering 8–12 hertz), moving to theta waves (4.5–8 hertz); and K-complexes, a quick burst of relatively high voltage coupled with sleep spindles (12–15 hertz) of one half to two seconds in length, occur. Then, slow-wave sleep gradually overcomes these rhythms, with electrical oscillations measurable at zero to four hertz through an EEG.[112] After 60 to 90 minutes, sleep transitions again, reading similarly on the EEG to the state between sleep and wakefulness, waves of low amplitude, approximate to the theta state, dappled by alpha waves. At this point, the eyes get busy again, undergoing REM.

A prime young specimen of a laboratory human will have their dose of around eight hours of sleep, including two hours of REM, two hours of short-wave sleep and four hours made up of stage one and stage two sleep. REM to NREM cycles occur four or five times during a sleep session, each time extending the length of the REM period and lessening that of the NREM sleep.[113] A 'good' sleeper

will sleep through the night, but with fifteen to twenty episodes of thirty to sixty seconds of wakefulness, usually due to shifts in position or the transition from REM to NREM sleep. Only a few of these patches of waking amidst sleep are likely to be remembered.[114] Each of these features of sleep can be further decomposed, with variation in the strength of each wave changing over the sleeping period. REM is strongly linked to the circadian system, becoming stronger and more likely over the period of a sleep, corresponding to the fall in body temperature. The shifts and weaves of different rhythms across time and within a body are articulated in terms of heat, movement, electrical activity in the brain and variably within the brain. What is interesting to read in many of the scientific papers that discuss this phenomenon is that there is no overriding need to explain what occurs in relation to an ultimate underlying and primary cause, only to make a sharp description and to question what happens. There is an attention to the precision of watching, of sensing, but through medial organs, a concatenation of sensing, recording, reading, some results that lead to some propositions, which are in turn a means of calculating through a problem. How in turn, amidst all of this flux of waves, might we imagine an art that works in relation to the eye's capacity to sense the presence of light, or the activity of eyes without vision?

The eyes have no cause. Rapid eye movement is pure abstract vision that is, if vision is considered to be the yield of the ocular function, the simple processing and undergoing of vision rather than discernment into images or meaning. The movement of the eye is lively yet governed by something other than intent. Lidded, the eye focuses on a nothing that fluctuates into thickly irresolvable depth, the gathering

of all colours into black. Abstraction then is also in the eye, regardless of what is beholden: without needing to be pleasured by anything or to possess anything in sight, without recognition. Perhaps then, having being fixated on the idea of the image and the correlation of vision and understanding, we do not know yet what the eye is for, what it may become amidst other alliances.

24. How to thrive biologically

As the medicine of sleep is intersected and entrained by mechanisms for farming money, strange bulges and attenuations can be found in investment, according to territory, regulation and the potential to extend the capacities of certain chemicals or analytical devices. The illnesses of sleep become different things. Under the microscope they billow and blossom into forms to be further chased up and worked with. Thick seams of illness and difficulty to be mined for results and recompense, all the cash in all those blocked throats! All the potential for returns in arranging chemical bonds that sedate! But such seams also provide constraints, a set of opportunities that must be fought over, limits to what can be mined. Two of these seams are apnoea and insomnia.

Apnoea is a physiological condition where the structure of the throat sags during sleep. Often, but not absolutely, associated with obesity, it is correlated to the dumping of quasi foods into the diet of the West. As adipose tissues balloon out in fleshy ebullience, the inability of other body structures to maintain integrity starts to become manifest in different ways. There is no singular point

at which such a state will be reached across all individuals, the expressive range of parts articulated in capacities for cohesion and dehiscence. Apnoea can be intervened in by mechanical and surgical means such as continuous positive airway pressure (CPAP), where humidified air is blown into the mouth and nose of the sleeper. The throat strikes up an alliance with masks, tubes, fans and mists to maintain the lungs in a cyborg state of quiescence. Here, sleep exists in a complexly uneasy formulation between habits of body and social customs of sleep, the love of the mouth and intestines in relation to the demands of work, boredom and other forms of duress in combination with the comfort and nutrition given by what is eaten – because that is what is available and affordable – yet what is beyond the capacity of the concerted assemblage of flesh to actually metabolize and thus remains in a reservoir of stored energy that tendentially subsumes the capacity of an individual life to sustain it. Such conditions are amplified by the strife induced by the collapse of moral codes based on individual choice but framed within strictly constrained economic limits and a structurally depleted set of acceptable forms of life within a liberally encoded but increasingly authoritarian polity that is actually unable to name what it is doing to itself. Amidst all of this tangle are the experiences and undergoings of a body, many specific bodies, each with its own genealogy and afflictions, struggling to breathe and to have some peace amidst suffocating moments doled out in seconds.

At a different scale of abstraction to apnoea the other major zone of medical intervention into sleep is framed in terms of insomnia. There is no ready engineering fix, so the scale of intervention is chemical.

Here again, figurations of convenience, the formulaic character of statistically normal bodies, vie with attempts to resolve the difficulty of accommodating a life, an assemblage of parts held together in the face of strife, to the stress, demands and sometimes fatal requirements of other scales of being that may be coded as economic, familial, aesthetic or military.[115] The incompossibility of sleep with such conditions provides a steady and reliable line of income for pharmaceutical companies offering a buffer of chemical insensibility to compensate for the lags and grinds of those parts of the world that are in the peculiar state of seeing themselves as fully developed.[116] Since, however, insomnia is always also psychic and cultural as well as biological, and in many cases maybe primarily so as beings become out of phase with the demands made on them or the drives they co-constitute with, it is impossible to 'cure' as such. Insomnia may manifest as an immanent, and often highly repetitious, condition of sleep itself, and a cessation of sleeplessness may require an ethically grounded change in what is reckoned as health.

As well as being a place of vulnerability, sleep is perhaps less often the state in which one becomes ill than the mode one turns to in order to persist through illness. One may be driven to sleep by a fever. Undergoing pale-faced and sweaty sleep, a body wracked with coughing, constrained bronchioles and trachea and withered respiration makes the muscles of the chest and back cramp even with sips of breath.

When the person one loves and tenuously or thickly coexists in is gone in some way, there is an aching sense of strife. The sense, if not entirely of interdependence, of going through the world

together, is indeed a sense, though not located in one organ system. Loss of health is something similar, a familiar companion woven into oneself that is in turn changed by the composition, and whose absence recasts everything. The plethysmograph, a device for measuring the volume of air that can be shifted by lungs, or in another formation, that is attached to the genitals to locate sexual arousal in the bloody waxing and waning of the penis or vagina, has no equivalent for the fulsomeness of spirit as yet. Putting to bed a person who is grievously ill and, one wonders, may not be alive by the morning, invokes the horror of returning to them and finding a cessation of the subtle liveliness of sleep. Emepdoclean love finds itself manifest in this reciprocation, operating across the scales of being.

25. Repetition

Sleep can come in the guise of the mundane form of life lip-synced as repetition. It is so dully obvious as such. There is an endless bloody tedium in sleeping yet another night in prison, by enduring through the sentence, or having to persist, for reasons obscure, economic or decorous, in a place where your lover is not, a state that may be insurmountable. But, we mumble, change is also awkward. Who can sleep easily in a new room or a different bed, or even suffer the gradient of a different pillow, regardless of which doorway they are set up behind? If anything called for an absolute uniformity of the world, it is this relentless habituation to the same, life perpetually convalescing in memory foam. The

comfortable boredom of what is known is undemanding, relaxing, until that moment it is offended by variation. Each sleep is different; however, it is only that sleep itself manifests that constitutes the return to persistence.

Sleep rituals, preferred positions, preparation of sheets and clothes, arrangement of cuddly toys, repeated words of good night, a kiss, a prayer or more than one, the precise way you touch your check when pulling a sleeping bag over your head against the street air and turn your spine towards the road, this is where the behaviour in the sociological category of the everyday bleeds over into the potential for analysis as obsessive compulsion. There is no chance of disorder in the tactics used to dissuade oneself from screaming or bursting into howling scornful laughter against the utter greatness of the day just undergone.

Is it reasonable enough to believe that one will wake up after sleep? The relation of causality that links sleeping and waking, must pass through sleep. One can infer that it is likely, though possibly avoidable, given the state of one's health, a proximity to large falling objects and so on. Gilles Deleuze reads David Hume's idea of causality based on belief as giving rise to habit, a condition in which separate events, due to their similarity 'fuse in the imagination'.[117] The various tactics of mindfulness attempt to fend off the possibility of habit achieving an absolute state, to find in everyday life, in the midst of its fusion, the moment of germination. Sleep however sabotages such a capacity. While it may take much to win oneself into a state of sleep (exhaustion, satiation, chemical assistance or the maintenance of habit), once it is arrived at sleep precludes the tactics of mindfulness but allows

habit to perform. Here though habit is often surprising when reported upon by another who has witnessed ourselves asleep. What did you get up to, what did you say? Such a strange sound you made! Sleep is at least one condition where we can contrarily surprise ourselves with our habits.

26. Architecture

What buildings have provision for sleep? In one wave of urban change, purpose-built office blocks are being converted into spaces for the work of living, introducing sleep officially into spaces where it has always been surreptitious. Sleep under the table in the office, for the manager. A doze in the corner cubicle for the drones set amidst the lamenting, procrastinating and tutting at screens. Before and after hours in a toilet cubicle or supply cupboard for the cleaner, or the luxury of a doze on the divan with a discreet booze cabinet tucked informally into the office before its proper occupant arrives. Power naps for those whose brainstorming and team-bonding regimen necessitates living at work. Assuming that the state of sleep, or at least of a certain unshakable drowsiness, is the desired state or the actual content of most work, how will future archaeologists trace the usages of our buildings? No rooms are explicitly set aside for sleep in most workplaces, but it is a rare one that is exactly unslept in. Even those of greatest concentration, such as operating theatres, may at times become places of respite, and indeed even they organize themselves around the unconscious body.

27. Laws governing sleep

Sleep requires a place, if only a patch of open ground, and it is tied to the cycle of the day, making it measurable. The location of sleep over time presents itself as an easy means to link social control to location and the assembling of a labour force. In the *Grundrisse* Karl Marx recounts the work of Frederic Morton Eden, a follower of Adam Smith, who, working from the basis of parish Poor Law records, traced the late eighteenth-century inflation in the cost of everyday goods and food and wrote the first *History of the Labouring Classes in England*.[118] Amidst the catalogues of penalties for runaway apprentices and of the violent compulsion to work of the unemployed freed from villeinage but unable or unwilling to take work, he lists the degree to which sleep was regulated under the king, Henry VII.[119] Marx sees the regulation of wages in these passages as a boundary to the absolute 'subsumption' of life in capital. What however does that imply for the regulation of sleep, the explicit recognition of sleep and the customary need for a siesta, as a kind of counterpower to the full extension of the working day?

Mario Tronti diagrams the refusal of work, of exploitation, as prior to the possibility of explicit political theory: before politics gains a voice and a capacity to organize, there is rebellion.[120] Discipline in turn is a by-product of the problem of 'fixing' manpower, of making it predictable in behaviour and roughly reliable in quality. Sleep as a substance, as a state of matter, is certainly not inherently rebellious in this context, as it can be disciplined by the clock, bells, drugs and by other means, and is woven into the cycles of reproduction of the self, configured as working flesh, but it provides something both

customary and biological, both idiosyncratic to the individual and the moment and part of species being, a conjunction of nature–culture, in Donna Haraway's term,[121] that both pushes back against disciplinary forms of life and provides them with their matter, a necessity to organize, refine and make productive of the self. If not productive, then locatable, fixed and available will suffice.

The place of sleep is linked to the habitual location of the person. During the Reformation of Henry VIII, if a valiant beggar is found outside of his allotted place, he was to be whipped and put in the stocks for a day. If found a second time, 'he is to be whipped once more, and have the upper part of the gristle of the right ear cut clean off',[122] with execution the result of a third offence. When Nas raps, 'I never sleep because sleep is the cousin of death',[123] the story told is of an account of life too intense, too endangered and manic to sleep. Sleep, in the classical allusion, is a falling from life akin to taking a shot to the head. Eden notes that for an 'idle' person early in the reign of Edward VI, the risk of staying around too long was of branding and of slavery for two years, at the mercy of whomsoever informed against them.[124] Running away from that condition meant slavery for life. Death was the punishment for running away a second time, setting the precedent for the great liberality of contemporary 'three-strikes' laws. A number of other conditions were imposed on local officials to ensure the universality of this law, one to be repealed a few years later, returning to the mere whipping imposed under the prior king.[125] The innovation of subsequent parliaments is in the refinement of the definition of the kinds of vagrancy[126], the efficiency of punishment, the integration of such vagrants into a system of poor relief and in the registration of the return of the vagrant to their place of birth

as the proper place for them to rest their head. An expanded system of officials and of the corollary taxation in order to implement and afford this regime was developed in the long reign of Elizabeth I and integrated into a wider set of conditions governing moral behaviour and attendance at the established church along with the requirements for setting-up a house of correction in every county.

While the very existence of this surplus population, and the concomitant requirement for alms and the regulated exercise of Christian charity, is what produces the problem, the most surplus aspect of their lives is their requirement for sleep and hence and at least momentary relation to a place. The growth of cities, where one could slip out of view or move between the regulation of parishes and the attentions of beadles, the expansion of colonies and the intensifications of industry all shifted the balance of the governance of the place of sleep over time. The registration and fixing of identity, tied to the place of sleep, continues in the allocation of visas and in the administration of hostel and hotel rooms and other places.

The architecture of housing is, from certain angles, based around the need to be 'fed, watered, washed and rested', the functions corresponding directly or obliquely to food, clothes and shelter. But the specific place of sleep in such a framework is highly variable. The bed, for instance, as one can find layered with brocades and crammed with horse hair and crested with ostrich feathers in the gilded chamber of the prince in any standard issue renaissance palace, of a medieval English monarch (to be attended by a Lord Chamberlain and concomitant underlings), or in the case of the white laundered gurney upon which Hosni Mubarak was wheeled to his inconsequential trial

for the killing of demonstrators in Tahrir Square,[127] is also a place to dispense, receive or witness the theatre of justice.[128] The irony and stone-coldness in the facial expression, the weariness that this is all the world has to offer by way of its barbarism and requirement for decision relates the bed precisely to the place of judgement. A judge dozing through the blander patches of a court case is a persistent figure of fun, but perhaps such somnolence is a result not of the agedness and indifference of the judiciary but of the lack of inventiveness among criminals.

The incipient blackmail of not having anywhere safer, more known, to place the skull on a pillow is a force that can generally be relied upon in the persistence of the family and its intimate cohabitant, the real estate market. Perhaps sleep is the requirement that, more than any other, ties us to debt. Both factors in turn find their expression in the shape of the built environment in the interplay of a basic physical necessity and the economic and cultural means for its satisfaction. It is in the particular shape of the house, flat, dormitory, shack, hut and hotel that the special relation between basic physical needs and the convolutional operations of financial systems and the availability of resources can be traced.

Along these lines, Marx cites a Public Health Report of 1866 at length to describe the number of people, sometimes several families, sleeping in a squalid room together, where three or even six people may share a few rags and an armful of wood shavings as a bed.[129] The examples are from a run of streets in Bradford, slums which are 'dark, damp, stinking holes' packed with workers hired at Worsted factories blessed with the health-giving benefits of Arkwright's system

of machinery.[130] Like much of Britain's structure that simply layers rather than ever resolves a social problem, some of the houses mentioned still stand. The problem has moved geographically, with saturation in housing occurring in London, where 'boom' conditions result in people living in sheds and garages, families living in one room bedsits from which maximum rent can be extracted. But in its rich flexibility capitalism also treats sleep as a waste product, a form of friction to its smooth running, a natural barrier that can perhaps be overcome.[131] The abolition of a legal right to siesta for civil servants in Mexico in 1 April 1999 and in Spain in 2005[132] is part of a wider move to plug sleeping life into regimes of work that see relaxation or sleep in particular as something to be condensed into a manageable unit, not lingered over. Sleep becomes a burger hurriedly squashed into the face of the insatiable night to be simply swallowed, to abnegate an inconvenient need.

Other forms route sleep into the battery of productive mechanisms, intensifying its yield, exemplified at a certain time in the totemic bed of the hip bachelor, astronaut of the lounge capsule, exemplified by the rotating, camera bedecked, relentlessly equipped satin, leather and electronics office of the idealized playboy, who of course is a connoisseur of fine somnolence and a modular yet seamlessly integrated lifestyle in which sleep is just part of the workflow.[133] Sleep becomes somewhere to be equipped, saturated in opportunities for added value. Customizable mattresses, pills, electronic devices, healthy pillows, finely woven sheets, alarm systems and boxes of easy-to-tear sachets for the preparation of warm drinks containing thickeners, vitamins, minerals and powders to stabilize the powder of proteins extracted from liquid released by the udders of cows kept on farms in

a cycle of pregnancy and lactation to guarantee supply. There is a special insomnia to be had in wondering whether the optimal balance of equipment, accessories, diet and dosage has been reached or whether sleep could be better. It always could be improved; more entities could be assembled around it. Perhaps a more wholesome, vegan form of sleep with generous sunlight and modern furnishings with plenty of bookshelves can be assembled, at the correct rate of return.[134]

Linking various economic forms, sleep as part of the composition of the refrains of life and lives is also integrated into what Elizabeth Freeman calls chrononormativity:[135] a term for the sheer repetitiveness of intimate and large-scale social forms built around cycles of various periodicity, integrating systems of memory formation with all of its medial subsystems, billing, breeding and domesticity that trap, stabilize, entrain and disturb other cycles, passages and latencies

Other times reveal different appraisals of sleep in terms of the anatomy of function: there is a history too of how built or temporary structures for living are arrayed in order to assemble the material conditions for alliances to be made with the elements of the sleeping body. Temperature, the flow of air, the more ineffable aspects of architectural compositions of thresholds and volumes, screens and surfaces in relation to climate are means of integrating conceptions of comfort, the requirements of health, the regularities and customs of place and good social order. There are rather few architects now who ask how air addresses the lungs, or how the oxygen within it jostles to dissolve into the blood. There was however an early twentieth-century movement of fresh air enthusiasts who promulgated the idea of open-air sleeping, creating novel structures or adapting existing houses.

The vernacular form of the sleeping balcony reached its apotheosis of grandiosity in Los Angeles's Arts and Crafts–style *Gamble House*, but prior to air conditioning this was a common feature of homes in the warmer regions of the United States.[136] More inspiringly, perhaps, the fresh air cult's desire for the efficient circulation of gases gave rise to awnings or little tents being built onto the outside of sufficiently large windows. A bed would be modified to butt up to the window and cushioning fitted to the sill, so that the sleeper's head could protrude out of the house's envelope and into the open air. For those who shared a bed with someone without such an enthusiasm, awnings could be fitted that reached into the house from the window, allowing the sleeper's head to receive the revivifying airs while leaving the rest of their body inside.[137] The apparatus of sleep is magnificent, appealing, healthful, modern and necessary!

A hotel chain, speaking with a corporate 'we', may explain to the individual you how much it cares for your sleep experience. Set out in a brochure, once you have already purchased a stay, it will list its attention to your thoughts and the means of providing feedback on the great sleep experience and enumerate the range of great brands in soap, duvets, tea, mattresses and towelling systems that it has assembled in order to arrange them around you. Your job is simply to relax. What is most important to our guests? Comfort, you say – and we hear you! Spacious, modern, comfy sleep. The benefits of soft and firm, slim and plump pillows placed on quality beds attended to by passionate highly skilled staff whose care about the earth, your sleep and your health will not be undersold.

In person, such solicitous comments about the quality of a companion's sleep may be part of a morning ritual if the rare leisure is

available. But arising is also an opportunity for subtle revenges: of the method of urgently and conscientiously rousing a drunken master a servant recounts, 'He was waking up but I slapped him a second time anyway.'[138] The mere equipment and structures of sleep have less opportunity for such pleasurable initiative, but in their agency, and the exaggeration of its efficacy, there is a comedy of systems, objects and improvements that is constantly playing with the pleasures of attending to mastery, though we perhaps have yet to learn to recognize the more subtle of its tricks.

Equally, we might see here that the idea of living in harmony with the cycles of a purported nature, extending out into those of years or generations, nested tight as the beat of a heart or the taking of a breath and another, is something of a trick in itself.[139] Cycles in themselves may create rip tides and undertow as they mix on the shores of a life. Becoming attuned to the ways in which such cycles mix, creating turmoil, pulses of delicate glistening foam or fast stirrings with flat surfaces, is an art of immanence. Equipment makes an interposition into such cycles, arranging links across their scales or vaulting them. Equipment may act as a jetty, offering the requisite amount of deep water to get into; or a tide-breaking groyne assisting the shore in not getting washed entirely away; or a boat, a bed. At the same time, it can never house and regularize them all.

A single night has so many bodies in it, so many sleepers with their intestines, eyeballs, teeth, limbs in various states of tonus or slackened musculature, tongues lying in mouths making their bed among teeth, so many parts moving in and out of sleep, so many sleepers who continue into the day, pass through the day. The continent of sleep that

passes round the globe in darkness has routes cut through it by light, electricity and the demands of work.

As recounted in *Capital*'s section on the working day, nineteenth-century bakers turned up to work at night and mixed the dough in tubs for the following day's bread.[140] No loafers, they slept on boards over the dough as it proved, perhaps providing a little ambient warmth for the yeast, and woke two hours later to start working it, kneading and then shaping different kinds of bread. Here the length and place of sleep is determined by the actions and needs of a micro-organism within the dough. The hours of sleep are uncounted for by the wage but required by the work. There is a coupling between sleep that goes unfulfilled, and the liveliness of a minute entity, like raising babies rather than making dough. Yet this is not a simple dual relationship but one scaffolded by conditions of work. Sleep occupies a seam of time that is to be mined by the employer, its satisfactory exploitation leaving the baker, at that time, with an average life expectancy of forty-two.

In the extended mind arguments of Andy Clark, Dave Chalmers and others, mind is an analytically fecund category to have alongside that of the gross materialist brain, in that it is able to denote all the other entities, media and operations by which the brain is reticulated, extended and sidestepped, and by which it thinks.[141] The mind in this sense includes all those means by which thought is ordered, arranged and thought with: lists, sets of instructions, computers. Here, however, the mind needs also to be formed in the interference of its patterning with sleep, and also with attention to the pathological dimensions of the extended mind, the exterminatory madness of spreadsheets and accounts books that induce the ideas of extracting value beyond the

capacity of life, at an individual or ecological level, to support it. When an economic force is thinking through your flesh, calculating its capacity of becoming, sleep becomes an obstacle to its self-realization. An economy may make strategic or tactical alliances, even accidental ones, with particular organs in order to break open the resistance of others: the belly, an insolent worm threaded from mouth to anus; the brain, seat of anxieties and capacities for delusion; the eyes, omnivorous and cunning; the skin in its liking for silks and warmth, the touch of others.[142] The idea of an economic force may couple with the reimagination of parts, as in the Soviet elevation of manual labour coupled with its intensive humanistic work on literature, scholarly production and science. The proud tenor of the extended mind converged with Vladimir Illyich's imperative to learn, learn, learn and the fatal tempering of such learning within the consideration of 'objective conditions' and the hypostasis of a mind able to determine them. The ideation of an economic becoming may also produce new alliances with organs, weird arrangements between brain, ears, eyes, hands and belly, the commune, collective, festival, commonwealth that may in turn generate fields in which new organs may flourish. What modes of sleep might be expressed here?

28. Film sleep

A kind of skewed answer or relay to this question might be found in Andy Warhol's 1963 film *Sleep*, one that is also the answer to another question: how to be a lover to an enthusiastic user of amphetamines? Sleep seductively, sleep handsome, keep sleeping. Sleep knowing that

you must abandon yourself to registration on film, a 16mm Bolex running on 100-feet lengths, some to be later duplicated, running to a time of five hours and twenty minutes. Warhol's first public film, made at the initial height of his celebrity and part of a series of films lauded for their exploration of the durational capacity of film, is an extended portrait of John Giorno. Silent, black and white, filmed with relatively loose attention to camerawork, this is a film that argues that to watch is to love and that sets out to induce that attention in the second-order watchers, the viewers of the film. It implies in its filming, a patience only realizable by artificial means. Watch for so long that something becomes convincing, abstract, tender, that time becomes a fug that is breathed and emanated together in all the oddness and disjointedness of its participants.

The film moves around the sleeper, and light hits and enters the simple glassed chamber of the camera from a number of angles while its motor proceeds at the usual pace. Slabs of black and grey, light on the face shifting with the movement of light in the room and the exposure settings of the camera, body parts blurred or coming into resolution according to focus, composition, ear nose, mouth, back, arse, sheet, pillow, shifting from one length of film to another. Forehead, nose, chin and eyelid blacken and brighten in geologically slow time, drifting up and down the frame. Shots are made that slice into the body at unusual angles, revealing it not as a set of coherently composed forms but as something more elemental – the right ear, the slope of the neck becoming a shoulder, a furred chest, bulging up to a chin, sloping up to the scission point where the mouth is out of frame. Others shots appear where there are masses of flesh in white and grey bulk but no singularity to reveal them as addressed to or as

exemplifying a particular part. Breathing becomes a plot line, sampling the universe in sips at a rate far slower than the camera. The line of the hair couples with the shadow on the pillow, forehead, eyes in shade, nose; persistence in its heaviness blackens light; thick black sensation as the eye curves around a form, a buttock on its side, massive, cupped by the curve of the shadow until it persists long enough to be sheer isolate mass. Another sequence arises from the top of the mountainous skull, across the plane of the forehead made independent by light to the place where the eyes leak water. The sleeper's face in turn becomes a shaper of morphogenetic forces, throwing shade, eliciting light; the skin turns, slides into cheeks, thickens, opens into lips or nostrils, allows time to accrete to the musculature and bone underneath. Between the very corner of the mouth, the doubly curved skin between the side of the nostril and the beginnings of the cheek and the shadow thrown by the curve of the unskinned eye bearing thick lashes there is a momentary echo, as if each accompanies the other. The camera wobbles and is re-established while sleep persists among its recorded lengths. The interplay of light and flesh as presiding forces triangulated by the concatenation of camera, film, processing, screen and viewers decodes and loosens the hold of the overly apparent image, variation and distinction of parts being produced instead by the intimacy of sustained experience.

There is no specific part of the body required for sleep. One can sleep with or without legs, sight, hearing, stomach; any of those parts can be done without, and others can be replaced or bypassed by an intensive-care unit and which are monitored when the computer running them has not yet crashed causing the nurses to run over and reboot it. Sleep

is not solely located in the brain, although it may be used as a proxy to verify it, but it is the juicy bait that draws wanderers into its folds to monitor, sink fingers into and caress for data.

Perhaps the properly sleeping subject is never fully arrived at, just like the woken one. It is something that must be conjured up or proven by the attachment of a device. Judith Butler writes of the imaginary schemas that address and conjure bodies to organize them, descriptions that are 'psychically and phantasmically invested',[143] producing erotogenetic, normative and imaginal forces when coiled into or overlaid into persons, bodies, formalizations, conjugating twisted loops of selfhood and alterity in their mutual and asymmetric fibrillation, containment and provocation of the scale and dimensions of each other. Here we encounter organs and body systems that work through matter and ideas about matter, divulging and convoluting experience. Perhaps too we can see in entities such as the imaginary of the phallus that is never ideally anchored, nor identical to the specific object that it purports to trope, a wider set of understanding of the assemblage of the body that sleeps or does not yet sleep. There is a potential bestiary to be assembled of such bodily-imaginal entities. The pineal gland's overloading with functions and role as cosmic object makes an obvious additional candidate. The soul, with its complicated anatomical sense of being located in and transcendent of the flesh predates and to some extent prepares the ground for these entities. Part objects and quasi objects follow in proliferating the libidinal and psychic diagrammatics of parts and bodies composed of them. But such things are also a way of recognizing what has historically been described as media. Marshall McLuhan's formulation of the 'extensions of man' is in many senses an avoidance of the thick, often

dirty and complex ways in which media come into composition with persons and the personifications that go before them, run through them and are left as traces by them instead reducing each to a neurological telos, set in place by but yet betraying what is already manifest in the human.[144] Certain media forms certainly compose phalluses, among other things, and indeed the successful recapitulation and instantiation of such entities in the capacity and range of each media system may form part of their genealogy: how each media system manages to produce, optimize and elicit its own range of organismic or partial organs, projections, each with their own hypochondrias, inertias and lusts. The variations of the debate about remediation or skeuomorphism in media may provide a means of mapping each media form as an imaginal organ, variously articulated in ideals, conventions, abstractions and related systems of coordinates onto other forms. Where the idea of such fantasmic entities and their relation to sleep gains traction in the context of media is in relation to the proliferation of medial forms around sleep that imagine mobile body parts for it.

One of the innovations of sleep medicine has been the arraying of devices, apparatuses and institutions around the sleeping body, its panoply of mediation. Unlike many other forms of medicine that address the person at the level of a constituent entity in a population where the particular target is a pathogen or gene, or something below the level of the personificatory scale, sleep medicine often has the individual sleeper as a particular point of reference. A specific articulation of this tendency has been in the growth of devices for measuring sleep available in the form of apps. Some of this work relates to the distributed social movement or fashion known as the 'quantified

self', in which many data about life processes are captured, rendered subject to analyses and in some cases made public. Numerical bodies and processes, manifest in concatenations of software and hardware, made legible through application programming interfaces (APIs) and graphic interfaces, are put into place around systems of organs, filtered through skins, read off into spreadsheets and data visualizations, made 'social', leading in turn, so the imagination goes, into new regimes of diet, exercise and sleep regulation. In turn such organs provide means of farming data in aggregate to third parties, for other layers of interpretation and feedback.

One might imagine that lingering over the phallus as brought about by media, through processes of identification and consolidation, that delete ambiguity and turn the Empedoclean body into one bloc, is simply a ruse by which we miss the generalized investment in a wider set of imaginal entities brought into realization or persistent near-manifestation by such systems. After all, they are merely tools, so the story goes, for self-understanding. But perhaps we can also imagine it as part of, an exemplary model in, a wider population of fantasmic entities captured and wrapped up in psycho-material loops and patternings that are also technical. As popularly commoditized variants on technologies that were and are often initially developed in medical contexts such things have complex histories. The imaginal forces that they are imbued with are as much computational and numeric as they are social and bodily or pathological. Metrics are introduced into bodily processes and in turn interpolated by data structures that adduce and commute relations among things. Via the means of recordings, analyses, the collection of 'indicators of life' users are to achieve a form of structural coupling with self. A window,

replete with scroll bars, graphs, models and projections, of more than one kind, is put into place, related perhaps, to a fistula placed into the flank of an experimental subject in order to monitor the cycles of digestion attributable to the species. One is offered the possibility to make oneself something approaching coherent, to enact and receive discipline. At the same time however that sleep coalesces into the figurations of an app, run on a smartphone, saved as a data set to a server, it also sets up a means by which sleep both becomes a coagulant of referents, a reservoir of data and a means by which the body effervesces, shedding data like skin cells that collectively can be aggregated and turned into other bodies. We are not talking about simply closed forms of reflexivity here, but a proliferating set of medial and bodily relations that are also interpolated by sensors, databases and targets, themselves composed by the imaginaries of logic, ordering, proliferation, entrepreneurial 'disruption', user-centredness and ideas of health and improvement. Sleep and imaginal sleeps are composed and recorded under such conditions by medial organs whose capacity for cathexis remains yet to be fully explored.

Sleep's oscillations, the systems of sleep and its populations of parts proliferate outside of the body via means such as media, by organismic forces such as the circadian system that hooks it into the movements of the cosmos. Moving bodies are always composed of other bodies in motion. Take a day to watch the shadows in a room slide across the walls and floor, the slow swirl of light part of a larger system of transients. The shadows cast in a room change incrementally every day in a way that is barely perceptible without recording devices and practices.[145] The sun's gratuitous spillage takes part in a cosmically

laughable Morris dance of interacting parts and relations inhabited by other kinds of entity, flushes of chemicals, the lidding of eyes, changes in the measurable state of muscle tonus and in the language used to describe it and the apparatus that enfleshes and prompts it. If one philosophy of media reminds us that the human evolves partly in relation to an originary relation to technologies,[146] such a condition also emerges in a co-constitutional relation to sensual metamorphoses of wider scope: drugs, spices, physical practices. Patterns of sleep are tangled up in, induced, irritated and prohibited by systems of trade, intoxication, commonality, religion and colony building that they imply. Madnesses driving themselves to new heights of craziness and unconsciousness induce sleep, modulate it, interlace their own temporalities and effects into its rhythms. Sleep exists in order to be perverted by such things, and in the urgent necessity of escape from them.

29. The man controls the day. But we will control the night[147]

Parasomnias are the category of sleep events where the ensemble of parts is conducted by a force that is not quite the properly verifiable subject. Sleepwalking, night terrors, sleep talking, sexsomnia are bodily functions engaged in self-parody. The sight of a shambling body, eyes glazed and countenance drowsy, muttering imperatives, rebukes, chastising the world, or maintaining muteness; searching for something, getting dressed to carry out an obligation; or rushing away from an entity consisting solely of a mentation, acting out the duress

of the day in great fear, registers as uncanny, frightening, laughable. Carrying out something like an everyday activity, but from which the intelligent knowing agent has been shucked off, easily subverts the categories of activity as which they aggregate.

At certain points, such a condition coincides with the difficulty of establishing will and intention in a legal rather than a solely cultural or philosophical sense. The juridical quandary of assigning culpability for crime committed while asleep is perplexing. As Matthew Wolf-Meyer shows, it can extend to debates about the relative culpability of a killing committed while driving when asleep compared to a murder committed during sleepwalking.[148] Sleep makes intentional will difficult to grasp, suggesting crimes without authors as much as bodies without subjects. Crimes appearing as virtuals that only await their actuation regardless of the specific person carrying them out are a familiar category in corporate or military crimes, where simply carrying out orders may alleviate the pain of culpability. Market imperatives, social norms, moralities, property relations, the lack of or overabundance of legal frameworks and guidance create conditions where crimes are brought into fructuation simply by the logic of the parts, laws, conventions and norms that are aggregated and activated by a particular process of singularization. The variation in kinds between codified law and collaged common law are a means of negotiating this variance and capturing the field of potential or retrospectively actual and particular crimes and adverse events.

The encounter with a person on autopilot, or the recognition of undergoing such a state oneself, can be as perplexing, or not dissimilarly confounding than everyday life. Foregoing will and intent, causation or an etiology may be allocated to something else at another

scale. What is below conscious will can be framed in turn at multiple levels. Beneath the level of what is tidied up and categorized as affect and sensation is an almost mythological level, 'nature', but which, it is supposed, through scientific analysis becomes a known, stable object, one gifted with a certain relationship to the rational, a specific chemical, the dose of a certain hormone, a sleep debt, that maybe becomes a commodity or – given enough lab work, the satisficing of the right tests and the possibility that it can be effectively addressed to an identifiable set of problems – the opportunity to be muttered to by another chemical or adjusted by the adoption of proper habits. What is intriguing however is that at the present state of knowledge, parasomnias are so partially known in terms of their etiology, their genesis so untracked and indecisive.[149] They appear as problems without sufficient resolution to resolve as something fully describable, categorically known or determined as such. This is not to say that medical descriptions of these conditions are not becoming more abundant. Indeed, given the recent prolixity of sleep science, and the established benefits of the categorical establishment of a term, if not a fully stable object for it to refer to, there is a rapid development of such categories. That the *International Classification of Sleep Disorders Diagnostic and Coding Manual* is renewed so frequently shows the generativity of the field.[150] What is treated are symptoms, or equally often, those whose sleep is complained of are treated with pharmaceutical materials that align their gross behaviour with that which is congealed as a norm. Indeed, the category of knowledge about a problem is, given some treatments, foundationally recursive. Certain of the sleeping drugs, that is, Ambien/Zolpidem, produce amnesia in some sleepers, giving the impression that a good night's sleep has been had, simply because

the insomnia cannot be remembered.[151] Other effects include imagined sleep, with the pill acting as placebo.

Given such an unstable state, it would be conceptually too neat to say that knowledge about the domain is itself a highly profitable mode of sleepwalking. Such would be a critical appraisal arising out of an understanding that routinely, almost absent-mindedly, figures science as reification. The objectification of sleep becomes not solely a reduction but an extrapolation or ramification of parts. It may indeed reduce by compression (one electrode of event the finest EEG to represent the electrical activity of thousands of neurons), or indeed distort via magnification, as in the standing in of data, such as that gathered by a polysomnogram, for sleep itself. What is underway instead, or also, is a process of numerous kinds, of finding affinities between instruments, ideas, modes of recording and phenomena, forms of organization and economies, among which are in part eliciting or tendentially encouraging the autarky of certain aspects of the body or the capacities of certain assemblages of parts to override, become disjoint from, or seal off those of others. At the same time, each of these is subject to integration, conjunction or various modes of address, disavowal or blanking by other organizing factors. The assemblages thus underway constitute the ecologies in which sleep falls.[152] Sleep-related groaning, talking, laughing or vocalizing in sleep, sleepwalking, night terrors, episodic nocturnal wandering, recurrent or isolated sleep paralysis, nightmares, confusional arousals, all amidst the unstoppable list of bodily expression.

A man tells me his wife wakes him up laughing every night. He thinks it is remarkable, amazing, unique, inexplicable. That wonder of

human nature, his wife, takes me aside separately to complain about the awful jokes her husband makes in his sleep.

A moment when body parts are not held in accustomed place by their relation to others may also disjoint their relation to other formations, such as the sleep of others.

One child wakes up fighting and shouting every night for a year. Fists flailing, he runs, bare feet slapping against the floor. His face is clenched and roaring, 'You wankers! You fucking wankers!' The urgency and dramatic perilousness of the event becomes a routine, a bore, nothing to remark upon. Waking up the household becomes just a tedious fact of life, akin to the noisy emptying of a particular psychic or nervous bladder. The fantastic conflict is forgotten, although bruises are gained and yelling is done, blame circulated as the currency of the house. The treatment is to wake him up earlier, before the anger, before the particular cycle of sleep in which the rage occurs. Gaining sleep becomes a rhythmic intervention, an edit: the cut is made to montage slow-wave sleep (stages three and four of REM sleep) or stage two sleep abruptly to waking, and then fade back to sleep.[153]

Just as diagnosis of sleep and sleep disorders operates in relation to manuals, categorical grids and developing methods, instruments and research programmes, certain parameters of the body are probed for their truth and the ability to yield such in relation to domestically available kits, regimes, aids, helpful clutters of things that clip on and plug-in. The investment into gadgets that are to be attended to, updated, fiddled with and that fiddle with the user might be labelled

as narcissistic if they were not so mundane. Surely a proper Narcissus looks for a mirror that gilds the frame and delights the senses rather than transduces them to a set of tables mapping a small range of variables over time. Full-scale home polysomnography is yet to come, so we may download tens of apps to encourage the sleep of their user including breathing exercises, neurolinguistic soothing, nature sounds, caffeine and food intake and exercise mapping; apps that measure motion and translate that into a chart corresponding to dreaming and deep sleep, with apparent sleep length recorded and mappable over time, with data impartable to both social media and security hoards. Such apps build on the computer's celebrated ability to store and compare data, to generate billions of unique ambient tunescapes and to receive and give orders. One turns the unconscious self into a smart home that can be programmed and monitored from a distance, beyond the boundary of sleep.

Such medial organs may also operate on what Michel Foucault calls the regimen, serial attention to and modification of small acts of life.[154] Such devices amplify the proliferation of parts carrying out minor specular operations on the rhythms of the user's body. Social and bodily activities are sustained over time as medial organs in order to become more natural, in tune with themselves, or better, to improve upon what is given. The regimen is adaptive rather than prescriptive, providing advice on balance, and involves note taking, a diary of habits, incidents and pleasures in order that the reasoning self can operate upon itself over time.

The scale of the regimen is transversal, moving across organs, sensors, surfaces, anticipating attention as well as providing it. But

development cycles mean that the pleasure of such an object, once one actually has it, is always contaminated by the knowledge that it will soon be outmoded.[155] The rhythms of the body are intercalated with those of product development and release cycles. Indeed, part of the mildly frenetic nature of such things, and which drives their subjects towards sleep, is the recognition of their transience. Here they fuse with the generality of interaction based around staving off and responding to irritation, convenience and boredom. Dystopian science fictions have assumed that people would want to watch dreams, to subscribe to fantasies, as a space of refuge from the world in the manner of drugs. But what we also find is more material. Both awakeness and sleep are turned into sources of data farming and the potential for habit improvement. Note taking is tedious, so outsource it to your phone, which can never be as bored of itself as you are. How long before our best sleeps are played back into the nervous system as peak performances, algorithmically determined favourites and special memories of that really awful night that actually meant something?

The twentieth century leaves us with the gift that every time an aspect of life is reflected upon it carries with it a vile double, of how it was arranged in the camps. Much effort is expended in the avoidance of seeing this doppelgänger in fear that it will make us sense the resonances of the present to clearly. That this is a commonplace also doubles and shadows things in the crassness of not recognizing its complication.

Is there something significant in the fact that the architect Ernst Neufert, who defined the modern field of standard measures for objects in buildings, published the second edition of the *Bauordnungslehre*

with the Volk und Reich Verlag in 1943?[156] The regimen of good order expressed as ergonomic tables for the proportion of all building components, including beds and bedrooms, among stairs, lecture theatres, corridors, windows and doorways, the air and light in a room, arrived in bookshops and into the hands of specialists while in the spring of that year a crematorium and gas chamber complex was finished and went into operation at Birkenau.[157]

In Margarete Buber-Neumann's account of Ravensbrück, the bunk with its meagre mat of straw tick becomes a miniscule refuge. As the pressures of the war state increased and new prisoners poured into the camp, there was a concomitant increase in dirt, vermin and epidemics and the requirement to sleep three or four prisoners to every two mats.[158] Although this particular account is one of the maintenance of a boundless margin of solidarity between women in such conditions, the sleeper next to you became a vehicle for the torture of relentless proximity. In this degrading intimacy, to be asleep next to that withered specimen, and to be that degraded thing for another and for oneself, to be reduced to a substandard replica of a dross that replaced you was a marker of the intimacy of war.

Part of the efficacy of sleep deprivation as a mode of torture is that it forces the victim to be a subject, to be alert, to exert reason, but to recognize the collapse of the possibility of that position. As such, as in the treatment of Chelsea Manning and others, it is the exemplary form of torture for the democratic West in its current state of war against spectral, probabilistically determined enemies, in that first and foremost it asserts the respect for the dignity of the victim as a subject, something that must be fully conscious of itself and hence compulsorily awake.

30. Headless brim

In *Daybreak*, the prelude to his work on morality, Nietzsche suggests that we disavow our dreams, as something horrible that we have no control over, all the better to convince ourselves that, by comparison, we have some control over our waking lives. Dreams rather, as arising entirely from ourselves, are what we cook up entirely autonomously.[159] Nevertheless, there is little that the profound poet of physiology, nutriment, place, climate, recreation, suggests about sleep. His is a philosophy of wakefulness in all the abundance of its humours, where sleep is only mentioned as an indicator of play at great tasks, whose residue as text might excite one from sleep.[160] Night is mainly reserved for walking, dancing and for feasts.

The break of day following the long party of Zarathustra exemplifies however one of the key uses that sleep is put to in text if it is to be considered as a medium. If, in visual art sleep is the pretext for a lingering address of the body as object, as surface and variable form for the play of light and signification, in text, it often occurs that sleep conversely provides the author with a chance to tuck figures out of sight. While his guests sleep, Zarathustra raises his head to speak to his eagle, and then receives the visit from the Lion accompanied by doves. Once the meaning of this visit is confirmed, the revellers awake to have it explained.

Sleep can act as a means of buffering one or more of the entities in a narrative sequence. This is the case with the kidnapped Trojan women upon entry to Arcadia in Johann Wolfgang von Goethe's second part of *Faust*.[161] Here, though asleep, the women transition to the new zone, but yet, like spikes of neurotic activity damped by a

swig of antidepressants, sleep is a form of stupefaction and a means of moving them to the side of the activity in the story. One can sense a similar set of ruses occurring in the movement of activity based on an inverse cycle of sunlight in the movement of stock exchange activity between New York, Tokyo and London. When 'all cows are black'[162], the scene goes dark, manoeuvres are made, one awakes all innocent and blinking, awaiting news:

> Preferably tell us something that's so strange we can't believe it;
> For we all are bored to death here, sitting looking at these cliffs.[163]

Similarly, Andrey Platonov's benighted English engineer Perry awaiting judgement from the Peter the Great, in punishment for a botched canal, 'lay down to sleep, to shorten the useless time'[164], precisely too the rationale for the protagonist's gorging on comically bad novels in the story.

Something also of this state of abeyance is visible in Edgar Bundy's painting *The Morning of Sedgemoor*.[165] Beneath a clutch of peasant tools tied to poles and lashed a little too sketchily to quite function as weapons more than narrative devices, a tangle of men lie in straw, the surface of the paint sinking some deep amidst the fodder, others visible as stray limbs or faces slumped adrift in sleep. Having thrown their lot in with the doomed revolt by Monmouth, a protesting chancer failing to catch his historical moment against the Catholic James II, this moment is a prelude, for these men, to the Bloody Assizes or death in the subsequent rout, and, for the historically dominant party in the English ruling class, to preparations for the landing in the west country a few years later by the mercenary army of William of Orange. But sleep, the painting narrates, is not merely an entr'acte,

but a moment when history recuperates and builds itself for the next slaughter. Sedgemoor's night-time attack leads to the collapse of the rebellion, and the lone, rather gormless youngster who stands on guard in sackcloth with his sun-burnished cheeks, badly held flintlock and long scythe standing painted to attention, rests his gaze on the viewer. The sight of sleep, his expression suggests, implies comradeship, and those who watch do not disturb.

In David Shrigley's eight-minute film *Sleep* (2008) an itchily lined sketch of a man lies in bed, not quite serene, not yet fully irritated. His nostrils seem too heavy for the strokes of the pen that bear them, causing him to suffocate slightly. Sleep is transposed by recording devices, not those of the psychologist but the animation tools that bring the figure to life yet place it in a state of suspension. Teeth and facial creases cluster round an open mouth. Two lank arms are folded over the counterpane while breathing keeps him busy with the heavy throat and lung work of shallow breathing. There is no rest. Sleep is a time of moronism, when one is given over solely to the function of organs. An artist may record his sleeping noises and sound as atrophied as a cabinet minister, as catarrhal as a coal miner. In sleep, none of these sleepers is directly defined by their work or their social role but by the gunge of which they consist, which may in turn arise from such factors. Is the sleeper's breath laced with the botanical tinges of gin, the sweet tang of cough mixture? It's hard to get close enough to tell in a projection. At different ages, so the theory goes, specific organs define you, for a decade or so. From the mouth of the child to the genitals of the youngster, to the brain and belly of later years, on, if we survive long enough, to the decades of the kidneys and of the

liver. The sleeping liver is merely relieved from the usual tilt of gravity. This is important, an organ of the moment caught between two imperatives. In times of great difficulty it is, for instance, important to stay sober. But in order to invert the incipient apocalypse, it is important to drink as much as possible in order to restrain the liquids from swallowing the earth.

31. At the edge of sex

The shepherd Endymion was sent to sleep by an enchantment from the moon goddess Selene so that she could embrace him, uttering the timeless and honourable line, 'Since you are lying down we might as well have sex.' Luckily, several paintings exist of the encounter to prove that it occurred and that we might learn from its example. Study, in this regard, should also be made of the paintings of Judith and Holofernes, where sleep provides the opportunity for a decapitation.

Feigned sleep as a mode of seduction: do what you want to me, but I am not in possession of my self. I may be dreaming however. I have simply taken a paracetamol and fallen asleep with my head in your lap. It is well known that a person's hands twitch and move in sleep sometimes. Place oneself with care in relation to them. Just as a rose is produced in between the morphogenetic fields produced by the sensory apparatus of the bee or other pollen-gathering insects, the mutational capacity of the species and variety, and the aesthetics and capacities of the plant breeder, each particular seduction plays itself out, even if only for the moment of a glance, between the poles of the

seductees and the seduction. Sleep, feigned or otherwise, plays its part in the repertoire. But take note, it is rare that such a move will work out well on a train or short flight.

Extending this problematic, the *Sleeping Beauties* performance staged by Taras Polataiko[166] consisted of a series of female performers gussied up in long ivory-toned polyester gowns overacting princessly sleep on a raised white satin dais taking turns in two-hour daily shifts. While recordings of Eric Satie's *Gnossienes* blasted the air and cameras streamed the proceedings, visitors who were over eighteen years old, who could show a passport and did not exhibit cold sores were able to sign a contract promising to marry the performer should the latter, who had signed a reciprocal contract, awake upon receiving the kiss. It was a media *cause célèbre*, due to the succinct way in which it fused anxieties and trepid hopes around marriage, fate, intuition, love and chance. The last chance indeed was an implicit aspect for some viewers. Naturally, while the sleepers acted as a poultice to draw forth a cavalcade of males to exhibit their hopefulness, intuition, sensitivity and prowess at taking a wager, the project neatly culminated as a media narrative when one of the performers opened her eyes to a kiss from another woman. Sleep, or the imagination of it, mobilizes seduction by offering itself as an object, here wrapped in the imagined finitude of a contract.

To be slowly awakened by the touching, soft licking, kissing or sucking of parts seems a form of perfection in which a moment of love or pleasure moves from the conscious to the unconscious and back, unable to make a divide between the two and thus averring its fullness. There is no argument with its excellence as a form of arriving at

consciousness, for out of all of the modes of those available, this one is likely the most preferable. And to be loved while asleep, at which point one is at least primarily innocent by virtue of stupor, or at least minimally offensive, if not strictly desirable, seems perhaps more likely often than when awake. But this is complicated. To be fucked while asleep is the narrative of more than one bad story (The sour closing scene of Larry Clark's film *Kids*, or the case brought on behalf of Miss W against Julian Assange).[167]

For reasons of the potential perfection of such an awakening it is of course mainly insufferable, to be drawn from one state to the other, under the action of another human, who is, after all, as oddly configured in terms of motivations and strange kindnesses as oneself. There is a possible reproach incipient in such adoration: why are you not awake and already lusting after me? Accidental sex while almost asleep, stirred in the night when both somehow arrive at a state of entanglement 'without knowing' born out of a love in which each conjunction arises out of a multivariate familiarity and desire and out of the lust of exploration, that such occurs while in more than one state of consciousness is, as while awake, delicious.

Such events are part of the aspect of the move from the immobile to the motivated in sleep, but the pleasure in such moments is related to Bataille's argument for the roots of religion in the sensation of immanence.[168] Here, the animal is figured as a momentary pulsion of energies, sensation, power, as water in water, setting up a resonance between Leibniz's monadology, as one creature is, from this ecological perspective, differentiable from another as simply a more or less powerful wave of sensate matter. At such moments, the brain is relieved of its primary role as the organ that governs the state of

sleepfulness or of being awake to be caught up in a relation of immanence with others. The grammars of subject and object may come into play, perhaps as the flickering of a conceptual and interpersonal fetish, and perhaps too as a route through to something more delirious or insensible.

The animal, in Bataille, is placed on an indeterminate continuum between the inanimate thing and the human, who is cut away from, yet in, the world. The immanence of the animal manifests, for the human, at times such as the momentary fusion of festival, the dark, exuberant and libidinal chaos of collective breaking loose into the sacred that Bataille sees as an 'amiable reconciliation'[169] with such immanence and which roots all of society. In these reflections on festival, the continuum between human and object is traversed, but with a certain danger: 'The constant problem posed by the impossibility of being human without being a thing and of escaping the limits of things without returning to *animal slumber* receives the limited solution of the festival.'[170]

The state of the animal is here figured as equivalent to the state of sleep in the human. Sleep is not figured as a non-state but as a form of animality that is alternate to that of the festival or of sacrifice, which in turn are themselves limited by the prudence of consciousness.

Is there something too homogeneous about this figuration of animal sleep? It is well known that different kinds of animals, for instance, insects or fish, have different patterns and kinds of sleep, or relatively lessened states of physical and nervous activity, than mammals, and within that mammals, prey species differ from predators quite significantly in terms of the timing and length of sleep. Sleep, like intelligence and other physiological traits, evolves in relation to ecological

context: more or less fitting, more or less disturbing. There are other continuums therefore between the human and the generality of 'the animal'. In his lucid commentary on the various figures of the animal in Nietzsche, a mapping of the exhilarating power of energies and capacities in life, one that suggests a certain capacity to evaluate and differentiate among them, Alphonso Lingis notes that Nietzsche's animals do not operate as anthropomorphic dumping grounds for preexistent human qualities, but that they act as attractors drawing the development of the human towards their own exemplary *virtú*.[171] The various styles of Kung Fu inspired by observation of the movement of animals might be exemplary in this regard. Zarathustra gains the traits of pride and wisdom from associating with the eagle and snake, while other populations align themselves, by agriculture and other means, with cattle or fish, with different kinds of domesticity or wildness implied.

Eroticism as a form of conjuring animality equally acts as a capacity, like a magnet's interaction with iron filings, but, one should thankfully note, a little less predictable, a means of coming into combination with sleep and of inventing, drawing out and arising towards new forms of animality: virtual species in becoming, formed of sleep, desire and exhilarated physiology. At the edge of sleep, sex produces a whole rainforest of animalities to learn from and to find oneself, or to nurture the capacity of, becoming. Asleep, animality underlies and founds the species once known as the human.

The image of the sleeping warrior who awaits under the ground to protect his land or people at the moment of utmost crisis, as epitomized in the figures of Holger the Dane or King Arthur, was echoed

in the belief among some that Vladimir Lenin merely sleeps in his mausoleum, awaiting the kiss of the revolutionary masses,[172] the sleeping beauty to the proletariat's prince. In this case the revolution, the solution to the crisis, brings about the revitalization of its heroes. Meanwhile the state agency in charge of maintaining the correct chemical conditions of transhistorical sleep for Lenin is spun off as a private company, ready to serve in a global market of political embalming.

The threat of the obligation of playing a part in a significant moment in history, let alone of reversing it by being roused from sleep, is neatly sidestepped in the story of Rip van Winkle, who evades the American War of Independence and the travails of his domestic life by magically falling asleep in the bosom of the Catskill Mountains for a score of years. This is a great stroke of luck, but it also leaves him untimely, an anachronism whose ligaments and tendons to society have been torn.[173] One is obliged to sleep and to awake in unison with one's time. Indolence and magic as means of slipping out of joint with the curses of history will, the story suggests, make us lonely: but one might indeed have the temperament for it.

The 'Sleeping Beauty' fairy tale stages the fantasy of erotic anticipation of wakening with a kiss as an obligation, a binding of desire to chance. The image of the sleeping maiden, brambles, tendrils and flowers writhing slowly around her to assure her security from wakening, is one that is close to that of the drowned Ophelia. The vegetal longing of the forest gives forth and absorbs the figure, face remaining until last. And yet the plants hesitate. The sleeper is compelled to sleep. Only in seduction may she arise, but only in loosing her heart

to the one that proffers the wakening kiss may she achieve proper personhood again and change state from the cruel trick of sleep that erases her agency. One might say that either way she is doomed to loss of selfhood. Would it be better to remain asleep?

The power of desire overcomes conscious and 'considered will'[174] in a state of being beside oneself even when a person is awake, in the delight of being overcome by the forces and capacities of sexual rapture. To be held in such a condition, or its anticipation, while asleep by the force of magic is an uncanny state. Both sleep and erotic convulsion are momentary means to evade proper selfhood, and as such they may become a precious resource in its constitution and regulation.

A variant of such a moment is to be found also in phenomenological accounts of waking from sleep in which the person is yet to be assembled into their proper coordinate system.[175] The categories of space and time are localized and articulated in a person as place and memory, yet there is a pause before they are fully loaded into the conscious subject. There is a sensorial play in which the organs at the surface of the body have yet to become arrayed in relation to what has yet to coagulate as a self.

32. No tools left in this vehicle overnight

Imagine a new baby sleeping on its back, with legs open, arms above its head, head lolled to one side. Now imagine being that baby. It is impossible. One has passed through too much, a sequence of thresholds that concresce as a person and by contrast the baby is at the

beginnings of its genesis. One can admire the gesture, correlate it perhaps with the well-calculated advisability of sleeping supine rather than prone in order to avoid sudden infant death disorder (or, conversely, the advice in favour of sleeping prone in order to develop the chest musculature desirable for respiration and crawling) and envy the ability to be so magisterially oblivious, but that particular state of sleep seems elusive. This is what the child wakes you at three or four in the morning to remind you of, but in sleep there is that precious pre-personal state, in the loss of which, via the needs of such a creature, one experiences both an encounter with and the torn need for.

One does not exactly return to the sleep of a baby as one gets older, Sleep and kinds of sleep also change, but it is a parallel aging distinct in some ways from that of the woken self, growing its own idiosyncratic habits and capabilities. The tightening and thickening of muscles and the shortening of ligaments, the habits of posture and of movement meaning the full slackening of limbs has to be trained back into. Sleeping styles age in their own way, but always take part in the pre-personal, great breathing warm succour of night. The commonality of sleeping in what is named the foetal position traces the fossil of baby sleep retained in the adult, returning it to a prior sleep, one imagined as much as present.

Throughout nearly a century of photography, Manuel Alvarez Bravo arranged numerous photos of people asleep: on curbs, on steps, legs pulled up a little on their sides, a cloth or stretch of newspaper under them.[176] The pictures do not constitute a series as such, rather a line, an enquiry that wanders through his work. *El Soñador* (The dreamer) exemplifies them in a certain way: a strong-bodied customs porter

whose image is taken low, from the level of the street, while he basks on his side upon the raised kerb near Santiago Tlatelolco station in Mexico City. In conjunction with the line of the camera, his beautiful face is turned up so that the lips and chin are upmost. He may be dreaming indeed behind those thickly lashed eyelids, but the sleep itself is exuberant.

Other photographs are taken from slightly above, less monumental, at the eye level of a passer-by. In one the sleeper is crashed out under a length of patterned fabric on a set of stone steps close to the edge of the frame. The position and nature of their body is indeterminable, opaque to view and the images of this kind are more recessive, minor, showing an open repertoire of positions and, in a certain way, both evidence of a city that reciprocates and is tolerant of sleep in the open and of the conditions that contrive the baleful necessity to do so.

The gestures of sleep are carried through into the photograph entitled *Fallen Sheet* – one that could be that of a crime scene in its starkness. The covering lies alone, accidentally taking on the echo of a figure with knees pulled up and head curved slightly inwards, crumpled on a patterned tile floor. Here, the metonym for sleep is its covering.

The sheet overcomes the face in the most explicit of his essays on the typology of sleep, *De Los Maneras de Dormir* (Of the ways to sleep) as the breathing parts of the lower face are exposed between two parts of white fabric arrayed diagonally across the frame. Next to the slack open mouth of the young man with the scuffed cheeks is a smooth-skinned hand, flopped over from the wrist. Sleep here is composed of the brute respiratory fact and the limp indolence of the

relaxed hand with its uncannily neat row of fingers. There is a cascade of folds of the white sheet over his eyes to block the bright even daylight in which the photograph is taken. One could be looking at justice, still blindfolded but taking a day off from hefting the scales. There is no sight: eyes closed under the cloth, sightlessness is doubled.

Street photography hinges on finding the unnamed forms of composition that emerge in the city, in the windows of shops, the angle of bridges, the reciprocations and contradictions of people, manners, the surprise and dolorousness of revealed tenderness. Bravo's, *Los Perros durmiendo ladran* (Sleeping dogs bark) shows a small white dog, not quite a chihuahua, with black head patches lying under the sun on stones and impacted earth. The shot is low and the dog is tiny, really. The diagonal lines of a worn, rough, wooden fencing panel angle down onto him as if the downward slant of gravity became a diagram and could be laid to one side, resting against a wall. The bones and flesh of the dog, sunk into sleep, still provide some resistance to it, but no more than do the extra rolls of furry skin around his neck, the exposure of the darkened tip of his groin at the centre of the base of the image and the subtle ready indolence of his lips. The sleep of dogs here has its Hercules.

33. Unswept benches

Ilya Ehrenberg sends a parcel of observations back to Moscow to be published in 1933, photographs of people on Paris's streets, taken in close intimacy thanks to a special Leica camera that appears to

be pointed at ninety degrees from its target.[177] Since the photos are taken at an angle of adjacency, it relinquishes their subjects from the requirement to tidy themselves up, and the book, laid out by El Lissitzky, does not impose anything further on them. All the images are taken in the open air, though the texts accompanying them venture indoors. Workers on their lunch break; boozers necking the dregs; the leftovers of the Great War, widows and concierges, array themselves on steps, benches, café chairs, anywhere for a little snooze, or somewhere to anchor the body against the waves of exhaustion. Printed on rough paper, with plates made from high-contrast prints, figures thicken amidst their worn clothes, creased into geological folds. Sleep here is haggard, worn into overlapped patches of fraying time. Compared to the paranoid facilities of cities such as contemporary London, we see that benches are not even securitized against horizontality; rather, they act like versatile pieces of gymnastics equipment for the uncomfortable art of freestyle immobility. Various moves are possible according to the particular design of the bench. Wedge yourself in an angle, or across some slats; or turn backwards and rest your chin and chest against the upper beam. Additionally, the commodious angle between walls and ground, for instance, curled under a poster for the Fête Nationale on Bastille Day of 1931, the same year as the Paris Colonial Exhibition, may also provide terrain for a somnolent parcours. Hunger, booze, necessity, accident, the knackered attainment of indifference to cold and hardness or the assistance of the warmth of a dog curled up in the spread of one folded and one outstretched leg, align to achieve sleep for a moment as the apex of an empire of citizens under bridges.

34. Trains and buses

On a train with a low-backed seat, a head nods forward, jerks awake enough to reposition itself when it has already self-righted and felt the wince. Drooping forward onto the chest, it lets the neck go. Eventually the bearer of the head wakes sufficiently to notice another sleeper in an elaborate dress, head sinking slowly to her side amidst the knocking of the rails. Her head rocks backward, and she jerks forward still asleep, never once desecrating her elaborately raised and sprayed coiffure by breaking it on a surface against which her head might rest. The hairdo is, while impressive, somewhat dated and hence perhaps difficult to replicate, requiring care. In search of something to slump against, the head only finds the muscles of the neck and their aptitude to spasm at just the right moment. While asleep, the skull probes space for its optimum resting point, a balance that is thrown out by the movements of the train over the wonky track. The relationship between hairstyles and sleep is a complex one, with histories of gender, and of hairstyling products to be drawn through it. It was in the last decade of the last century, though, that 'bed-head' household styling gels, foams and waxes explicitly began to advertise themselves as giving a texture equivalent to that of those freshly risen. Curlers and hair-nets probe an opposite lineage of composition, while antimacassars impose a neutral zone between furnishings and the head, most often now found on public transport, where sleep can be savoured.

Sleeping in a manner sufficiently artful to avoid paying train tickets involves a whole rhetoric of the apparent depth of sleep and of its absolute necessity coupled with the implication of the abrupt

rudeness that would be involved in any attempt, even the customary light tap on the shoulder, to wake the sleeper. Such a rhetoric can involve the placement of objects and paraphernalia, as if the passenger had inhabited the place for a long sojourn and had already been checked. As with the use of sleep as a buffer in literary narrative one can move oneself out of the direction of travel of a procedural regime. Some passengers may even wish to display genuine tickets at this point, primly arrayed on the table to be checked and marked as a warding-off device while they are asleep – some find being subject to the exercises of authority within sleep variably comforting. Some love it.

Sleep is a loss of alertness, a culturally understood passivity where the material of the body reneges on its requirement to produce a soul or active agency. Standing guard, watching out from the fire at the centre of the group or with an ear to the barricade, or waiting for the drone, the missile proudly named after the least useful member of the hive, is left to others, the young who like to patrol the perimeter. Turns are taken to sleep.

Sleeping on guard duty is a military crime, however. One's organs and limbs must be present and correct and ready for action, to watch, to shout warning, to alarm, to fire. The brain is in a purely supporting role, allocating and ordering the action of other organs and limbs in relation to the protocol of defence and engagement adopted. How many soldiers owe their lives to the dissimilarity between the knees of humans and horses, whose ability to lock into place while standing allows them their ability to stand and nap? Gravity is the heavy blanket that pulls the jointed body down to the level of the surface it lies on.

35. The smell of sleep

There is no one to register the scent of sleep but the mosquito tugged closer by the waft of carbon dioxide in softly exhaled breath, the tang of lactic acid oozing from skin; no one but the passing guard, the intruder, the dozily watching lover. The dark air is inflected with oxidizing sweat, the soft nose of a cock that has fucked a while ago but from which, as a matter of indolence, a residue under the foreskin has not yet been rinsed. The releases that remain unwitnessed but that simply thicken the air, seepages of a great flat involatility, a night's portion of the one and a half litres of water vapour breathed out in an average day, the champagne bubble whiff of stewed carbon dioxide, the nauseating innocence of those who slumber with dog breath in your face, the air-locked cabin of a seagoing craft adorned with one man who has no need to wash because, when they have not yet developed a sheen, the sheets eventually rub the fetid outer layer from his epidermis, the rough blanket of an aged dog worn into its basket, a still-faintly pungent pulp of crushed petals partly rubbed into the sheets under two old bodies on the occasion of an anniversary. Amidst sheets that are resoundingly laundered with a residue of ingredient parfum, a woman might be found who admiringly believed that her lover released a certain scent when she reached orgasm, only to later secretly recognize that it was the mixed tang of her own cooled sweat upon a momentarily shared stretch of warm skin that carried to the nose the bittersweet vapours of mimosa, or who might think, in falling asleep with a cheek on the inside of her forearm, that the woman scented in the way that is mimicked by that plant in flower could always overpower her. Such things are always assemblages.

Scent, a smell, on its own does not yet exist in that mode, implying a nostril, nervous system, appetites and responses. But neither is what yields it inactive 'merely' a chemical before the scent manifests as such. Neither also is the recipient. A sleeper may be alert for coffee, the whiff of a hot knife being readied on the gas fire, the weekly malt of the brewery a terraced street away that makes its bearer salivate and twitch out into the world as woken.

36. The child's bed

'Is there anything warmer, more secret, more fragile than the inside of a child's bed? That is one of the places where the world is endlessly reborn',[178] Pierre Guyotat asks in his staging of intense encounters between experience, perception and words. In such rebirth, it is a surprise to wake up and still be oneself sometimes. Robert Louis Stephenson's *Child's Garden of Verses*, a book that seems never to have gone out of print, has a figure playing with figures among the bedcovers. Textures, crumples and the seams of fabrics produce a landscape for cavalry or adventurers. Within the macrocosm, where kitsch intersects memory, there is a microclimate of warm parts and those colder ones that the feet have not yet dared to enter, and a sense of depth in the miniature.

What is under the bed? What else inhabits it? A tribe of cuddly toys, teddy bears, books, a torch, radio, phone and an imagined snake just out of reach of the toes. The rays of the screen falling on lidded eyes. The child is among all of these as one transitional object amidst a gathering of them.

As such, the child's bed is also the point of contemplation for the parents, struck in the gaze at their offspring, in some kind of shock and awe inversely powerful to the size of the creature that lies there. A few years later, the child watches over a parent, or more, places an ear to their door, briefly checking their state, before slipping out of the window or through the door.

The bed may be a place of punishment and banishment, one turned inside out by the psychic escapology of Maurice Sendak's *Where the Wild Things Are*, a child's version of Jean Genet's *Our Lady of the Flowers*, the prisoner's bed becoming a place of mirage so powerful that it makes mere dream seem slight, and in which sleep acts as the disrupter, one that is more infused with the reality principle than with the day, 'in the evening the preliminaries of sleep denude the environs of myself, destroy objects and episodes, leaving me at the edge of sleep as solitary'.[179]

37. Brain as labourer

The dream is a site often overrun by work, with till jockeys remembering price codes and customer-facing verbiage; call-centre flesh interfaces remembering menu structures and scripts where once, so the myth goes, persons in such a position might deign to make decisions rather than be placed there in order to fend them off; and data-entry staff dreaming through windows and combinations of them, words and numbers, appearing interminably from the clattering of their fingertips. From weeks picking in the field, eyes reperceive the

patterns of distribution of strawberries under leaves, feel the thick stems of lilies in the hand as the eye moves to find the next correctly curved flower in the row. We are drenched in work, it drips from our digits and it passes through us, each particle taking on a swerve, an additional rider of the constant reworking implied by its transition through a person, a more or less cohesive set of body parts.

A news story appears at the outlet of an email service. Research conducted at the University of California San Diego found that people often solve ongoing problems during REM. 'When people sleep, the brain reshuffles memories, combining old associations and new ideas to come up with solutions', says study author Sara C. Mednick, PhD.[180] Not one to evade the possibility of working a category, even Aristotle noted the tendency to arrange lists of objects during dreams in his sleep.[181] The productivity of labouring sleep is lamented or found perplexing in many accounts, the recognition that one works at some pointless task even when asleep. Business-class sleep indeed includes the proposal for the 'power nap' with its regimens, tips and manuals for advanced users.[182] Rather than grind one's teeth about this, perhaps it might be better to intensify it, to work only when asleep.

Sleep is a time of latency and possibility for Walter Benjamin, a childlike state, precious as such, but to be awakened from into a political adulthood and moving itself generation by generation in a gyre of awakening and succumbing to sleep and the collective dream he saw as epitomized in the city.[183] In this cyclical mode, a skill laboured at through hard work, repetition and practice is intuitively learned, resolved while asleep, a time for incoherently learned material to organize itself into an insight.[184] Sleep is a means for learning to sink into the brain and other muscles, in memory

consolidation now usually, but not solely, formulated as taking place in REM via the consolidation of synaptic links.[185] Such memory consolidation might be a point of contestation for the formulation of the extended mind as a self-consistent thing rather than something that comes about through lags and rhythms of connection and dialogic formation.

38. Melnikov's Promethean sleepers

For a student to fall asleep during a lecture or a lesson is to be expected. For a lecturer to fall asleep in the middle of teaching is a sign of illness or, in certain cases, a close attentiveness to the material at hand. The relation of sleep to work however is a complex one. Yevgeny Zamyatin's novel *We* extrapolates the rational management of Taylorism into all areas of life, including compulsory hours of sleep, thus providing a new image of the sleep of reason.

In 1929, Soviet architect Konstantin Melnikov proposed a building called the *Sonata of Sleep* (*SONnaia SONata* in Russian, where *son* is a noun for both sleep and dream).[186] The building consisted of a light-filled atrium, from which, tilted at a slight angle to the ground, a pair of long two-storey blocks led off. These wings of the building contained chambers for washing and dressing and undressing. With the beds aligned to the inclined plane of the floors there was to be no need for pillows, since the body was to be integrated more closely into the system of the building as a whole and in turn to the wider scheme for a green city planned to rejuvenate the frazzled workers of the communist metropolis.

As in Melnikov's own house, the beds themselves were platforms, similar to a raised dais that integrated the sleeping surface with the rest of the structure. Indeed, rather than the bed being one scale of a wider formal and functional program with a shared aesthetic, one can say that it became the key unit of composition around which the rest of the building was formed. The inclined plane of the floor merged with that of the bed, activating surfaces in a way that pre-empts later topological fascinations with slopes and the blending of spatial forms. Here, though, function was not to revel in some kind of spatial indeterminacy but to intensify around the process of sleep.

Sleep was to be encouraged throughout the day and night, and was to be had in the broad daylight afforded by the glass facade as much as in darkness. Busy in the service sections of the building, at the tip of each dormitory wing, were to be groups of technicians operating sophisticated technology aimed at intensifying the relaxation of the resting bodies. Soothing but educative sounds, such as those of birdsong and music, were to waft across the recumbent bodies as they breathed evenly in the purified and scented air. Sleep was a time of experience, one in a simply different register to that of wakefulness, one that could become productive via early versions of the idea of hypnopaedia, learning while asleep. This learning would not be that of the rote ingestion of a language or the rules of driving a car, but that of a poetic subject capable of living in a revitalized world. The building attempted to formulate a fragment of such a world at a moment in the development of Soviet society when the debate was on how to best create the communist subject and what exactly that economic and cultural form meant. Societal striving for such new figures was being carried out by economic means,

propaganda, new institutions and new forms in art and their repression; and in the moment when the debate about precisely what the correct, or most likely or most historically necessary, form of such a subject might be, what it might spring from or what it might plug into in terms of existing archetypes, what form of cultural 'lock-in' might be required and whether it must be imposed, inculcated or drawn out, still raged. All this was fought through with all the means and urgency of a society in turmoil and yet being built. The concatenation of conjunctions forms some of the ways in which the disputes and forces of Soviet society threw open and closed down upon myriads of known categories of life. At moments of social crisis, as with the English Interregnum, there is a great proliferation of ideas for reform of the soul and of the individual; revelations of the secrets of a successful personality, of the true harmony of the individual with their body; and sources of everlasting health to be found in charms, amulets, almanacs, ionizers and patent cures. As Blaise Cendrars notes of the 1905 Russian Revolution, there is: 'A frantic loosening of all ties, which was mistaken for mysticism, was at work in every level of society.'[187]

The author of the sole monograph on Konstantin Melnikov in English, S. Frederick Starr, suggests that the building's aim was to armour workers with a subjectivity formed in a concentrated experience of nature and aesthetics as a means of surviving the onslaught of productivity. The beds of the *Sonata of Sleep* were to gently rock for the relief of shock workers drained by the workday of Joseph Stalin's first five-year plan. The green city remained unbuilt, and the 1930s saw a flood of workers being admitted to asylums and sleep taken up by Ivan Pavlov and his disciples as a problem to be solved

by the use of bromides or early barbiturates such as the 'truth serum' sodium amytal.[188] The sanatorium too subsequently developed as a mass form, with tens of thousands of workers undergoing recuperative stays consisting of rest, fresh air, gymnastics and plenty of food in order to recompose their capacity for work.

Amidst the planned garden city we must conquer that third of the day left to sleep as a means of developing the properly collectivized worker, one that can survive the glory of being turned into a machine part. While it is unclear what specific forms of aesthetics the poetry and music to be performed for the cultivation of the sleepers was to take, this was not the only building planned by Melnikov to have worked directly on the body. The USSR pavilion for the Paris International Exposition of Modern Decorative and Industrial Arts of 1925, was built in Moscow from wood by peasants using the traditional Russian axe and clad in sheets of glass. The design epitomized constructivist simplicity and daring. Progress through it was designed to dilate the pupils of visitors at the entrance before witnessing the wonders of Soviet society, and bathing them, for renewal, in reflected red light as they entered back into the cluttered humdrum of the West. As they left in a narrow file through the portals of the Soviet uterus, the roseate eyelids of sleeping humanity were there to be gazed through into the bright sunlight of the future.

39. Sleep debt

'Sleep debt' is a term describing the effect of insufficient sleep. No doubt debts should normally be written out, inscribed in ledgers

or worked out through the shifting of registers of ink or electrons. Without records, debt is rather more difficult to maintain. Perhaps this is why one has to pay fastidious attention in order to discern the ethico-aesthetics of sleep. Writing however drifts from its moorings into new forms, and sleep inscribes bodies between parts, movements and ensembles. Such debt is homeostatic, written by hormones and acids in organs and glands and muscles, cascades of drowsiness.

Should what is understood as inert also be free of obligation? Debt's nose is attuned enough to sniff out the liveliness of sleep itself, to recognize that there are stirrings there which are of value. This is the introduction of an internal pseudomarket into the subject, an innovation in keeping with the failures of the times. Sleep debt? Do you owe it to the economy, the gross national product, the balance book of the universe, your boss? To good familial arrangements? To your self, who must act as, and who is responsible to, incidentally, all of these things? Send the bailiffs in on yourself and drag your white goods, televisions, computers, intestines and other organs, your febrile and tender parts, not to mention the jewellery, out onto the street to be sold off to relinquish the debt. Cram them all into a new warehouse to be flogged off. Better, make a distraction and take them round the corner and back in through another, secret, entrance. By such means an article, a precious hour of sleep, may be taken out and logged as recovered more than once.

Sleep debt is named so that we understand that it cannot be taken seriously enough since it concerns the vocabulary of money. But there is also literal sleep debt: in certain territories, if someone is diagnosed with obstructive sleep apnoea, or another sleep disorder, their driving

license is removed unless they can prove that they are undergoing a regime of treatment.

Another kind of repulsive sleep may also be that of the sleeper for whom the self is an employee of a sleeping, ever-needful employer demanding that they work harder so that the other may go to sleep. There is a class struggle between the one who wakes and works and the one who demands that they stay in the sleeping state in order to rest sufficiently to do so. The tired and alert worker fries themselves so that the heavy and content boss may rest more at some point in the future, that of a few hours ahead, or of many years to come. These two classes are trapped in the same body and will fight to the death.

40. Sleep on the road

In writing *Blue-Eyed Devil*, the story of a journey across the United States to meet fellow Muslims, ranging from street-syncretic Five Percenters to prim assimilationist lobby groups, the author Mike Knight uses the network of Greyhound buses.[189] Occasionally, when a place cannot be found to sleep on location, he is certainly not overly fussy, and, blessed with a month's pass, will take a ride from one city to another overnight, returning by a bus in the opposite direction. Sleeping on the streets is thus avoided by dozing while skimming a few feet above them.

Sleeping across a pair of seats is a meagre luxury, and the need to sleep means that people wedge themselves into whatever cracks they can find in the city. From 2002, until the end of 2011 when they were taken off the road in London, the bendy buses provided free

night-time sleeping places that were marginally warmer and safer than the streets, a soothing space with prickly surfaced seats. Since they were not capable of being effectively overlooked by the driver, two of the three doors provided access without need to pay the fare. The buses became a honeytrap for Border Agency swoops, where not having a ticket might entail the passenger in a process for a full ID and deportation, with the police acting as revenue protection officers for the companies running the routes,

The particular model of bus concerned, the Mercedes Benz Citaro, was also covered rather well with cameras, providing another sort of security of imagined watching to those who would ride every night from the centre of town to the suburbs and back and then out again.[190] The free bus was a magnificent invention describing a fault line between the shifting bulks of absent cash and of necessary movement across the city. It was always busy, so it had to be closed.

The free bus's cousin in transport is that discussed by Marcel Mauss when, in his foray into cataloguing the techniques of the body, he talks about nomadic warriors moving across country on horseback.[191] Riders arrive while having slept, exhibiting uncanny movement across space, untaxed by the rent of time in transit.

Death by sleeping coach driver is a traditional part of any summer news headline round-up in the British Isles, the helmsman dropping off on the road into oncoming traffic or into the scenic gaping void that many touristic regions keep installed for this purpose at the side of their roads.

It is generally assumed that the condition that will not name itself as neoliberalism is the scourge of sleep, that it reduces its populations to overworked specimens wracked with anxiety, tiredness and

the fatigue of processing everything from data to meat and tokens of emotion; not to mention the labour of toting papery cups of coffee and cans of hysterical energy drinks everywhere they go in order to cope with the burden of staying awake to witness it all. That is to say, contemporary society does not nurture sleep so much as agitate new forms of insomnia.[192] Locked into its rictus whinge, the Left laments that there is no natural sleep unencumbered by the woes of a toxic modernity, but has yet to provide an image of the militant sleeper.

However, we can also say that contemporary capitalism does invoke new kinds of sleep. This is not only the figurative sleeping wakefulness of the citizen of spectacular society, the ideological sleepwalker, but also one that has a dimension proper to sleep: sudden bursts of exhaustion; lingering feelings of working while in the throes of pleasure; news snippets of sleepers equipped with the ability to delete enormous quantities of value simply by falling asleep face first at the right keyboard with a nose pressed to the key for authorizing transactions.

41. Terraforming

Samuel Palmer made the figure of the shepherd in the landscape an enduring motif of his work. Walking through the fields full of wheat at dusk accompanied by a dog, lying above trees on a buxom hill among the clouds conversing, in a fold of a field reading a book, or lying next to or among the flock in a field yet to be rendered gleanable, the shepherd provides the key to the habitation of the landscape. Images of harvest, ploughing under moonlight and of boughs uncannily heavy with fruit are coupled with those of respite from work. In

the closing phase of the arable revolution, the shepherd is already a ghost but one that provides the key to the voluptuousness of the landscape. A serene, twilight, open state of the world is epitomized by the youthful figure in repose in a crude hut, a hand raised to touch the face and provide a prop to the head. A few scattered items, crook, hat, bag, light just over the horizon establish the grammar of glimmers and deep inks of earth under moonlight. The illuminated landscape is nearly always deep in Palmer's work. Such depth is ensured because in the light just over the horizon that is faint, thick or failing, there is so much interplay between what is visible and what moves out of sight. The earth is abundant, even in sleep.

Sheep, whether they manifest as bonily haunched or as rotund gatherings of wool clustered together, well-herded and content, the ease of lying down, legs folded oppositewise at the knee, underneath them or thrust outwards. Folk wisdom – with its genial indifference to the scientific principle of falsifiability – suggests that, in the fewer than three hours a day that sheep spend asleep, they do so with their heads uphill, the curve of the land providing a pillow. In geological terms, it is said, the rubbing of surfaces in this way by generations of fat-bottomed sheep contributes marginally to the conical shape of hills.

42. Nocturne

Alongside the assertive and deliberative dimensions of such actions, the public display or use of sleep as protest, as in occupations of buildings or squares, is part of its strength. The vulnerability of the

recumbent body on the street or in the factory and lecture hall is counterposed to the malevolence or cynicism of those to whom it is asked, 'How do you sleep at night?'

A tumble of bodies lies collapsed, transported and bereft of thought after a dance, festival, party, curled into corners, in twos or threes, or single, spreadeagled, unclear as to whether the ketamine took hold. Escape into sleep, not from work or from the erosions of domestic life but by bodies worn beyond thrilling. Sleep overcomes them, on grass, concrete, the benefit of a knackered sofa. The boundary between the dancer and the bundle of rags is effaced in a certain stylistics of collapse – microcultures of sleep. Crusties, as a visible subcultural stream, reaching their peak in the 1980s and barely with us any longer, had this style of sleep, where the world became an ambulant nest, however harsh, that one could sit or fall down into at any moment. In sleep, the dissolution of clothes, sense, consciousness all interwove their fecund decay. If aspects of punk emphasized the subtle intelligence of stupidity, crustiness aimed at the animality of obliteration. The free party scenes of the 1990s drove the style of sleep of the flung body harder as the beats per minute neatened and maxed. The style of sleep, driven by exaltation, in embracing one's category as a momentary conjugation of waste, makes the link between crusties and dogs and evidences their relation to the Cynics (*kynos*), living on the streets, refusing work, in the wisdom and stupor of rags with no place. Diogenes slept in the street as a sign against vanity but also out of a hunger to know life through the inversion of all that is raised up on high, especially the pride in being ostentatiously humble.

The question asked by such sleep is of the appropriate matter to know and to come into revelatory composition with what

constitutes life's primitives. If civilization consists in the proliferation and improvement of the means to concentrate on not thinking about what is actually happening, of what can be taken for granted, then sleep is both the most fulsome and sophisticated of its fruits and one that comes for free.

How admirable are the gluttons of sleep! Night after night of it, overlong, distended, unhealthily unmeasured barrels of sleep coursing through them in a feast of unconsciousness running down their chin and over their bellies. There is no end to their ability to remain crashed out. There is a dedication here, palpable in the looseness of the fingers, the limp smile of the lips. How enviable they are, not merely drowsy but flung fully into sleep, so contented and still. What is the word to utter to greet them on arrival back into wakefulness, a whisper, a nod or something requiring a dictionary of drowsy murmurs? How eloquent they are in the warmth of their gestures. The head stirs, an eye half opens. And then the head falls back, there is a look of heavy-lidded oblivion and we can hear them snoring.

Are the gluttons of sleep, these champions, aware of their outstanding ability? Are they subject to indices and audits of their capacity to ingest long stretches of time in the belly of unconsciousness? What is it about the world that there is no glittering international prize for the best sleeping by a newborn, the best sleeping by a woman, a lifetime contribution of peaceful indolence? There is no doubt that any average cataleptic will have done more for global fraternity than any of the recent winners of the Nobel Peace Prize. Perhaps we should be glad that there are no such prizes for somnolent excellence as yet. Sleep is

something held in common by hypocrites, warmongers and the as yet morally pristine as much as with anyone else.

Voluptuous inertia: the Greek statue captures some of this, in the phantasms of turbulent flesh delineated in sun-stroked marble. The sleeping human is more ungainly, more detailed, more fleshed out, inevitably. There is something about the stillness of the human assemblage of a sleeper that gathers up the capacities and interactions of its parts which goes beyond the stabilization of variables, correspondences and the 'reliable witnesses' that accompany them. This inertia has the potency of an egg, suggesting an embryology of sleep. Such a field would have implications for the patterning of sleep in a shared bed. If you are an egg, closed in and succulent unto itself, you can sleep. Uncannily, the skin fits exactly round the body: perfectly, even in old age. If you are transected by another body, even by the touch of a hand or a breath, you may awake. A problem with such a formulation however is the status of such a touch, one that can also be composed by an absence, or a thought, or what passes for one, an idea on loop. The egg in its state of pluripotent immanence is a difficult state to maintain, but it is a powerful counterprinciple to strife within a body yet complicated by the force of love across bodies.

Look at the face of Mars in Botticelli's *Venus and Mars*. Composed of glowing masses of strokes, but with the slightly iffy dental work that guarantees his place in London's National Gallery, he is thrown open yet asleep. Mars is in an egg-like state of voluptuous inertia, but perhaps the wasps buzzing round his head indicate an approaching threshold. At his other ear, a satyr with a conch blows a rough cheek-swelling note in Mars's shell-like. Repeating the trope of the sleeper

and the contemplative watcher, this painting, as previously remarked, revisits the principles of love and strife in the relation of the serenity of Venus and the sated and exhausted state of Mars. Here too there is a reversal of the frequent position in paintings of naked female and clothed male who awakens her. The playful satyr toddlers usurp the lance as an intermediary, releasing it from its proprietary composition as the instrument of the male. His armour is off, scattering the body parts of metal. The breastplate lies under him, and is being crawled through, giving a tortoise-like effect, by a satyr. The tortoise, being both stone and flesh, is an exemplary conjunction of elements, allowing for an imaginary of recomposition in play.

Except in the cave or the bunker we rarely live in an environment free of zeitgebers and distractions, openings into other arrangements. The light will change, even that from the inner glow of the figures. Hunger may stir in the serpent of their intestines. Other thresholds of event, accident and state cluster around any inert condition offering their own voluptuousness.

43. Dozy-looking

When the actor Tilda Swinton ostensibly slept in a raised glass cabinet in Cornelia Parker's installation *The Maybe* in 1995, a time, difficult to place now, before the ubiquity of what for an even briefer subsequent phase were called camera phones, it was observable that people attending the exhibition did not want to look at her face, in case she awoke or adjusted her eyelids from the masquerade or the actuality of sleep and was forced to undergo a recognition not native to that of

sleep but one that haunts its edges. Such recognition and the proliferation of those recognitions of others are what make up culture.

Celebrity, like other codes, acts like a transferential magnet, so it would not be quite Swinton one would see, but looking might impose the work of the deferral of non-attention and the implication that its inverse was wanted. The calculus of recognition would be entered into. Sleep's obliquity renders impossible the satisfaction of the hunger for clarification, for sight into the very depths of what can no longer be called a soul, direct access to the real. One is present at an intimate moment for the actor, but she is absent as an active subject, though present as an enfleshed, delicate, neatly folded entity, and clean. The cleanness is that of the well-provenanced art object, attended to by diligent operatives. There is something in the clothing, the freshness of the sheets, the regular polishing of glass that is succinct and impressive. Precise attention to the matter of a thing is one of the qualities of art, producing a situation in which one faces reality like a diamond cutter before their bench, painstakingly and minutely, with senses enhanced by lenses and by tools, approaching the flaws and robustness and singularity of a thing to release its brilliance. The diamond cutter who sleeps, who becomes their own carbon, is a miracle.

Within art the experience of sleep is something that rarely occurs. Sleep, or sleepers, may be depicted, and historically speaking they are not exactly underrepresented in the grand ages of painting and sculpture, but actual sleep as art is rarer. The possibility for such is latent however in those currents that, as Lygia Clark, the Brazilian neo-concretist who made objects to propose kinds of being and sensing, suggests, refuse 'the work of art as such' in order to 'place the

emphasis on realizing the proposition'.[193] Here we can say that the proposition is something like a dare, a challenge or an invitation to an experience.

Art is increasingly unwilling to be simply less than life. (This tendency has many aspects, one of which is the adoption or formation of artistic characters who are televisually calculated to be voluminously 'larger than life', as in the recent wave of documentary films presenting artists as heroes, or in the use of artists as agents capable, broadly speaking, of transcending or ameliorating social problems, something also partially resulting, in a certain sense, from the general thinning out of different social roles with any degree of credibility or freedom associated with them.) As art methodologies move into the everyday, which itself alters to claim and alter them, in ways not uncomplicated by the mechanisms of prestige, taste and life, they may rearrange sleep and learn from sleep in its ubiquitous non-obviousness. One thing that might be observed is that while art methodologies double life with its contemplation, it may be that the function of some art in relation to life is often to speed it up or to make it more intense, or at least more 'precious' if not tear-jerkingly self-aware. Slowing things down to the point where one becomes by and large oblivious to them may be an alternative approach to all this clutter of sensation.

It is likely indeed, that art arranged so as to be experienced, used or inhabited solely or primarily while asleep is yet to be proposed. Of what might such a thing consist?

A Tudor remedy for coping with the cohabitants of a night was to take a scrap of fur to bed with you in order to attract and draw away the bed bugs and fleas paradoxically lured by the warmth their

own bodies would bring to it. This could then be burned or washed free. Objects that are to be slept with, that tangle themselves into the experience of sleep, such as teddy bears, pyjamas, bedding would be of immediate sensory presence: lie next to such a rag of fur, on top of it, deny its pleasures to the mere insects. Soft sculptures that make alliances with body parts, long and subtle along the stretch of the body might also be invented. The thermal qualities of sleep establish other scales at which to operate. Fantastic beds, uncanny in terms of their siting or their composition, or the companionship they propose might be imagined, such as that in Keira O'Reilly's performance *Sleeping with a Pig*,[194] in which she spends a series of days and nights in a specially constructed straw-filled pen. Such a companion may be a mattress that requires a little more exercise of the capacity of balance of the sleeping being. The hammock curves inwards to hold us in place, but perhaps there might be surfaces that have a camber.

The siting of sleep as an aspect of life inimical to, or impossible in certain contexts, drives other work, here bringing the assemblage of a sleeping person into composition with other systems. Sleep, social conventions, the sets of affordances of particular pockets of space are put out of whack. Here, the interaction of the oscillators draws in other entities that may be more properly thought to be external to the configuration of the private person. Sleep, as well as being a form of withdrawal, also flows outwards. Frans Masereel's images of a city containing myriad entities coming into composition can be a guide: sleepers through a window, the rhythm of the slope of roofs, the tip of a crane in a dockyard and an argument in the street, all set out in the repetition and variation of building forms.[195] As woodcuts

these image sequences run patterns of black ink across the page, marking the interaction and similitude of parts. The harmonies of bodies composed in the admixture of love and strife run through the composition of ink and its absence, their different orders and that of the city engendering the image.

Sometimes a homeless person will sleep in a place in a city when the convention suggests that it is more likely that they will be dead than simply resting. The cultivation of a style of sleep may add to this effect. Sleeping stone still in the midst of an activity – perhaps the tip of a cigarette paper held between two fingers, the other hand become inert while plucking some threads out of the corners of a pouch – may be an effect of narcolepsy but might also raise suspicions, were anyone to notice, due to its obvious lack of attention to the world around it. The sleeper is too much of an egg, too autonomous. Sleep so urgent that it loosens one's bonds to the immediate surrounds is a form of affront to the proper order of things. Satisfaction of a base organic need in public is a form of persistence, but being overly corpse-like on a shopping street is tantamount to a crime.

Since the public domain is also one for sleepers, Sakiko Yamaoka lies down on her own in a bank foyer, watched by an accomplice with a camera in a performance called *The Best Place to Sleep*, running in a series from 2007. The performance takes place in front of a small row of ATMs. A modest figure in a coat, tucked into a corner rather than sprawling and obstructive, she lies on her side with an arm out, head on her bag.[196] The performance ends when they are politely asked to leave by a curious security guard. A parallel series (2008–9), *Come with Me*, involves participants coming together out of the crowds in

streets in places such as Ginza, the luxury shopping district of Tokyo, to lie down on street corners next to the shops of brands targeted at the wealthy. When asked to move on, the cluster of people, who lie next to each other, eyes closed and cheerful, merge with the crowds and then regroup to find the next place to lie down together. This is not sleep, not a *die-in* as of more explicit protests of previous decades, but it uses something more than an image of sleep, the postures and behaviour, lying down, closing the eyes, calming the breath, to make a public collective behaviour of something proximate to sleep.[197]

Therapeutic exercises for insomniacs often start by thinking of a certain part of the body as heavy, with sleep moving in a slow ripple out from it. Perhaps it is also possible to do this with external entities. Think of the automatic door at the entrance to a shopping arcade as weighty and somnolent and as ceasing to give service. Think of the city you are in becoming drowsy, becoming heavy, breathing.

Something related happens in Peter Handke's line 'The moment the child falls asleep her cold feet get warm (and down in the street the sidewalk is drying in the night wind).'[198] Here the parentheses mark the ligature of parts, the connected movement of the elements water and fire, the notebook's constitutive recognition of openness to the world. Cities, the sleepers that make such places, also consist of such bodies: Handke's book insists on the primacy of the particular event as the compositional force that must be attended to.[199] The singular muddles with the learned, the planted, the paved and the gardened.

In a series called *This is XX*, Chu Yun hires young women to take sleeping pills and lie down in front of a paying audience. Those who are selected and delegated to sleep are clothed and may bring books

and other objects to lie with under a duvet on the soft fresh white bed while they can be scrutinized at knee height during the opening times of the gallery.[200] The sleeping pill guarantees the production of a good object, although one that might disappear under the bedding, or hide her face under a pillow. In a related work, *The Ambien Piece*, Trajal Harrell places himself and a collaborator on a thin floor mat in a gallery.[201] What are we watching here? Simply the force of an ingested chemical manifesting on the surface of the skin as if it were the screen to which its program is printed.

The nude or sleeping figure, in earlier art, entailed the personification of allegorical virtues, and this is somewhat renewed here in these sleeping works in that the figure becomes a blank, something that is both pre-personal, onto which the viewer can project, and which is capable of being inspected with all curiosity as a singular specimen bearing its special accretion of traces of time and of the forces of parts and organs. If the work cites previous formalistically derived aspects of art, it does so in a way that frames them by the pill, in turns an anaesthetic of sorts. The allegorical virtue is thus perhaps applied to art, as something that manifests itself through attention, naming and the frame, transposed to the floor, but also as something that also pins down, makes still and alters consciousness even if in readily accessible form.

44. Licked surface

Sleep occurs in painting more than any other area of art in part because, given the presiding interest in the figure, sleep is, at least for the sake of the model, at least as likely an outcome of the form of work in certain

poses than muscular cramp in others. As the exposés of feminist art criticism have also noted, sleep with its possibility for flavouring with other tones, from the classical to the romantic or modern, gives a pretext for the pleasures and intensity of looking at bodies, imagining and experiencing them at certain degrees of both removal and unusual proximity, and in various relation to forms of imagined perfection, itself a form of rapture due to its peculiar relation to the actual. A long time ago it was possible for Marcel Duchamp to cause a scandal by having the nude rise to descend a staircase. The sleeping nude, is an ideal that becomes normative and laughably kitsch, but perhaps we should look at not what such paintings say about bodies pertaining to the passing notions of a particular gender, but what they say about sleep which is more enduring.

45. Waking up

One of my neighbours has set himself the task of translating the words of *The Internationale* into a sufficient number of hitherto non-existent languages and performing the anthem every day in each one, to ensure that the anthem is now sung in more languages than it is not. It is not clear whether each language pertains to a particular time zone or whether there are just variously accented mumbles throughout the night. In the flat below this, a family whose male head at the time would come back from work every morning at around 4 a.m. and play the electric guitar. Every night he would play one song and wake that column of flats up, the others being insulated by a stairwell. I could never recognize the song and never woke up sufficiently to know it, though every night it would wake me. He did this for a few

months, and then gave up. Now I wonder whether he was asleep and struggling to remember a song he had dreamt up. It might have been his ticket out of there, but it is unlikely.

You wake up because the sound of the termites or woodworm that have been persistently chewing at your house has suddenly stopped. This happens in Bela Tarr's film *A Turin Horse*. The horse stops eating, the wind becomes permanent, darkness never abates and the digestive tract of the worms ceases its squeezing. It is a sullen confirmation that the end of the world is coming on schedule.

46. Equipment

Related to the question of how sleep is unknowable, and hence unreflexive, is the development of equipment for sleep. Sleeping people do not design earplugs, beds, headrests, eye coverings, pills, sleeping bags and potions, yet all of these things are made to act on sleep and in the moment of sleep, at which point they are unknowable. But there is a groping form of knowing in the way that nests are folded, duvets and blankets rucked and tangled. What kind of apparatus can sleep produce in this moving, alleviating and knotting of things? Sleepers may move twenty to sixty times a night. Such movements may include shifting a pillow to a certain height, moving or rolling it to a cooler patch. Here, there is a mode of design of space peculiar to sleep. It is limited to minor gestures, the turning to one side to avoid an unpleasant partner or a wriggling child, the inhabitation of the edge of a mattress to avoid the sagging parts and insurgent springs, or sprawling to gain sufficiently maximal space. If the surrealists aimed

towards trance states for automatic writing and drawing, here, at a deeper level of unconsciousness is a form of automatic design.

A patch of grass retains a hare's form. A space is left bowed in swirls by lying bodies that seem to have been, in the remains of their sprawlings, larger than human. Aids to design of this kind include polyethylene terephthalate bladders of apple residue-scented ethanol sieved with bubbles of assorted sizes. Cider-aided design renders all situations liveable. That is to say nothing of pyjamas.

In *Dreaming of a Butterfly*, a delicate, detailed painting of lines and washes by Liu Guandao, a court painter of Kublai Khan in the latter half of the thirteenth century, we see another figure, a scholar in repose, surrounded by the paraphernalia of sleep and waking activities. Here, due also perhaps to the length of the painting, with everything stretched out in the sweet aroma of the pine branches that hang down over the upper parts of the paper, there is a golden ease.

The refined desk, neat stacks of books, two brushes for calligraphy set in their rests, a vase with a complex flower, and other vessels. On the rough-edged wooden platform that serves as a bed there are more books in a neat stack, two scrolls and a mandolin. The man's legs lie in two open curves, one foot on the platform obscured from view by the hang of his loose and elaborately edged robes, the other foot resting its upper side on a bamboo foot rest, its sole addressing the sky. One hand draped over the handle of a delicate fan that rests on his abdomen, the other raised to his breast, the man's head lies with great ease on a miniature leather stretcher or trestle. A water basin sits nearby on some poles with a bucket should it need to be refilled. Also ready is a servant boy who attends in sleep, arms wrapped round his legs, head

on his chest and tucked under a nearby tree. His sleep is as a part of the master's paraphernalia but also as the means to activate these objects.

The couch is a repeated site of contemplation for Liu Guandao, as can be seen in another painting of a similar style, *Cooling from the Summer Heat*, where a man reclines on one in front of a screen depicting a man seated on a similar platform.[202] Here too he is attended, but by two younger women, and the paraphernalia is related but multiplied. A large barrel-shaped cushion replaces the headrest, and the slippers are given their own platform next to the bed. In the picture on the screen, the man sits upright, attended by a boy. Perhaps he is making a pronouncement to two slightly bowing figures to the side. The painting of a landscape sits within this image, echoing the clusters of foliage in the first. Sleep is deeply in among the active world, not set aside, even in different furniture. Paraphernalia mark and make its transitions and lie close at hand so that the transition between sleep, thought and writing, reading, music and discourse is close. Where sleep is a pleasure that is in some sense only indirectly experienced it is intensified and exemplified by its equipment.

Henry David Thoreau's journal aphorism 'how vain it is to sit down to write when you have not stood up to live' has a nice ring to it, but it sounds like he needs a good lie down. There is too much emphasis on verticality in the city anyway. The only reason to be perpetually on one's feet is for lack of space due to density of population, such as in the train at rush hour. At other times it is appropriate and pleasant to take a rest in the luggage racks.

Just as they involute, sleepers proliferate things and requirements on them and others: the equipment of sleepers can also be seen in a chain

of objects outside them. Sleeping may be almost autonomous an act, or it may hinge on a network of relations to other objects, processes and their stabilization. In a classic Dutch interior from seventeenth-century Leiden, Quiringh van Brekelenkam's *Woman Asleep by a Fire* (1648) has the subject, asleep at a book, tucked in between a small fire and a side table laden with bread, cheese and butter, her feet resting on a small wooden frame containing a ceramic foot heater. The Dutch urban interior of this period, as a series of boxes within boxes to retain heat and move light, included beds set into cabinets in walls, and in the houses of the sufficiently wealthy, lined rooms to hide from the winter. Here, the baroque physics of the architecture of thermal comfort did battle with the more renowned transparency of Calvinism and its predilection for large windows to display what could be passed as the innards of the house. Sleep involves both a coiling inwards and a sprawling outwards in heated, fresh or conditioned air.

In thinking about the equipment of sleep, one hesitates to recall the class dimension, but then the word is all over it, of sleep on aeroplanes. Rather the display and enjoyment of the understanding of what is assumed to be the preconditions for sleep: space, horizontality, moderately nourishing or passably non-toxic food, warmth, relative silence and lack of obligation to move for fellow passengers, assume a dimension that is indexed indubitably to money. For the rest of us, Valium or valerian, eyes masks, earplugs and other equipment, or sheer patience, become substitutes for the upgrade and offer lethargy as a means of routing round the immediate need for class struggle that, like everywhere else is too readily diagrammed in space.

But sleep above the heads of the suffering compressed masses is an ancient privilege. Juvenal, the wry and scornful documenter of late Rome, writes of the elite carried in litters, able to read, take notes or sleep while four slaves heft them smoothly down the perilous and jammed street.[203] The image of the sublime rest of the luckily or cunningly elevated dozing sea cow of an emperor, a state attained while all around is mayhem and misrule, gives a precise edge to Juvenal's merry filleting of his city at its apex. Those sleeping further above, on the jerry-built floors of the endlessly extended housing blocks, subject to fire and collapse, are gripped by an insomnia that seems remarkably contemporary, but yet that has its own historically precise quality.

47. Sleep upright in order to avoid death

Disturbingly independent of all such structures, the witch Baba Yaga sleeps in a tiny hut on legs – nose crammed to the ceiling, arms pressed to the sides, head to the front wall, feet to the back wall. The hut is her vehicle, a child-eater's enticing and frightening trap, as much as it is her couch, her kitchen and, most especially as the walls close in, her coffin. The hut, which reeks of the relics of death and crawls with magically mobile part objects, is a place where people are sent as a trick aimed at their cannibalization by the witch.[204] But, for some visitors to the hut, as in the story of Raisa, who is aided in finding her lost lover, Finist the Bright Falcon, by three crones, incarnations of Baba Yaga, this hell hole is a safe place to sleep, like a child lying down to rest under the

axles of a massive truck. Finist, many countries away, and who has since become engaged, is in turn drugged to sleep by his deceitful fiancée in order to be rendered as an object pliant to her will each time the cunning Raisa gains access to the chamber. For him, sleep is the sharpest point of danger. In these tales sleep's proximity to death gives it an uncanny character. It appears as a means of escaping a trap, as a place of safety and of power, but it also becomes the point at which, in the state of the human as object, cunning can be wrought around the body of the sleeper.

What might sleep have meant to the listeners to these tales before their oral culture was turned into books? During the harvest, peasants sometimes collapse and lie exhausted in the fields, setting no time aside for sleep but falling when their body demands or is overtaken by it. Sleep takes on a timing that is distinct from circadian rhythm but produced by the annually throbbing abundance of the earth when days and nights of exhaustion make a change from days of drudgery. There is so much work to be done gathering the flesh of the soil before it withers that babies are left unguarded, to occasionally be eaten by dogs or other predators. Sleep is impossible because there is so much work to be done. It may take you at any moment, depriving the family of your labour, and the future days or weeks of food it would afford in the work you might have done. Sleep now and you will surely die later, lazybones.

Going further even than the body-experimenter Descartes in his appetite to distinguish the mind from its mere vehicle, in the film *I Robot*, (drawing on the novels by Arthur C. Clarke), sleep is something that a robot cannot do. People sleep, dogs sleep, but not machines. This is

part of their torment and of their superiority, and the film's theme, how to escape from one's hard-coded imperatives, by luck, force of will, or through the contradictory interaction of rules and contexts, provides an analogue to the refusal of sleep. Sleep finds itself posed as a problem too in early plans for artificial intelligence. In Warren McCulloch and Walter Pitts's famous argument that the structure of the nervous system, including the brain, is formally equivalent to a dynamic network of logical propositions, the idea that an organism can emerge from sleep (as from anaesthesia, convulsions or coma) and maintain what it has learned is of some interest to them.[205] Why does one recur after a period in which the brain devolves to a lower level of activity? The gradual lighting up of a network out of lower-level stirrings is the soup out of which a consciousness evolves: the procedural opposite of the manager of the Café Mably in Jean-Paul Sartre's *Nausea* whose head, when the café empties of customers, making him lonely, becomes void and he sleeps.[206]

48. Go to Guildhall Museum and look at the clocks

There is something great, even democratic for all the falsity of that word, about the waves of night and of sleep running through the globe. Sleep is a planetary phenomenon, articulated variously in different species, a great quietening of breaths and, for some species, a chance to operate. For Leibniz, thinker of the great flows and entanglements of being in *Monadology*, sleep as a lesser mode of consciousness or apperception, is, like them, something 'not given to all souls, and is

not given to particular souls all the time,'[207] a grounds in turn for the belief among his predecessors in rationalist thought that sleep is a form of death. Consciousness pulses through the regions of the earth, synchronized to light. The planet, in its state of rolling light, becomes a space of an unconscious multitude throbbing with the vitality and variousness of its kinds.

This rhythm is reciprocated in counterpoint in certain sectors of the globe with long throbs of gridded electricity for lighting, means of avoiding sleep, kerosene lamps, candles and fires. The latter is to keep what is awake away from those who are sleeping, the flames of candles and lamps drawing moths to them as an imagined sun, one that is too close to navigate by.

49. Animal sleep

Pippi Longstocking sleeps upside down, with her feet resting delicately exposed on the pillow at the head of the bed and the rest of her smothered in the blanket.[208] Such an anarchist may be rendered immobile by too much empathy, trying to take too much into consideration in its particularity, but they may also be full of a lively animality that makes things around them release themselves from preformatting. Heads are for cracking eggs with, soap may also be strapped to shoes and slid on, windows make excellent doors and the adventurer shows us that there is no universal anatomy of sleep. In Empedocles too the animal is commensurate with the human or with any other composition the interaction of the elements and forces might take. Animal sleep therefore is part of the interplay of sleep and

may well become manifest in that to be categorized at some time or other as human. At other times it is to be learned from as an art.

The albatross, for instance, flies for such an extended period of time that it stays aloft while sleeping first in one part of the brain then the other. Such unihemispherical sleep is something that is also found in cetaceans. In land-borne mammals breathing is a reflex, while in dolphins and whales and other descendants of mammals that returned to the water, it is necessarily consciously controlled, as for it to be otherwise would imply drowning. In mammals in such extreme conditions, then, the requirement for sleep fundamentally rearranges the capacities of the body.[209]

Equally, different anatomies of sleep spread out and reconfigure relations to the city. Tarmac, for its heat-absorbent qualities, is a beneficent place to sleep for animals, storing warmth from the day and providing a modicum of danger. Just as the bed is a place of horizontality, the road rolls on over the horizon. Find a car with a still-warm engine to loll under.

50. Wrap up warm

Is it possible to come up upon an animal in its sleep and to kill it for its flesh? Perhaps solely a domesticated animal or a sick one. Sleep is already attuned to flight from predators, so to switch from one mode to another does not entirely require a leap. Notable however is a species of tiny slow-moving mite that lives among humans. They are by and large harmless, taking the merest sips of blood even when they are most excited. What makes them unusual is their possible exhibition

of a degree of telepathy. In fact they are entirely capable of reading the thoughts of any human they are within ten metres distance of. Indeed, they do not so much read the minds of humans as undergo the state of mind of any human that they are in closest proximity to. The sleep of a human provides the only time when these mites are able to move around without undergoing such traumatic mental effects. Possibly the most disturbing of these is when a person recognizes the tiny speck of the mite, perhaps by a shadow thrown and grown monstrous by occasional lighting, and the mite tries to move off. Tectonically slow, especially for its size, it is unable to escape as the mentations of the human about to crush it become paralysingly apparent. The human is blasé to their high-fidelity echo in the mind of the insect. One should be careful in writing or thinking about such things due to the dangers of recursive loops: in case one really sees the mite at the same time that it sees you.

Over the course of its history, notes Kenton Kroker, sleep medicine moved from introspection to the adoption and invention of quantitative methods, evidence and instruments.[210] At the same time, since its object is also the sleeping person as well as the aggregate of chemicals yielding samples, organs leaving traces of electrical action or of excreta, registrations of actions over time, it maintains in turn an oblique relation to the question of *subjectivation*, of becoming. Introspection, alongside speculation and the vigour of lived cynicism, was an early method of natural philosophy. It is certainly something often better done in collaboration with machines, laboratories and tight scrutiny, since these provide a means of problematizing, and indeed extending Glissant's recognition of the opacity of self-on-self

thought. But there is something in the force of sleep that exceeds and demands more than such a condition.

In both her philosophical figuration of the nomad and in the exploration of the post-human, Rosi Braidotti calls for a real 'materialism of the flesh',[211] in which 'matter is not dialectically opposed to culture, nor to technological mediation, but continuous with them'.[212] Sleep here is a-subjective matter that fritters and shifts within itself, and that, depending on the concurrence of various forces, coheres as a subject, an experimental trait, a modality of love, a sweet escape, the patterning of dots on a graph and a cycle of biological force.

In her commentary on the Empedoclean fragments, Rosemary Wright notes how ancient Greek painting worked with combinations of colours to reflect on a simile regarding the combinatoriality of matter offered by Empedocles to describe the way greater proportions of elements may come together for different effects.[213] The mixture of colours, with strokes placed side by side, or layered in washes, created the optical effects of whole fields or parts, without fully merging the paints. Rather than being entirely mixed, black, white, red ochre and yellow ochre were placed in adjacent patterns of pure colour to create the desired effects, patterns or images.[214] Empedocles's formulation becomes active too as recognition of the immediately aesthetic aspect of the activity of matter.[215] The compositional force of art amplifies and makes curious the Empedoclean body that is shifting, revelatory, voluptuous, carnal, indifferent, technical. It is sensuality, art, flesh and science acting on and through each other in ways that render, in full force of deliciousness and dread, the thick seams of unconsciousness that run through and constitute life.

NOTES

1 René Descartes, *Meditations on First Philosophy*, trans. John Cottingham (Cambridge: Cambridge University Press, 1997).
2 Lars Iyer, *Spurious* (Brooklyn: Melville House, 2011); Lars Iyer, *Dogma* (Brooklyn: Melville House, 2012); Lars Iyer, *Exodus* (Brooklyn: Melville House, 2013).
3 Simondon uses this figure in the discussion of Augustine. Gilbert Simondon, *Two Lessons on Animal and Man*, trans. Drew S. Burk (Minneapolis: Univocal, 2013), p. 64.
4 The argument for sleep, along with deception and insanity, as evidence of being, is initiated in Augustine of Hippo, *Against the Academicians*, trans. Peter King (Indianapolis: Hackett, 1995), and developed in Augustine, *The Trinity, books 8–15*, trans. Stephen McKenna (Cambridge: Cambridge University Press, 2002).
5 Christine Brooke-Rose, *Remake* (Manchester: Carcanet, 1996).
6 J. M. Barrie, *Peter Pan, or The Boy Who Wouldn't Grow Up* (London: Hodder & Stoughton, 1911). Peter Schwenger draws up a rich literary history of hypnagogia, drowsiness and insomnia in *At the Borders of Sleep, on Liminal Literature* (Minneapolis: University of Minnesota Press, 2012).
7 The situation seems to be a persistent one since Samuel Johnson notes much the same at the outset of his 'Encomium on Sleep', *The Adventurer*, no. 39, London, 20 March 1753.
8 Laurie Anderson, *Institutional Dream Series, 1972–3*.
9 Michel Serres, *Variations on the Body*, trans. Randolph Burks (Minneapolis: Univocal Press, 2011), p. 9.
10 For a range of anthropological and cultural approaches to different territories and sleep, see Lodewijk Brunt and Brigitte Steger, eds., *Worlds of Sleep* (Berlin: Frank & Timme, 2008).
11 Mikhail Bakhtin, 'Forms of Time and of the Chronotope in the Novel', in *The Dialogic Imagination*, trans. Caryl Emerson and Michael Holquist, ed. Michael Holquist (Austin: University of Texas Press, 1981), p. 84.
12 That paradox coming down to the statement 'This sentence is false.'
13 Édouard Glissant, *Poetics of Relation*, trans. Betsy Wing (Ann Arbor: University of Michigan Press, 1997), p. 192.
14 Rosi Braidotti, *The Posthuman* (Cambridge: Polity Press, 2013).

15 Otto Mayr, *Authority, Liberty and Automatic Machinery in Early Modern Europe* (Baltimore: John Hopkins University Press, 1986).
16 Related measures for the protection of democracy include those specific to the environs of Parliament Square in London, notably prohibitions on sleeping equipment, 'any sleeping bag, mattress or other similar item designed, or adapted, (solely or mainly) for the purpose of facilitating sleeping in a place'. Established under the Police Reform and Social Responsibility Act 2011, Part 3, Section 142, clause 7 were revisions and extensions of measures originally, and unsuccessfully, brought in under the Serious Organised Crime and Police Act 2005 against the long encamped anti-war protest led by Brian Haw. These measures were subsequently used on other protesters, such as Occupy Democracy of October 2014.
17 *Manchester Guardian Bulletin*, 6 May 1926.
18 Franz Kafka, *The Castle*, trans. Mark Harman (New York: Schocken, 1998).
19 Aristotle, 'On Sleep and Waking', in *Aristotle VIII*, trans. W. S. Hett, Loeb Classical Library, (Cambridge, MA: Harvard University Press, 1957), p. 321.
20 A. Roger Ekirch, *At Day's Close, Night in Times Past* (New York: W. W. Norton, 2006).
21 Ekirch draws on the sleep experiments of Thomas Wehr, who independently produced such conditions. See, for example, Thomas A. Wehr, 'In Short Photoperiods Human Sleep Is Polyphasic', *Journal of Sleep Research*, vol. 1, no. 2 (1992): pp. 103–107.
22 For a discussion of the history of 'nocturnalization', see Craig Koslofsky, *Evening's Empire: A History of the Night in Early Modern Europe* (Cambridge: Cambridge University Press, 2011).
23 Sukhdev Sandu, *Night Haunts: A Journey through the London Night* (London: Verso, 2010).
24 The motility sensor is now more often replaced by an actigraph, a motion-sensing and recording device attached to a limb. The accelerometer in recent mobile phones also allows them to be used for this purpose.
25 Nathaniel Kleitman, *Sleep and Wakefulness* (Chicago: University of Chicago Press, 1939), p. 260. Mammoth Cave later formed the template for the cave structure of the first text-based adventure game, 'Adventure' programmed in 1976–77 for the PDP-10.
26 In the earlier experiment mentioned below, Richardson was unable to maintain a twenty-eight-hour cycle and carry on with his laboratory work and study obligations. Ibid., pp. 258–259.
27 Horace McCoy, *They Shoot Horses Don't They?* (New York: Simon and Schuster, 1935).
28 See Jürgen Aschoff, 'Circadian Rhythms in Man', *Science* no. 148 (1965): pp. 1427–1432.

29 Kleitman, *Sleep and Wakefulness*, p. 193.
30 Ibid., p. 266.
31 See Joshua Foer, 'Caveman: An Interview with Michel Siffre', *Cabinet* no. 30, Summer 2008, http://www.cabinetmagazine.org/issues/30/foer.php. Michel Siffre, *Beyond Time*, trans., Herma Briffault (London: Chatto & Windus, 1965). See also Paul Virilio's comments on Siffre as a parallel to his architecture, in Paul Virilio and Sylvere Lotringer, *Crepuscular Dawn* (New York: Semiotext(e), 2002), pp. 41–42. Siffre's later endurance marathon in Midnight Cave in Texas is recalled in Michel Siffre, 'Six Months Alone in a Cave', *National Geographic*, March 1975, pp. 426–435.
32 The presently established average is twenty-four hours and eleven minutes.
33 The close affinity between geological exploration and sodden sleeping bags is explored further in Willem Frederick Hermans, *Nooit Meer Slapen* (Amsterdam: De Bezige Bei, 2003), translated as *Beyond Sleep*, trans. Ina Rilke (Woodstock: The Overlook Press, 2007).
34 Siffre, *Beyond Time*, p. 194.
35 William Wordsworth, 'To Sleep', 1806.
36 Samuel Beckett, 'The Calmative', in *Three Novellas* (London: Calder, 1999), p. 38.
37 Sigmund Freud, 'On the Interpretation of Dreams', in *The Standard Edition of the Complete Psychological Works*, trans. James Strachey, in collaboration with Anna Freud, assisted by Alix Strachey and Alan Tyson (London: Hogarth Press, 1953).
38 Jacqueline Rose notes Freud's vacillatory prohibition on talking about sleep made at the beginning of *The Interpretation of Dreams*, in the essay 'On Not Being Able to Sleep', in *On Not Being Able to Sleep: Psychoanalysis and the Modern World* (London: Vintage, 2004), pp. 105–124. André Breton's account of their encounter is given in André Breton, 'Interview with Doctor Freud', in *The Lost Steps*, trans. Mark Polizzotti (Lincoln: University of Nebraska Press, 1996).
39 An exemplary history of sleep science, including the institutional take-up of the electroencephalogram (EEG), is given by Kenton Kroker, *The Sleep of Others and the Transformations of Sleep Research* (Toronto: University of Toronto Press, 2007).
40 Ibid.
41 Isabelle Stengers, *Cosmopolitics, Volume 1*, trans. Robert Bononno (Minneapolis: University of Minnesota Press, 2010), p. 92.
42 Jonathan Crary, *24/7* (London: Verso, 2013); Alexei Penzin, 'Sleep, Capitalism and Subjectivity', in *Subverting Disambiguities*, ed. Anke Hoffman and Yvonne Volkart (Zurich: Verein Shedhalle, 2012); and Alexei Penzin, *Rex Exsomnis: Sleep and Subjectivity in Capitalist Modernity*. Documenta

13, 100 Notes, 100 Thoughts (Ostfildern: Hatje Cantz, 2012); Matthew J. Wolf-Meyer, *The Slumbering Masses: Sleep, Medicine and Modern American Life* (Minneapolis: University of Minnesota Press, 2012); Simon Williams, *The Politics of Sleep: Governing (Un)consciousness in the Late Modern Age* (London: Palgrave, 2011).

43 A typology for such action drawing on a survey of social theory and sleep is set out by Arber, Meadows and Venn, who describe four modes of action on sleep: '1. The shift from public to private sleeping, 2. The relationship between work and sleep, 3. Sleep within consumer societies, 4. The medicalization of sleep.' Sara Arber, Robert Meadows and Susan Venn, 'Sleep and Society', in *The Oxford Handbook of Sleep and Sleep Disorders*, ed. Charles M. Morin and Colin A. Espie (Oxford: Oxford University Press, 2012), pp. 223–247.

44 Gilles Deleuze and Félix Guattari, *A Thousand Plateaus: Capitalism and Schizophrenia, Volume 2*, trans. Brian Massumi (London: Athlone, 1988).

45 Heraclitus, *Fragments*, trans. Brooks Haxton (London: Penguin, 2001).

46 See Derk-Jan Dijk and Alpar S. Lazar, 'The Regulation of Human Sleep and Wakefulness: Sleep Homeostasis and Circadian Rhythmicity', in Morin and Espie, *Oxford Handbook of Sleep and Sleep Disorders*, pp. 38–60.

47 Tom Crook, 'Norms, Forms and Beds: Spatialising Sleep in Victorian Britain', *Body and Society: Special Edition on Sleeping Bodies* vol. 14, no. 4 (2008): pp. 15–36. See also, for a differentiation between regimes of sleep improvement coded in terms of habit (individual and subject based) and hygiene (population level), Matthew Wolf-Meyer, 'The Nature of Sleep', *Comparative Studies in Society and History* vol. 54, no. 4 (2011): pp. 945–970.

48 Barrie, *Peter Pan*.

49 Octave Mirbeau, *Torture Garden*, trans. Michael Richardson (London: Daedalus, 1999).

50 Hans Berger, *Hans Berger on the Electroencephalogram of Man: The Fourteen Original Reports on the Human Electroencephalogram*, trans. and ed. by Pierre Gloor, *Electroencophalography and Clinical Neurophysiology*, supplement no. 28 (Amsterdam: Elsevier, 1969). Paul Achermann and Alexander A. Borbély, 'Low Frequency (<1Hz) Oscillations in the Human Sleep Encephalogram', *Neuroscience* vol. 81, no. 1 (1997): pp. 213–222.

51 See in particular chapter 6 of Kroker.

52 Pierre Gloor, 'Hans Berger and the Discovery of the Encephalogram', introduction to Berger, *Hans Berger on the Electroencephalogram of Man*, p. 1.

53 As a young soldier, in 1893, Berger had experienced a bad accident at exactly the same time as his sister expressed the certain knowledge that her brother was in mortal danger, compelling their father to send him a telegram enquiring after his son's health.

54 Isabelle Stengers's notion of an ecology of practices and Andrew Pickering's formulation of the mangle are useful points of reference here. Isabelle Stengers, *Cosmopolitics 1* (Minneapolis: University of Minnesota Press, 2010) and Isabelle Stengers, *Cosmopolitics 2* (Minneapolis: University of Minnesota Press, 2011). Andrew Pickering, *The Mangle of Practice: Time, Agency and Science* (Chicago: University of Chicago Press, 1995).
55 E. Adrian and B. H. C. Matthews, 'The Berger Rhythm: Potential Changes in the Occipital Lobes in Man', *Brain* vol. 57, no. 4 (1934): pp. 355–385.
56 Alexander A. Borbély, 'A Two-Process Model of Sleep Regulation', *Human Neurobiology* vol. 1, no. 3 (1982): pp. 195–204. A prior, but unrelated, suggestion of sleep being produced by two interacting systems is made by E. Brouwer, 'Harmonische Analyse van temperatuurcurven', *Nederlandsche Tijdschrift van Geneeskunde* no. 74 (1928): pp. 68–85. The first system consisted of a combination of the effects of food intake, muscular and intellectual work, and waking and sleeping. The second factor, whose contours were mapped by Brouwer, was unknown but shown by the formulae. Brouwer's work remains a tantalizing aporia in the history of sleep science. Kleitman, *Sleep and Wakefulness* (1939), pp. 198–199, discounts Brouwer's model as being unnecessarily complex, and it is not included in the extensively revised second edition of *Sleep and Wakefulness* (1963).
57 The cybernetic term of the governor is not accidental to this discourse. Sleep science, as with cybernetics, emerges in part through an attempt to get 'inside' the organisms to, in the terms of the Macy Conferences, the underlying physiological mechanisms deemed sealed off by behaviourism. See Andrew Pickering, *The Cybernetic Brain* (Chicago: University of Chicago Press, 2011).
58 Paul Achermann and Alexander Borbély, 'Simulation of Daytime Vigilance by the Additive Interaction of a Homeostatic and a Circadian Process', *Biological Cybernetics* no. 71 (1994): pp. 115–121.
59 For an exploration, see Steven H. Strogatz, *The Mathematical Structure of the Human Sleep-Wake Cycle*, Lecture Notes in Biomathematics no. 69 (Berlin: Springer, 1986).
60 Adrian Mackenzie, *Transduction, Bodies and Machines at Speed* (London: Continuum, 2002).
61 *Journal of Biological Rhythms* vol. 28, no. 3 (2013).
62 Derk-Jan Dijk and Malcolm von Schantz, 'Timing and Consolidation of Human Sleep, Wakefulness, and Performance by a Symphony of Oscillators', *Journal of Biological Rhythms* 20 (2005): pp. 279–290.
63 See Henri Lefebvre, *Rhythmanalysis: Space, Time and Everyday Life*, trans. Stuart Elden and Gerald Moore (London: Continuum, 2004); Steve Goodman, *Sonic Warfare: Sound, Affect and the Ecology of Fear* (Cambridge, MA: MIT Press, 2009).

64 Jean-Luc Nancy, *The Fall of Sleep*, trans. Charlotte Mandell (New York: Fordham University Press, 2009).
65 Victoria C. Chang and Steven J. Frucht, 'Current Treatment Options in Neurology', *Myoclonus* vol. 10, no. 3 (2008): pp. 222–229.
66 F. L. Coolidge, *Dream Interpretation as a Psychotherapeutic Technique* (London: Radcliffe, 2006).
67 T. A. Nielsen and A. Zadra, 'Nightmares and Other Common Dream Disturbances', in *Principles and Practice of Sleep Medicine*, ed. M. H. Kryger, T. Roth and W. C. Dement (Philadelphia: Elsevier Saunders, 2005), pp. 926–935.
68 This version of the phenomenon is called 'benign sleep myoclonus of infancy'. See D. L. Coulter and R. J. Allen, 'Benign Neonatal Sleep Myoclonus', *Archives of Neurology* no. 39 (1982): pp. 191–192.
69 Empedocles, Fragment 50 (57), from M. R. Wright, *Empedocles, The Extant Fragments* (Bristol: Bristol Classics Press, 2001).
70 Ibid., 52 (61).
71 Ibid., 53 (62).
72 Christine Brooke-Rose, *Life, End Of* (Manchester: Carcanet, 2006).
73 For an account of the body assessed by multiple perspectival mechanisms for atherosclerosis, see also Annemarie Mol, *The Body Multiple: Ontology in Medical Practice* (Durham, NC: Duke University Press, 2013).
74 Henri Lefebvre, *Rhythmanalysis: Space Time and Everyday Life*, trans. Stuart Elden and Gerald Moore (London: Continuum, 2004).
75 Charlotte Bates, 'Vital Bodies: A Visual Sociology of Health and Illness in Everyday Life' (PhD diss., Goldsmiths, University of London, 2011), p.109. Available at: http://eprints.gold.ac.uk/6373/.
76 Aetius, cited in M. R. Wright, introduction to *Empedocles: The Extant Fragments* (Bristol: Bristol Classics Press, 2001), p. 13.
77 See Annie Vallières and Emmanuelle Bastille-Denis, 'Circadian Rhythm Disorders II: Shift Work', in Morin and Espie, *Oxford Handbook of Sleep and Sleep Disorders*, pp. 626–647.
78 Jean-Luc Nancy, *The Fall of Sleep*, trans. Charlotte Manell (New York: Fordham University Press), p. 13. A discussion of this and a series of other philosophical encounters with sleep can be found in Simon Morgan Wortham, *The Poetics of Sleep, from Aristotle to Nancy*, (London: Bloomsbury, 2013).
79 Various kind of birds, reptiles, fish and amphibians have photoreceptors in the brain. Lockley Steven Lockley & Russell Foster, *Sleep: A Very Short Introduction*, (Oxford: Oxford University Press; 2012), p. 43.
80 Georges Bataille, 'The Pineal Eye', in *Visions of Excess: Selected Writings, 1927-1939*, ed. Allan Stoekl, trans. Carl R. Lovitt and Donald M. Leslie Jr. (Minneapolis: University of Minnesota Press, 1985), pp. 79–90.

81 G. W. Leibniz, 'Monadology', §18, in *G. W. Leibniz: Philosophical Texts*, trans. R. S. Woolhouse and Richard Francks (Oxford: Oxford University Press, 1998).
82 Ibid., §24.
83 Beatriz Preciado, 'The Contra-Sexual Manifesto', *Total Art Journal* vol. 1, no. 1 (2011): pp. 2–6.
84 Alexander Trocchi, *Cain's Book* (London: John Calder, 1963). Related to the Soviet move to inner migration, Trocchi became an early advocate of disengagement from mainstream social forms, via the establishment of Project Sigma, among other things, and suggested the term 'cosmonaut of inner space'. *Invisible Insurrection of a Million Minds: A Trocchi Reader*, ed. Andrew Morray Scott (Edinburgh: Polygon, 1991).
85 For a useful survey of the debate in biological and cultural anthropology and feminist theory, see Carol M. Worthman, 'Hormones, Sex and Gender', *Annual Review of Anthropology* vol. 24 (1995): pp. 593–617.
86 Beatriz Preciado, *Testo-Junkie: Sex, Drugs and Biopolitics in the Pharmacopornographic Era*, trans. Bruce Benderson (New York: Feminist Press, 2013).
87 Nelly Oudshoorn, *Beyond the Natural Body: An Archaeology of Sex Hormones* (London: Routledge, 1994).
88 Preciado, *Testo-Junkie*, p. 377.
89 Ibid., p. 137.
90 Huppi et al., USA Patent 6,658,577 B2, Breathing Status LED Indicator, 2 December 2003.
91 Félix Guattari, *The Machinic Unconscious: Essays in Schizoanalysis*, trans. Taylor Adkins (Los Angeles: Semiotext(e), , 2011).
92 For an overview of the effects of exogenous melatonin, see Derk-Jan Dijk and Christian Cajochen, 'Melatonin and the Circadian Regulation of Sleep Initiation, Consolidation, Structure and Sleep EEG', *Journal of Biological Rhythms* vol. 12, no. 6 (1997): pp. 627–635.
93 Leibniz, *Monadology*, §30.
94 See Paul David Pearson, *Alvar Aalto and the International Style* (New York: Whitney Library of Design, 1978).
95 National Board of Antiquities, *Nomination of Paimio Hospital for Inclusion in the World Heritage List* (Helsinki: National Board of Antiquities, 2005).
96 See Sven Olov Wallenstein, *Biopolitics and the Emergence of Modern Architecture* (Princeton, NJ: Architectural Press, 2009).
97 See, for instance, an analysis of endogenous circatidal rhythm in the speckled sea-louse, (Eurydice pulchra): M. H. Hastings, 'Semi-Lunar Variations of Circa-tidal Rhythms of Activity and Respiration in the Isopod Eurydice Pulchra', *Marine Ecology Progress Series* vol. 4 (1981): pp. 85–90. For a

discussion of lunar influence on human sleep, see Christian Cajochen et al., 'Evidence That Lunar Cycles Influence Human Sleep', *Current Biology* vol. 25, no. 15 (2013): pp. 1485–1488.
98 Stephen Jay Gould, *Wonderful Life: The Burgess Shale and the Nature of History* (London: Vintage, 2000), p. 14.
99 Leo W. Buss, *The Evolution of Individuality* (Princeton, NJ: Princeton University Press, 1987); Luciana Parisi, *Abstract Sex: Philosophy, Bio-Technology and the Mutations of Desire* (London: Continuum, 2004).
100 The question of what entities, such as genes, individuals or species, act as effective, even primary, units of selection for evolutionary processes has been crucial to the history of evolutionary theory and the modes of thought and experiment adequate to recognizing, producing and entering into composition with them. See Ernst Mayr, *The Growth of Biological Thought: Diversity, Evolution and Inheritance* (Cambridge, MA: Harvard University Press, 1982); Isabelle Stengers, *Cosmopolitics*, vols. 1 and 2 (Minneapolis: University of Minnesota Press, Minneapolis, 2011); Steven Jay Gould, *The Structure of Evolutionary Theory* (Princeton, NJ: Belknap Press, 2002).
101 See Till Roenneberg's work on bioluminescent sea alga, *Lingulodinium polyedrum*. Till Roenneberg, *Internal Time: Chronotypes, Jet Lag and Why You're So Tired* (Cambridge, MA: Harvard University Press, 2012).
102 Alfred I. Tauber, 'The Immune System and Its Ecology', *Philosophy of Science* no. 75 (2008): pp. 224–245, p. 4.
103 Longus, *Daphnis and Chloe* (London: Penguin, 1989) p. 36.
104 Longus, *Daphnis and Chloe*, p. 75.
105 Andre Breton, 'Disdainful Confession', in *The Lost Steps*, trans. Mark Polizzotti (Lincoln: University of Nebraska Press, 1996), p. 4.
106 Beatriz Colomina, *Privacy and Publicity: Modern Architecture as Mass Media* (Cambridge, MA: MIT Press, 1994).
107 Yingmei Duan, *Sleeping*, shown in *Art of Change: New Directions from China*, Hayward Gallery, London, September–December 2012. See also http://www.yingmei-art.com/en/works/sleeping/
108 The figure of the vulnerable sleeper, in Gabrielle Klug, 'Dangerous Doze: Sleep and Vulnerability in Mediaeval German Literature', in *Worlds of Sleep*, ed. Lodewijk Brunt and Brigitte Steger (Berlin: Frank & Timme, 2008), pp. 31–52.
109 Max Weber, *The Protestant Ethic and The Spirit of Capitalism* (New York: Dover, 2003).
110 Lucius Annaeus Seneca, Letter VIII, in *Letters from a Stoic (Epistulae Morales ad Lucilium)*, trans. Robin Campbell (London: Penguin, 2004), p. 44.

111 For the research that established the presence of the photosensitive ganglion cells, see Russell Foster et al., 'Circadian Photoreception in the Retinally Degenerate Mouse (rd/rd)', *Journal of Comparative Physiology A* vol. 169, no. 1 (1991): pp. 39–50; Farhan H. Zaidl et al., 'Short Wave Light Sensitivity of Circadian, Pupillary, and Visual Awareness in Humans Lacking an Outer Retina', *Current Biology* vol. 17, no. 24 (2007): pp. 2122–2128.

112 There is a long history of the different discoveries of each of these features of sleep, which is documented with great acuity in Kroker, *The Sleep of Others*.

113 Feinberg and Floyd, 'Systemic Trends across the Night in Human Sleep Cycles', *Psychophysiology* no. 16 (1979), pp. 283–291.

114 Dijk and Lazar, 'The Regulation of Human Sleep and Wakefulness', p. 40.

115 See Matthew J. Wolf-Meyer, *The Slumbering Masses: Sleep, Medicine and Modern American Life* (Minneapolis: University of Minnesota Press, 2013).

116 Much sleep research is financed and carried out to the requirements of militaries, resulting in a full-spectrum Keynesianism underlying the creation of materials for civilian secondary markets with anti-sleep drugs such as Provigil/Modafinil. Since these drugs are developed to meet military needs first and foremost, to what extent this implies a militarization of the population at a molecular level is open to question. A state of alertness, of readiness, of will overcoming somnolence at a somatic as well as a mental level may be key.

117 Gilles Deleuze, *Pure Immanence: Essays on a Life*, trans. Anne Boyman (New York: Zone Books, 2001), p. 40.

118 An abridged version is published as Frederic Morton Eden, *The State of the Poor: A History of the Labouring Classes in England, with Parochial Reports*, ed. A. G. L. Rogers (London: George Routledge & Sons, 1928).

119 Karl Marx, *Grundrisse*, trans. Martin Nicolaus (London: Penguin, 1993), p. 736.

120 Mario Tronti, *Strategy of Refusal*, 1965, online at Libcom.org, http://libcom.org/library/strategy-refusal-mario-tronti/

121 Donna Haraway, *When Species Meet* (Minneapolis: University of Minnesota Press, 2008). The term 'nature–culture' does have the problem that it potentially implies the uniting of two previously distinct categories rather than formulating a term that notes the operation of that distinction where germane, but moves beyond its partiality.

122 Eden, *The State of the Poor*, p. 7.

123 Nas, 'New York State of Mind', *Illmatic*, Columbia Records, 1994.

124 Eden, *The State of the Poor*, p. 10.

125 Eden, ibid., p. 13.

126 The development of the range and detail of the categories of rogues and vagabonds between the legislation of 1572 under Elizabeth I (Eden, p. 16) and the Act of Parliament of 1744 during the reign of George II (Eden, p. 55) is exemplary among its kind.
127 See footage of Mubarak, appearing in court in sunglasses, with ostensibly medical attendants, in June 2012.
128 The variable forms of the tradition of the *levée* and *coucher* and the role of the state bed as guarantor of proximity to the centre of power, with the attendant ritualization of such privilege, reach their apogee in Versailles.
129 Karl Marx, *Capital, Volume 1*, trans. Ben Fowkes (London: Penguin, 1990), pp. 816–818.
130 Ibid., p. 818.
131 See the series of stories on sleep on Libcom.org from around April 2012, published on the blog Recomposition.
132 Leslie Crawford, 'Spaniards Wake Up to the End of the Siesta', *Financial Times*, 27 December 2005.
133 Beatriz Preciado, 'Pornotopia', in Beatriz Colomina, Annemarie Brennan and Jeannie Kim, eds., *Cold War Hothouses: Inventing Postwar Culture from Cockpit to Playboy* (Princeton, NJ: Princeton Architectural Press, 2004), pp. 216–253.
134 The possibility of modernist dwelling was, as the Smithsons intuited (proposing a house that, like that of a seventeenth-century Dutch merchant, included a winch to haul in the regularly purchased possessions), to burst under the pressure of consumption, with more and more objects both taking up space and each with its own monadological aesthetic appetites contradicting and making demands on others, causing domestic space to be fundamentally incoherent.
135 Elizabeth Freeman, *Time Binds: Queer Temporalities, Queer Histories* (Durham, NC: Duke University Press, 2012). See also, Dana Luciano, *Arranging Grief: Sacred Time and the Body in Nineteenth-Century America* (New York: New York University Press, 2007).
136 In the British Isles, the sleeping balcony is present as an architectural element in a small number of modern buildings, such as Tregannick House (1935–36) at Penzance, designed by Geoffrey Bazeley.
137 Charlie Hayley, 'From Sleeping Porch to Sleeping Machine: Inverting Traditions of Fresh Air in North America', *Traditional Dwellings and Settlements Review* vol. 20, no. 2 (2009): pp. 27–43.
138 Aravind Adiga, *The White Tiger* (New Delhi: Harper Collins, 2008), p. 184.
139 Nigel Clark, *Inhuman Nature: Sociable life on a Dynamic Planet* (London: Sage, 2013).
140 Marx, *Capital*, pp. 359–360.

141 Andy Clark, *Supersizing the Mind: Embodiment, Action and Cognitive Extension* (Oxford: Oxford University Press, 2008); Lambros Malafouris, *How Things Shape the Mind* (Cambridge, MA: MIT Press, 2013).
142 For a discussion of the idealization of maternal grooming, see, for instance, the work of Sarah Richardson.
143 Judith Butler, *Bodies That Matter* (London: Routledge, 1994), p. 66. For the discussion of media, see Sadie Plant, *Zeroes and Ones: Weaving Women and Cyberspace* (London: Fourth Estate, 1995).
144 Marshall McLuhan, *Understanding Media: The Extensions of Man* (Cambridge, MA: MIT Press, 1994).
145 See the solar art of Olga Panades Massanet.
146 Bernard Stiegler, *Technics and Time 1: The fault of Epimetheus*, trans. Richard Beardsworth and George Collins (Stanford: Stanford University Press, 1998).
147 Mickey Finn and Aphrodite, *Bad Ass!*, Urban Takeover, 1996.
148 See the chapter 'Unconscious Criminality', in Matthew J. Wolf-Meyer, *The Slumbering Masses*.
149 For reflection on this, see Antonio Zadra and Mathieu Pilon, 'Parasomnias II, Sleep Terrors and Somnambulism', in Charles M. Morin and Colin A. Espie, *The Oxford Handbook of Sleep and Sleep Disorders* (Oxford: Oxford University Press, 2012) pp. 577–596.
150 American Academy of Sleep Medicine, in association with the European Sleep Research Society, Japanese Society of Sleep Research, Latin American Sleep Society, *International Classification of Sleep Disorders Diagnostic and Coding Manual* (Westchester, IL: American Academy of Sleep Medicine, 2005).
151 On amnesia and Ambien, see Bruce R. Canaday, 'Amnesia Possibly Associated with Zolpidem Administration', *Pharmacotherapy: The Journal of Human Pharmacology and Drug Administration*, vol. 16, no. 4 (1996): pp. 687–689. For an overview, see Stephanie Saul, 'Sleep Drugs Found Only Mildly Effective, But Wildly Popular', *New York Times*, 23 October 2007, and Jon Mooallem, 'The Sleep-Industrial Complex', *New York Times*, 18 November 2007.
152 Shelly R. Adler, *Sleep Paralysis: Night-mares, Nocebos and the Mind-Body Connection* (New Brunswick, NJ: Rutgers University Press, 2011). See also, for a characteristic survey of sleep disorders involving movement, Christopher P. Derry, John S. Duncan and Samuel F. Berkovic, 'Paroxysmal Motor Disorders of Sleep: The Clinical Spectrum and Differentiation from Epilepsy', *Epilepsia* vol. 47, no. 11 (2006): pp. 1775–1791.
153 See, that is, Zadra and Pilon, 'Parasomnias II, Sleep Terrors and Somnambulism'.

154 Michel Foucault, *The Use of Pleasure: The History Of Sexuality, Volume 2*, trans. Robert Hurley (London: Penguin, 1992).
155 Jonathan Crary, *24/7* (London: Verso, 2013), p. 45.
156 Ernst Neufert, *Bauordnungslehre* (Berlin: Volk und Reich Verlag, 1943).
157 Deborah Dwork and Robert Jan van Pelt, *Auschwitz, 1270–present* (London: Penguin).
158 Margarete Buber-Neumann, *Milena: The Tragic Story of Kafka's Great Love*, trans. Ralph Manheim (New York: Arcade Publishing, 1988), p. 176.
159 Friedrich Nietzsche, *Daybreak: Thoughts on the Prejudices of Morality*, Maudemarie Clark and Brian Leiter, eds., trans. R. J. Holingdale, (Cambridge: Cambridge University Press, 1997) Book 2, §128. pp. 78–79
160 Friedrich Nietzsche, *Ecce Homo*, trans. R. J. Hollingdale (London: Penguin, 1992), p. 37 and p. 43.
161 Johann Wolfgang Von Goethe, *Faust, Part Two*, trans. David Luke (Oxford: Oxford University Press, 1994), p. 158.
162 Goethe, ibid., p. 15.
163 Ibid.
164 Andrey Platonov, 'The Epifan Locks', in *The Return*, trans. Robert and Elizabeth Chandler and Angela Livingstone (London: Harvill Press, 1999), p. 62.
165 The painting featured in Patrick Keillor's *The Robinson Institute*, Tate Britain, London, 2012, and is thumbnailed in his accompanying book *The Possibility of Life's Survival on the Planet* (London: Tate, 2012), p. 60. James, Duke of Monmouth, Pretender to the throne of James II, was defeated at Sedgemoor near Bridgewater, Somerset, in 1685.
166 Staged at the National Art Museum of Ukraine in 2012, http://betv.com.ua/online/sleepingbeauty/
167 *Kids*, directed by Larry Clark, screenplay by Harmony Korine (New York: Miramax, 1995).
168 Georges Bataille, *Theory of Religion*, trans. Robert Hurley (New York: Zone Books, 1992).
169 Ibid., p. 55.
170 (Sommeil animal) Ibid., p. 53. (My emphasis)
171 Alphonso Lingis, 'Nietzsche and Animals', in Peter Atterton and Matthew Calarco, eds. *Animal Philosophy: Ethics and Identity* (London: Continuum, 2004).
172 Frederick S. Starr, *Melnikov*, p. 249.
173 Woody Allen plays on this plotline via postponed present in the film *Sleeper*, 1973.

174 Georges Bataille, *Erotism: Death and Sensuality*, trans. Mary Dalwood (San Francisco: City Lights, 1986), p. 92.
175 See O. F. Bollnow, *Human Space*, trans. Christine Shuttleworth, ed. Joseph Kohlmaier (London: Hyphen Press, 2011). Bollnow presents a moral microgeography in which a calculus of hope is what allows the subject the possibility of sleep in a state of security.
176 All images from Manuel Alvarez Bravo included in an exhibition at the Jeue de Paume (October 2012–January 2013), Paris, and reproduced in Gerardo Mosquera, Ivan De La Nuez and Catherine David, *Manuel Alvarez Bravo* (Madrid: TF Editores, 2012).
177 Ilya Ehrenberg, *My Paris*, trans. Oliver Ready, facsimile edition (Paris: Edition 7, 2005).
178 Pierre Guyotat, *Coma*, trans. Noura Wedell (Los Angeles: Semiotext(e), 2010), p. 202.
179 Jean Genet, *Our Lady of the Flowers*, trans. Bernard Frechtman (London: Faber and Faber, 1990), p. 104.
180 Sara C. Mednick, with Mark Ehrman, *Take a Nap! Change Your Life: The Scientific Plan to Make You Smarter, Healthier and More Productive* (New York: Workman Publishing, New York, 2007).
181 Aristotle, *On Dreams*, in Aristotle, *On Dreams, Parva Naturalia, On Breath*, (Cambridge, MA: Loeb Classical Library, 1957), p. 351.
182 There is a person who wishes to be associated with this term as its originator.
183 Walter Benjamin, 'Convolute K', *The Arcades Project*, Ed. Rolf Tiedemann. trans. Howard Eiland and Kevin McLaughlin (Princeton, NJ: Belknap Press, Princeton, 2002).
184 Walter Benjamin, 'Ibizan Sequence', in *Walter Benjamin: Selected Works, vol. 2, 1927–1934*, trans. Rodney Livingstone (Cambridge, MA: Harvard University Press, 1999), pp. 590–591 and, *Spain 1932*, same volume p. 643.
185 A counterhypothesis for memory consolidation to occur in slow-wave sleep is made in Giulio Tononi and Chiara Cirelli, 'Sleep Function and Synaptic Homeostasis', *Sleep Medicine Reviews* vol. 10, no. 1 (2006): pp. 49–62.
186 S. Frederick Starr, *Melnikov: Solo Architect in a Mass Society* (Princeton, NJ: Princeton University Press, 1978). See also Tony Wood, 'Bodies at Rest', in *Cabinet*, no. 24, Shadows, Winter 2006/07.
187 The period referred to is 1904–8. Blaise Cendrars, *Moravagine*, trans. Alan Brown (London: Penguin, 1994), p. 61.
188 Joseph Wortis, *Soviet Psychiatry* (Baltimore: Williams and Wilkins, 1950).
189 Michael Mohammed Knight, *Blue-Eyed Devil: A Road Odyssey through Islamic America* (Brooklyn: Autonomedia, 2006).

190 Robert Wilkins, 'Rough-Sleeping on the Bendy Bus', *The Guardian*, 9 December 2011, http://www.guardian.co.uk/society/video/2011/dec/09/homeless-on-the-bendy-bus-video/.
191 Marcel Mauss, 'Techniques of the Body', in *Techniques, Technology and Civilisation*, ed. Nathan Schlanger (New York and Oxford: Durkheim Press & Berghahn Books, 2009), p. 88.
192 Eluned Summers-Bremmer, *Insomnia: A Cultural History* (London: Reaktion Books, 2008).
193 Lygia Clark, '1966: We Refuse?', in Lygia Clark and Yve-Alain Bois, 'Nostalgia of the Body', *October*, vol. 69 (1994): p. 106.
194 Keira O'Reilly, *Sleeping with a Pig*, in the exhibition *Interspecies*, curated by Arts Catalyst, Cornerhouse, Manchester, 2009.
195 Frans Masereel, *Passionate Journey* (n.p.: Subterráneo Press, 1986). For a discussion of Masereel, see Clifford Harper, *The Education of Desire: The Anarchist Graphics of Clifford Harper* (London: Annares Press, 1984). See also Antonio Cataldo, ed., *Forms of Modern Life: From the Archives of Guttom Guttomsgaard* (Oslo: Office for Contemporary Art Norway, 2014).
196 http://www.sakikoyamaoka.com/WorksList.html.
197 http://www.sakikoyamaoka.com/performance_works_concept.html.
198 Peter Handke, *The Weight of the World: A Journal* (New York: Collier Books, 1990).
199 Peter Handke, *Versuch über die Mudigheit* (Berlin: Suhrkamp, 2012).
200 *This is XX*, in 'From Sleeping to Swimming', frieze art fair, London 2006, and in 'The Generational: Younger Than Jesus', New Museum, New York, 2006.
201 Trajal Harrell, *The Ambien Piece*, 2006. Also performed at Gallery Objective Correlative as part of Whenever Wherever Festival, Tokyo, 2012, in collaboration with David Bergé.
202 For a discussion of this painting, in which the artist's name is given as Liu Kuan-Tao, see also James Cahill, *Hills Beyond a River: Chinese Paintings of the Yüan Dynasty 1279–1368* (New York and Tokyo: Weatherhill, 1976), p. 153.
203 Juvenal, 'Satire III', in *The Sixteen Satires*, trans. Peter Green (London: Penguin, 1967), p. 95.
204 See, for instance, the story of 'Vasilissa the Fair', in *The Magic Ring: Russian Folk Tales from Alexander Afanasiev's Collection* (Moscow: Raduga Publishers, 1985), pp. 40–46.
205 Warren McCulloch and Walter Pitts, 'A Logical Calculus of Nervous Activity', in Margaret Boden, ed., *The Philosophy of Artificial Intelligence* (Oxford: Oxford University Press, 1990), p. 24.
206 Jean-Paul Sartre, *Nausea*, PDF file of unspecified edition, unnamed translator, no URL given, p. 8.

207 G. W. Leibniz, 'Principles of Nature and Grace, based on Reason', in *Philosophical Texts*, trans. Richard Francks and R. S. Woolhouse (Oxford: Oxford University Press, 1998), p. 260.
208 Astrid Lundgren, *Pippi Longstocking*, various editions.
209 William Dement and Christopher Vaughn, *The Promise of Sleep: The Scientific Connection between Health, Happiness and a Good Night's Sleep* (London: Macmillan, 2000).
210 Kroker, *The Sleep of Others*.
211 Rosi Braidotti, *Metamorphoses: Towards a Materialist Theory of Becoming* (Cambridge: Polity Press, 2002).
212 Rosi Braidotti, *The Posthuman* (Cambridge: Polity, 2013), p. 35.
213 See M. R. Wright, 'Introduction' in, *Empedocles, the extant fragments*, (Bristol: Bristol Classical Press, 1995), p. 38.
214 Methods for such work are given in Pliny, *Natural History Books 33–35*, book 35, trans. H Rackham, Loeb Classical Library (Cambridge, MA: Harvard University Press, 2003).
215 Empedocles, *Empedocles, the extant fragments*, 15(23), p. 179.

INDEX

alpha waves 80
Alvar Aalto 65–6
adenosine 44
alarm clock 14
albatross 160
amygdala 52
Anderson, Laurie 7
animal sleep 118–20, 159–61
apnoea 82–3
Apple (computers) 60–1
apps 101–2, 109
Aristotle 22
art methodologies 146
A Turin Horse 152
Augustine 3

Baba Yaga 156
bakers 96
Bakhtin, Mikhail 12
Barrie, J. M. 37
Bates, Charlotte 48
Bataille, Georges 51, 116–17
Bauordnungslehre 110–11
Beckett, Samuel 31
'bed-head' styling products 126
bench 125
Benjamin, Walter 131
Berger, Hans 40–2
biopolitical theory 8
blue light 79–80
body temperature 26
Borbély, Alexander 42
Border Agency 138
Botticelli, Sandro 73, 141

Brian Q. Huppi 61
Braidotti, Rosi 13, 162
brain 4, 6, 9, 14, 19, 21–3, 30, 38,
 40–3, 45–6, 51–2, 79, 80–1, 96, 100,
 117, 127, 131, 158–60
brain wave 40
Bravo, Manuel Alvarez 122–4
van Brekelenkam, Quiringh 153
Breton, André 73
Brooke-Rose, Christine 47–8
Buber-Neumann, Margarete 111
Bundy, Edgar 113
busses 138
Butler, Judith 100

Camberwell 16
Capital 96
The Castle 19
catalepsy 50
Cendrars, Blaise 134
Chalmers, Dave 96
chronobiology 43–4
circadian rhythm/system 26, 38, 42–3,
 49, 50, 52, 68, 70, 80–1
Clark, Andy 96
Clarke, Arthur C. 157
Clark, Larry 116
Clark, Lygia 145–6
Cretan Paradox 13
curlers 126
chronotopes 12
coffee 139
Cold War 29
Come with Me 148–9

INDEX

Cooling from the Summer Heat 154
cortisol 64
Crook, Tom 35
crusties 141

Daphnis and Chloe 71–2
Delilah 72–3
Deleuze, Gilles 86
De Los Maneras de Dormir 123–4
Descartes, René 2, 52, 157–8
desynchronization 70–1
Dijk, Derk-Jan 44–5
Diogenes 141
dream 2–4, 7–8, 21, 28, 31–2, 36, 38, 45, 72, 110, 112, 122–3, 130–1, 132
Dreaming of a Butterfly 153
Duan, Yingmei 75–6
Duchamp, Marcel 150
Dullaart, Constant 61
van Dyck, Antoon 72–3

Eden, Frederic Morton 88–9
Edgar, Adrian 42
Ehrenberg, Ilya 124–5
Ekirch, Roger 22–3
electrode 31, 33, 40
electroencephalogram (EEG) 40–1, 43, 64, 80, 107
El Lissitzky 125
El Soñador 122
emails 34
Empedocles 46–7, 59, 159, 162
Empedoclean 56, 60, 69, 102, 162
Endymion 115
estrogen 64
epithalamus 51
extended mind 96–7
experiment 30
eye 81–2

Fallen Sheet 123
Father Christmas 37
Faust 112
Finist the Bright Falcon 156
Foucault, Michel 109
Freud, Sigmund 31
Freeman, Elizabeth 93
fresh air 93–4
free party scene 141
Foxconn 61
functionalism 65–7

Gamble House 94
General Strike 1926, 16
genes 50, 68
Genet, Jean 130
ghrelin 64
Giorno, John 98
Glissant, Édouard 13, 161–2
von Goethe, Wolfgang 112–13
Gould, Stephen Jay 67
Guandao, Liu 153–4
Guattari, Félix 62
Guyotat, Pierre 129

hagfish 51
Handke, Peter 149
Haraway, Donna 89
Harrell, Trajal 150
Heraclitus 35
heroin 57–8
hiccups 45
Holger the Dane 119
homeostat/homeostatic system 39, 42–3, 50, 52, 70
hormones 58–60, 63–4
horror 75–6
Hume, David 86
hypnic jerks 45–6
hypnagogic myoclonus 45–6

INDEX

hypoglycemic fit 48
hypothalamus 50, 52

immune system 68–9
inner migration 29
Institutional Dream Series 7
International Classification of Sleep Disorders Diagnostic and Coding Manual 106
insomnia 17, 82, 83–4, 139, 149
intertidal zone 67
Interregnum 137
Iyer, Lars 3
I Robot 157–8

Journal of Biological Rhythms 44
Judith and Holofernes 115
Juvenal 156

Kafka, Frans 19
k-complexes 80
ketamine 141
Kids 117
King Arthur 119
Kleitman, Nathaniel 24–7
Knight, Mike 137
Koller, Július 74
Kroker, Kenton 41, 161

larks and owls 63
Leibniz, Gottfried Wilhelm 53–5, 58, 63, 116, 158–9
Lefebvre, Henri 44, 48
Lenin, Vladimir Illyich 97, 120
leptin 64
Life, End Of 47–8
Lingis, Alphonso 119
love and strife 48, 57, 69, 144, 148
Loos, Adolph 74
Los Perros durmiendo ladran 124

Mammoth Cave, Kentucky 24
Manning, Chelsea 111
Marx, Karl 87, 91, 96
Masereel, Frans 147
Mauss, Marcel 138
McCulloch, Warren and Walter Pitts 158
McLuhan, Marshall 100–101
melatonin 52, 53, 62–3, 64
Melnikov, Konstantin 132–5
Mirbeau, Octave 38
Monadology 53, 117, 158–9
Mubarak, Hosni 90–1

Nas 89
Nausea 158
nest 45
Nancy, Jean-Luc 45, 50
narcolepsy 50
Neufert, Ernst 110–11
Nietzsche, Friedrich 35, 112, 119
NREM 80–1

Occupy 15
Ophelia 120
oscillators/oscillations 42–5, 53
Our Lady of the Flowers 130
O'Reilly, Keira 147

Palmer, Samuel 139–40
pillow 152
Polataiko, Taras 116
Parasomnias 104–6
Paimio Sanatorium 65–6
Parker, Cornelia 144
Pavlov, Ivan 134–5
Peter Pan 6
photosensitive ganglion cells 79–80
pineal gland 23, 51–2, 79, 100
Pippi Longstocking 159

Platonov, Andrey 113
plethysmograph 40, 85
polysomnogram 23, 109
Poor Law 87
posthuman/posthumanities 13, 50
power naps 87
Preciado, Beatrice 56, 58–60
prolactin 53

quantified self 24, 101–4, 108–9

rapid eye movement 52, 80–1, 108, 131, 132
Richardson, Bruce 24–7
Rip van Winkle 120
Rhythmanalysis 48
Rubens, Peter Paul 72–73

Samson 72–3, 77
Sartre, Jean-Paul 158
scent 128–9
von Schantz, Malcolm 44–5
Selene 115
Sendak, Maurice 130
Serres, Michel 8
self-experiment 25–7
Seneca 78
serotonin 53
sheep 140
shift work 49, 116
Shenzen Skies 61
Shrigley, David 114
siesta 92
Siffre, Michel 27–30
sinkhole 21
Skinner Box 55
Sleep (Shrigley film) 114
Sleep (Warhol film) 97–9
Sleeping Beauties 116
Sleeping Beauty 120

Sleeping with a Pig 147
sleep debt 135–7
sleepwalkers 34
sleepwalking 104
slow-wave sleep 52
sodium amytal 135
Sonata of Sleep 132
spittoon 65
Stalin, Joseph,134
Starr, S. Frederick 134
Stephenson, Robert Louis 129
Surrealists 31, 152–3
suprachiasmatic nucleus 49, 79
Swinton, Tilda 144–5
symphony of oscillators 44, 55–6

Tarr, Bela 152
testosterone 59, 61–2
thalamus 52
theta waves 80
The Ambien Piece 150
The Best Place to Sleep 148
The Maybe 144–5
The Morning of Sedgemoor 113
This is XX 149
Thoreau, Henry David 154
Torture Garden 38
Trocchi, Alexander 57–8, 59
Tronti, Mario 87
Turing Machine 4

USSR pavilion Paris 1925 135

vagrancy 89–90
Venus and Mars 73, 143–4

Warhol, Andy 97–9
Weber, Max 77
Where the Wild Things Are 130

Wittgenstein, Ludwig 4
Wolf-Meyer, Matthew 104
Woman Asleep by a Fire 153
Wordsworth, William 30
Wright, Rosemary 162

Yamaoka, Sakiko 148–9
Yun, Chu 149–50

Zarathustra 112, 119
zeitgebers 49, 143